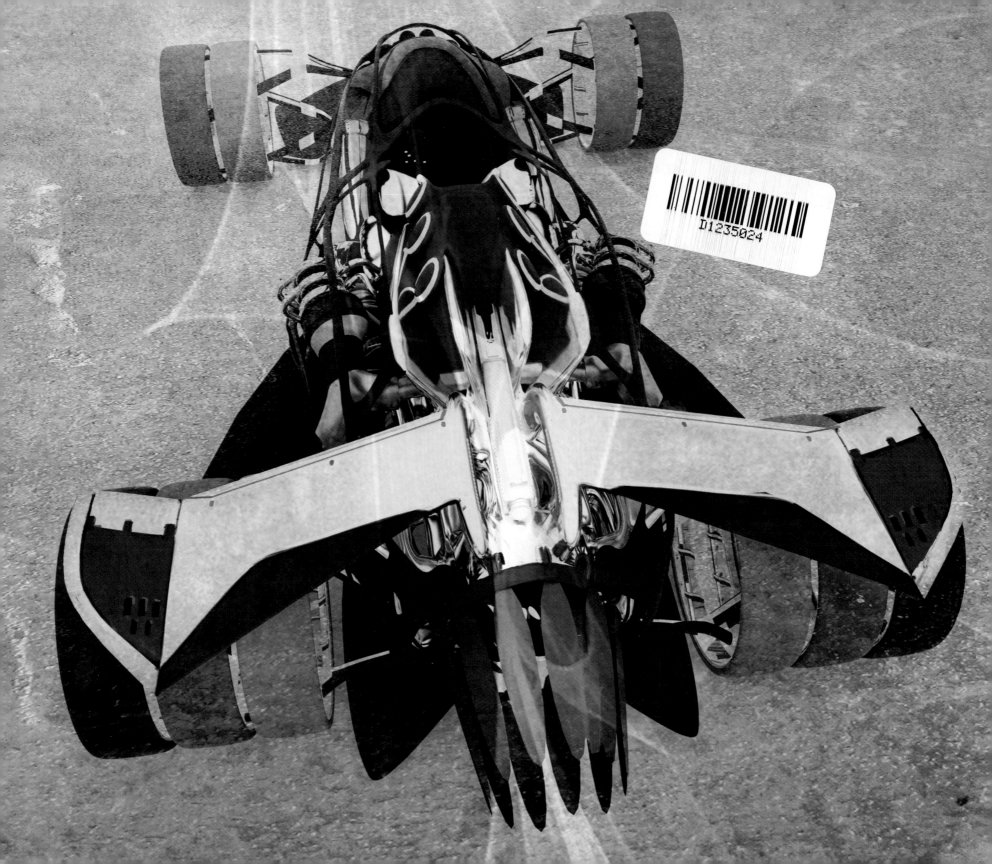

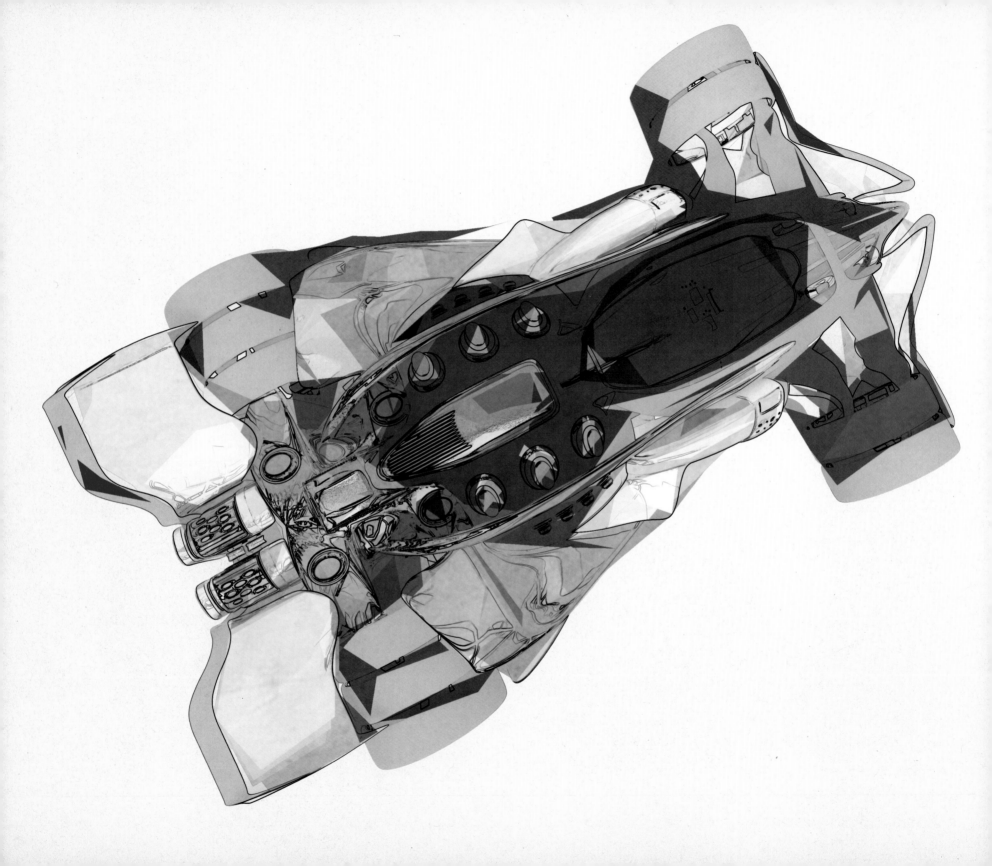

DRIVE

vehicle sketches and renderings by
scott robertson
daniel gardner
annis naeem

designstudio|PRESS

dedication

This book is dedicated to all of you who have given me your continued support and in return the "drive" to complete this book.

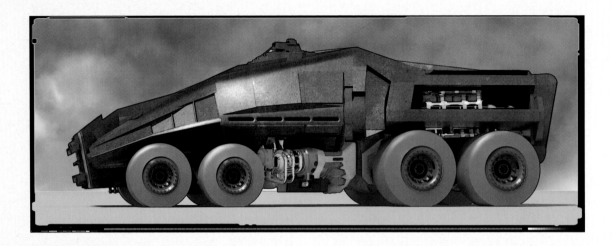

contact info

Scott Robertson can be reached by e-mail at: **scott@drawthrough.com**.

To see more of Scott's work visit: **www.drawthrough.com** and **www.drawthrough.blogspot.com**

Published by Design Studio Press
8577 Higuera Street
Culver City, CA 90232
Website: www.designstudiopress.com
E-mail: info@designstudiopress.com

10 9 8 7 6 5 4 3 2 1

Printed in China
First edition, November 2010

Hardcover ISBN 13: 978-1-933492-86-5

Paperback ISBN 13: 978-1-933492-87-2

Library of Congress Control Number:
2010932199

CONTENTS

introduction 006

CHAPTER 01 : **AEROSPACE** 009

CHAPTER 02 : **MILITARY** 049

CHAPTER 03 : **PRO SPORT** 095

CHAPTER 04 : **SALVAGE** 140

bios 174

afterword 176

introduction

Welcome to my newest book, *DRIVE*.

After completing my first two books, *Start Your Engines* and *Lift Off,* I decided to switch gears and spend my personal design time creating otherworldly creatures, characters and environments, culminating in the book, *Alien Race.* Once that was finished in the spring of 2009, I yearned to get back on track designing vehicles for my next personal book project for Design Studio Press.

A few things led me to explore the particular types of vehicles in this book. I have a strong desire to always force myself to expand the many ways in which I can create interesting and endless variations of conceptual vehicle designs. In this pursuit, I taught myself how to use several 3D modeling and rendering software programs, then challenged myself to integrate them into my design process, to augment the traditional drawing and rendering skills that I have relied upon for years. A few subtle breakthroughs occurred along the way.

One of the first was the application of specifically designed Photoshop custom brushes stamped over a base rendering of a chassis, generated using Luxology's software, modo. This system took me away from traditional drawing and focused graphic design at the forefront of the creative process. Through this technique I generated many new vehicle forms which I sincerely doubt I would have been likely to draw with just a pen and paper. Since the new graphic shapes were being collaged and warped over a base rendering of a 3D vehicle package, I could work as abstractly as I liked, while always knowing where the hard points were (meaning the wheels, engine and occupants of the vehicle). I still have some research and experimentation to do on this workflow, but once it is refined I intend to document the results in my next book, which will be all about my design process. To jump ahead to see a few examples of this process, check out pages 40, 105 and 106.

The work I share with you in this book features the concept designs of four basic vehicle types: fast cars, off-roaders, a few motorcycles and huge sci-fi vehicular monsters. In putting the book together, four basic stylistic genres emerged: aerospace, military, mainstream contemporary/futurism and salvaged. As I could steer the work in any direction, I chose to think of these vehicles as mostly for the video-game space. This allows for much more character and fun in the designs, which wouldn't be the case if I had made each of these concepts for the real world. So with a newly renewed "artistic license" in hand, the designs presented over the four chapters of this book are intended as pure styling exercises to further advance my own fascination with imagination, and the refinement of my own concept design processes. From quick thumbnail sketches and digital paintings done by hand, to 3D images created with a digital "kit-bashing" of various digital model parts, I hope you enjoy this latest collection of design sketches and renderings.

The work featured in *DRIVE* was created not only by myself, but with able assists from two very talented entertainment design students from Art Center College of Design: Annis Naeem and Daniel Gardner. I have always shared my ideas and techniques with the concept design world at large, and the work Annis and Daniel contributed to *DRIVE* makes me very proud to have been their teacher. I think the book is a fabulous example of what strong teamwork—combined with good foundation design, drawing and rendering skills—can accomplish. The sum of these collective artistic and design efforts are much greater than I could have hoped to achieve on my own. Thank you, Danny and Annis. As for the credits of the work shown throughout, just look at the bottom of any page and you will find the names of those who worked on the content of that page. Enjoy.

Scott Robertson.

Scott Robertson
July 2010
Los Angeles

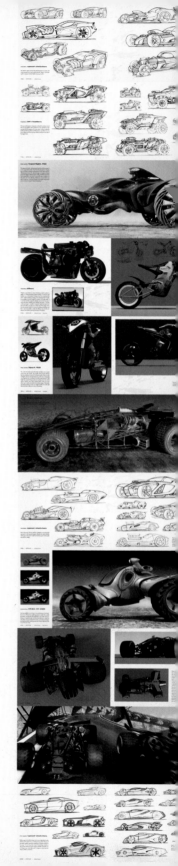

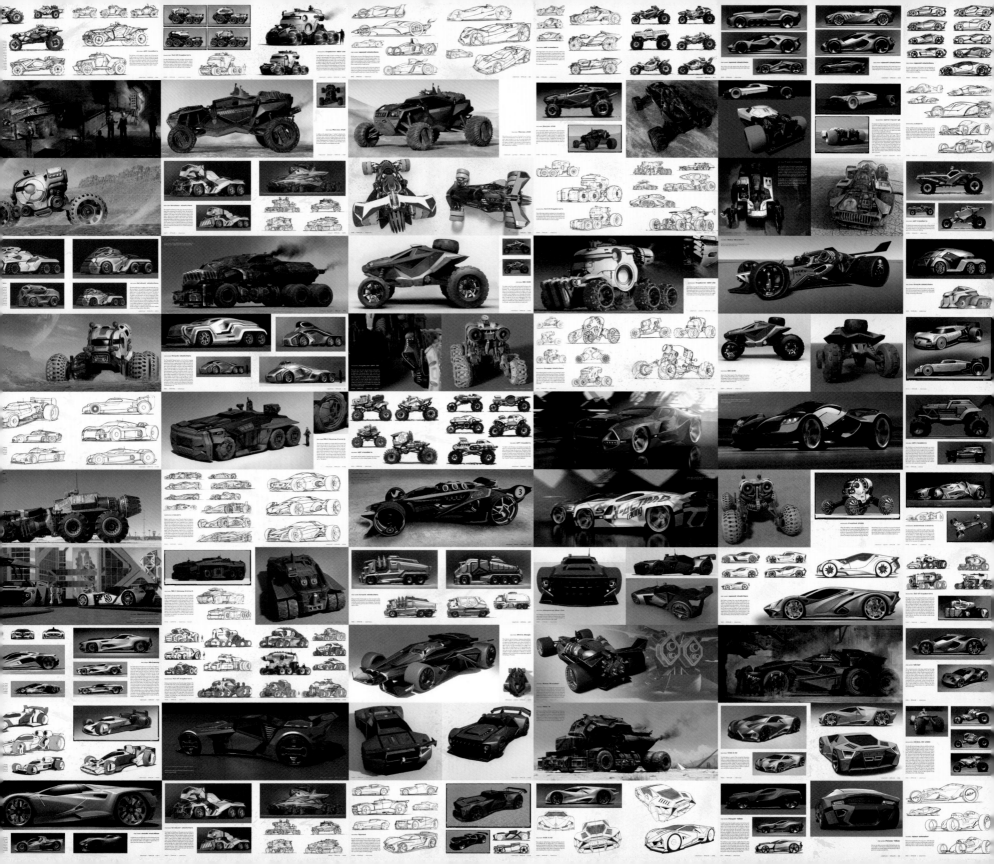

Spacecraft have long been one of my favorite type of vehicles, and in this first chapter I thought it would be fun to imagine our video-game-style road vehicles inspired by the shapes, colors and detailing found on old and modern-day spacecraft. I have visited the Smithsonian Air and Space Museum several times and have found it more and more inspiring with each trip. The thousands of photographs I've taken there, as well as at several other space museums, served to inform the visual research that Danny, Annis and I used for the design of our vehicles. Some of the vehicles are meant to explore a variety of environments, while others are all about power and speed. Drawing on our research, I found that the black/white color combination with a few red, blue or gold material accent colors went a long way toward making a convincing connection back to the spacecraft that so inspired us.

RIGHT REAR

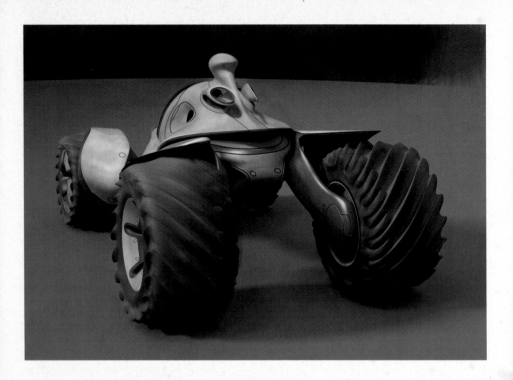

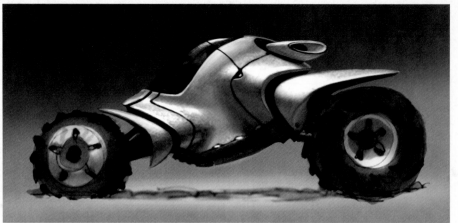

AEROSPACE: F.R.O.G. RT-2010

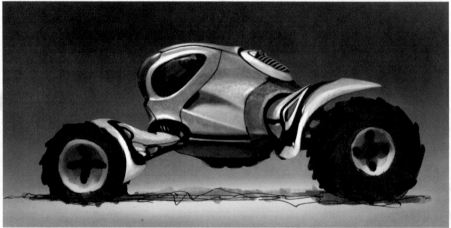

This little off-road racing buggy is the first vehicle we did for this chapter. The design grew out of the sketches to the right, which are actually very quick digital mash-ups, and then paint-overs, of three spaceship sketches found at the back of my previous book, *Lift Off*. I just added wheels to the ship sketches, made a few other proportional tweaks and thereby generated three design directions to choose from. We went with the top sketch, and then I jumped into modo to realize the design into the three-dimensional digital model pictured above and on the opposite page. As the design took shape in modo I liked the whimsical round forms, so I kept them and decided to let the suspension arms and other details stay very simple and clean, giving the design a more sci-fi looking aesthetic. As it is supposed to be an off-road type of buggy, an aggressive tread pattern is best to communicate that to the viewer. The rear view of this design (shown above) says that the aesthetic is, first and foremost, all about the tires...and then you see the little single-seat driving pod floating at the middle of the design.

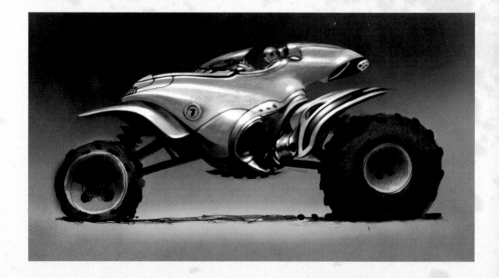

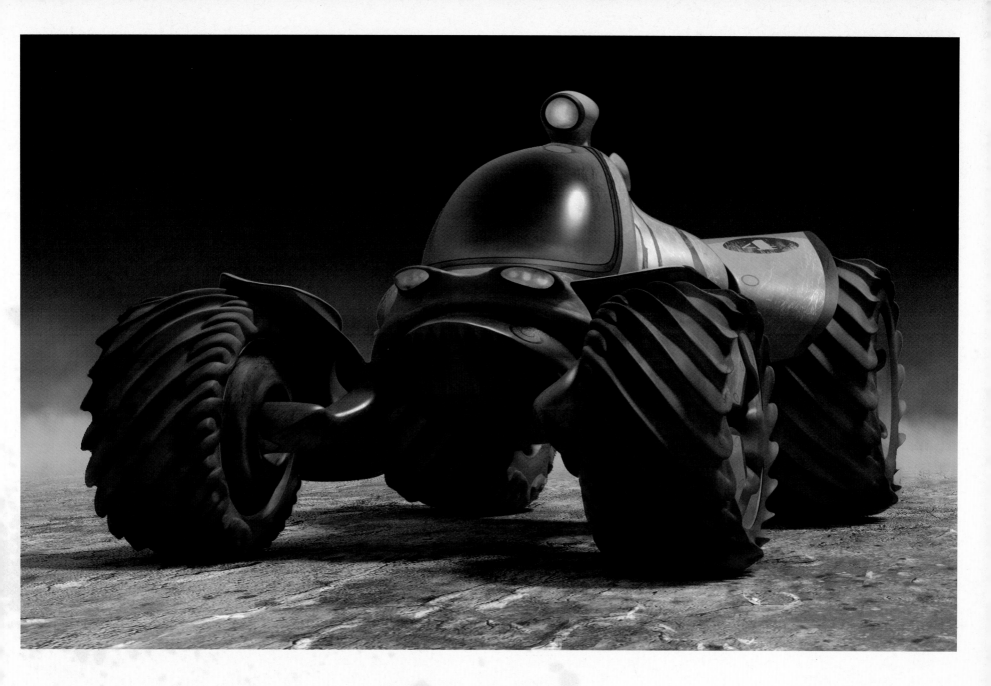

AEROSPACE: F.R.O.G. RT-2010

The front view of the buggy shows even more of the whimsical character of the design, as the "face" of this vehicle reminds me of some type of frog. This is very evident through the frown-ing mouth gap where the front suspension arms attach. You can tell by the nice dusty weathering Danny added that this F.R.O.G. does just as well on land as it might in swamps.

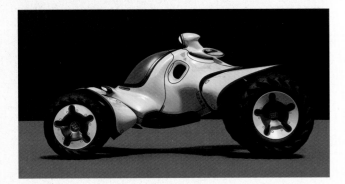

AEROSPACE: F.R.O.G. RT-2010

We have added a lot of dust to our renderings in this book. Here's how. We run two rendering passes in modo. Then, inside Photoshop, we drop the dust rendering on top of the color rendering on a separate layer, and then erase the dust to reveal the color below. It is very fast and fun to do, as it's easy to imagine touching the vehicle, cleaning areas your hands might touch like around the door latch.

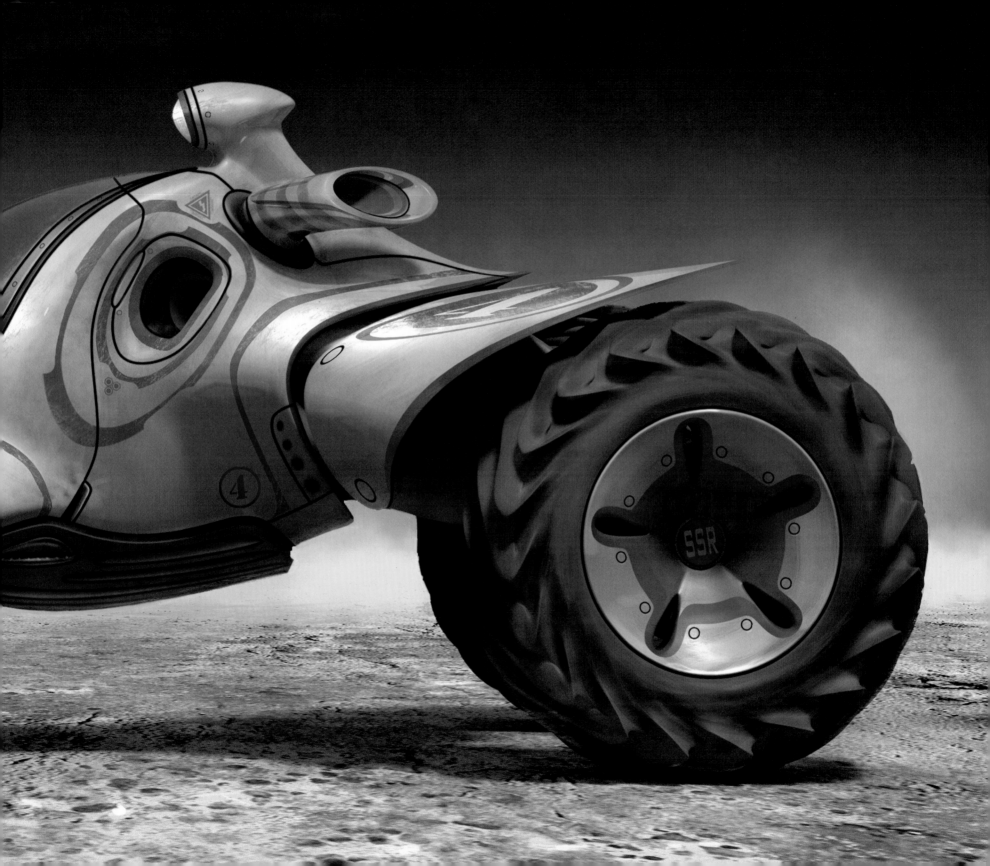

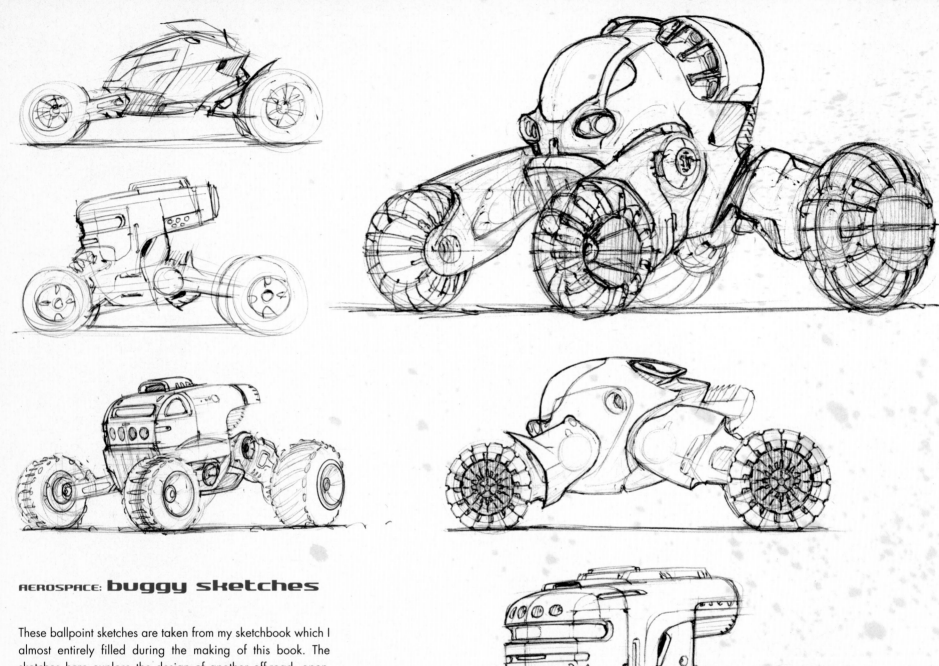

AEROSPACE: buggy sketches

These ballpoint sketches are taken from my sketchbook which I almost entirely filled during the making of this book. The sketches here explore the design of another off-road, open-wheel vehicle. This direction retains a bit of the fun from the the previous design with a strong "face," and adds to the aerospace aesthetic with more sci-fi wheels/tires, some rugged exploration-style lights, a more "tech" suspension system and an exposed engine at the back.

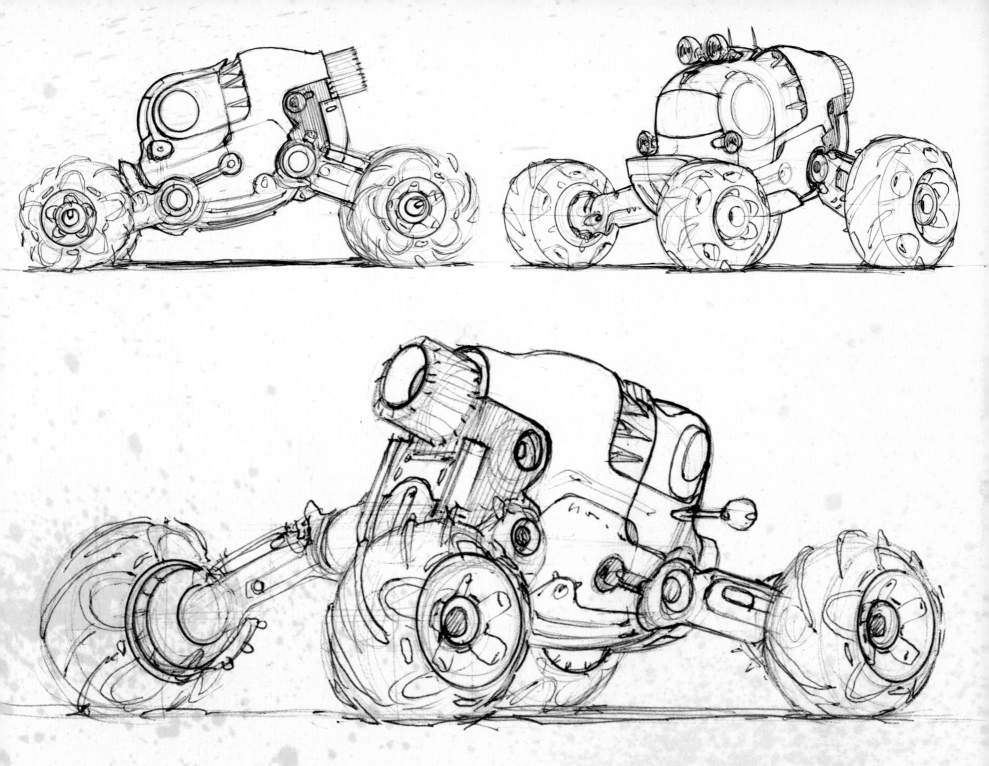

robertson : DRIVE : 015

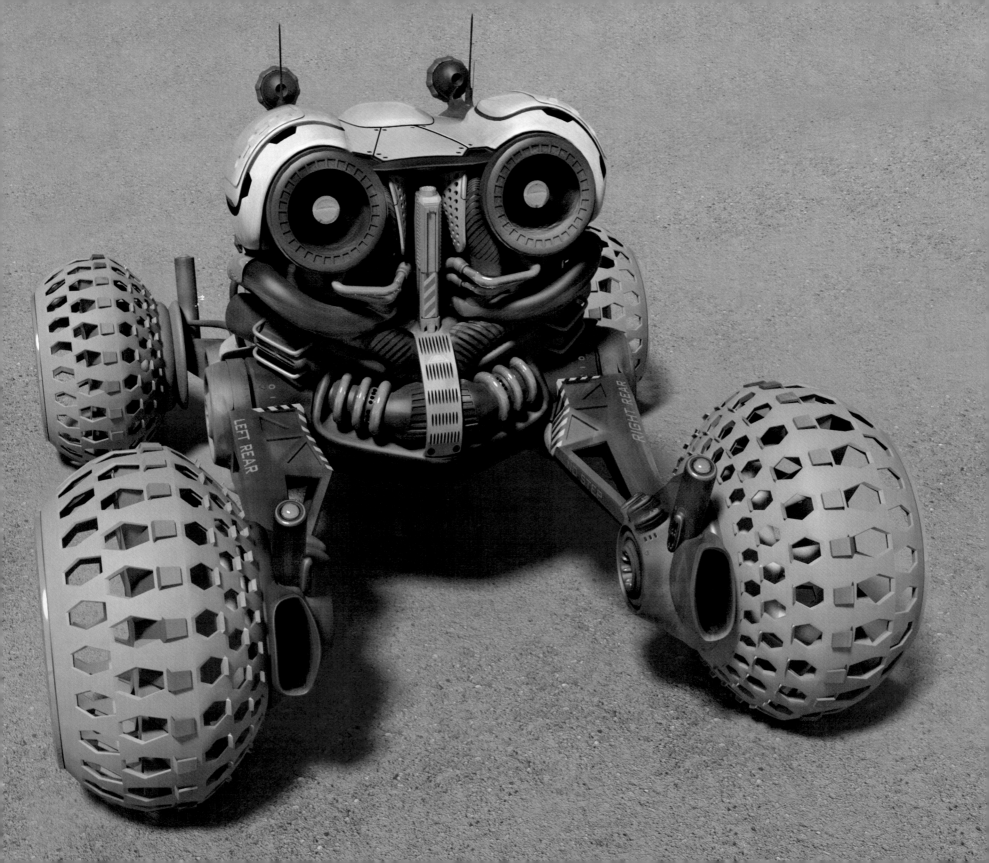

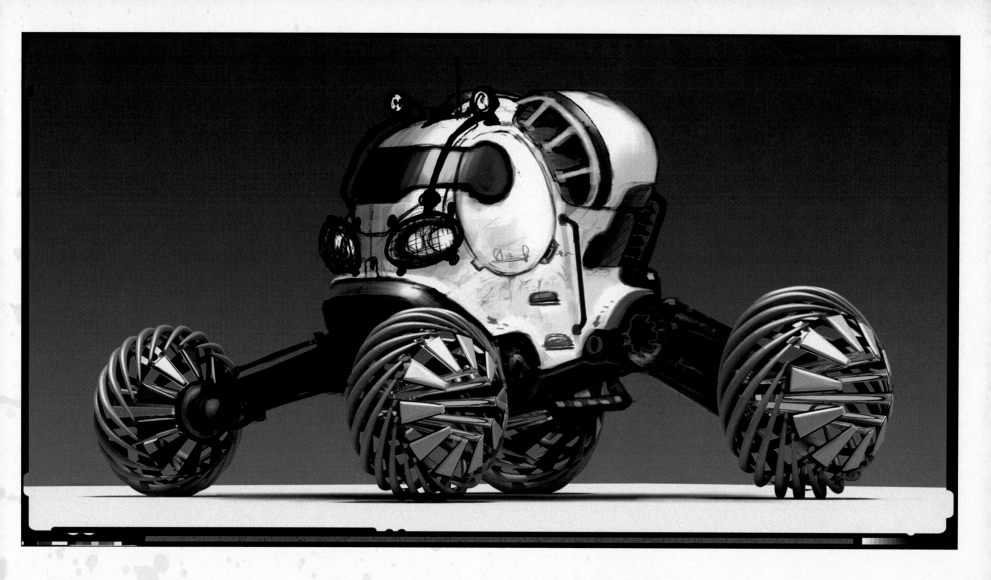

AEROSPACE: ExoPod 2500

Where 3D modeling in modo really helped us take our sketches to a higher level was in executing the wheels. The sketch above shows this well. The body of the ExoPod 2500 was done very quickly as a loose painting in Photoshop. By having the photo-real image of the wheels and tires as a base rendering to paintover, the design automatically feels more real. We used this technique a lot, as it is very time-consuming to do photo-real renderings of wheels and tires by hand. Oftentimes, rendering the wheels by hand can take even longer than the entire rest of the painting. Doing wheels in a 3D program like modo has really accelerated and added value to sketches like this one.

After we finished rendering the ExoPod, Annis dropped it into his sci-fi landscape painting to give us a sense of the vehicle in its otherworldly environment.

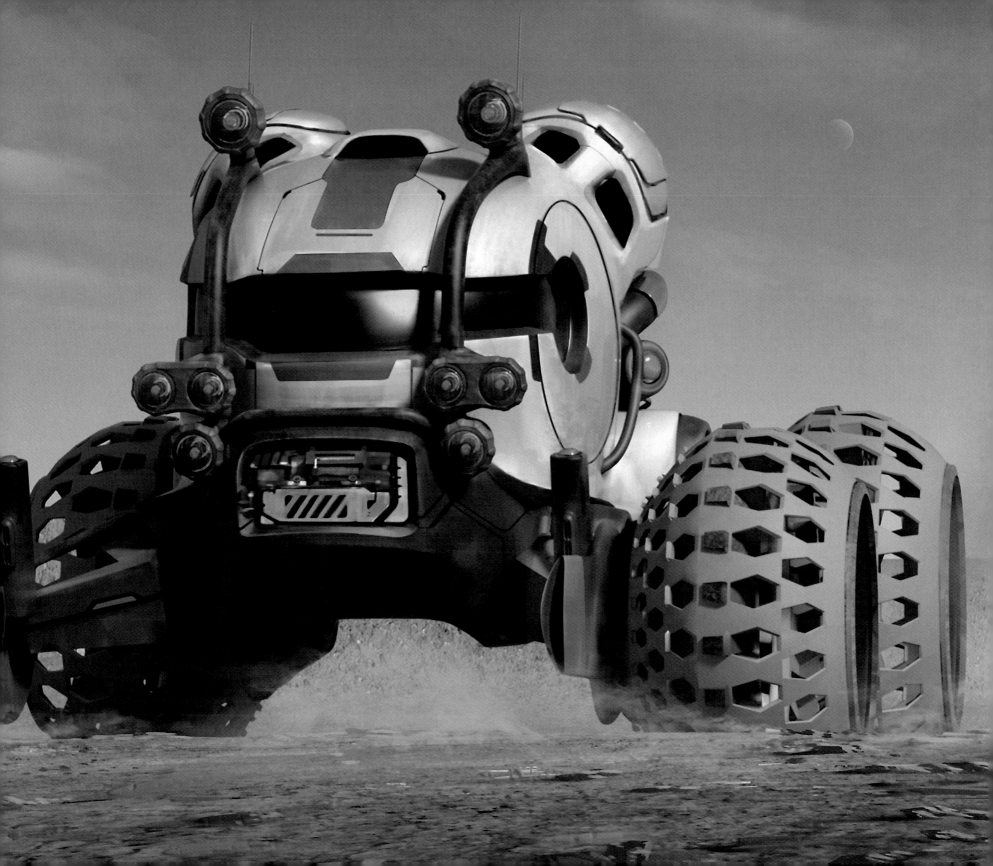

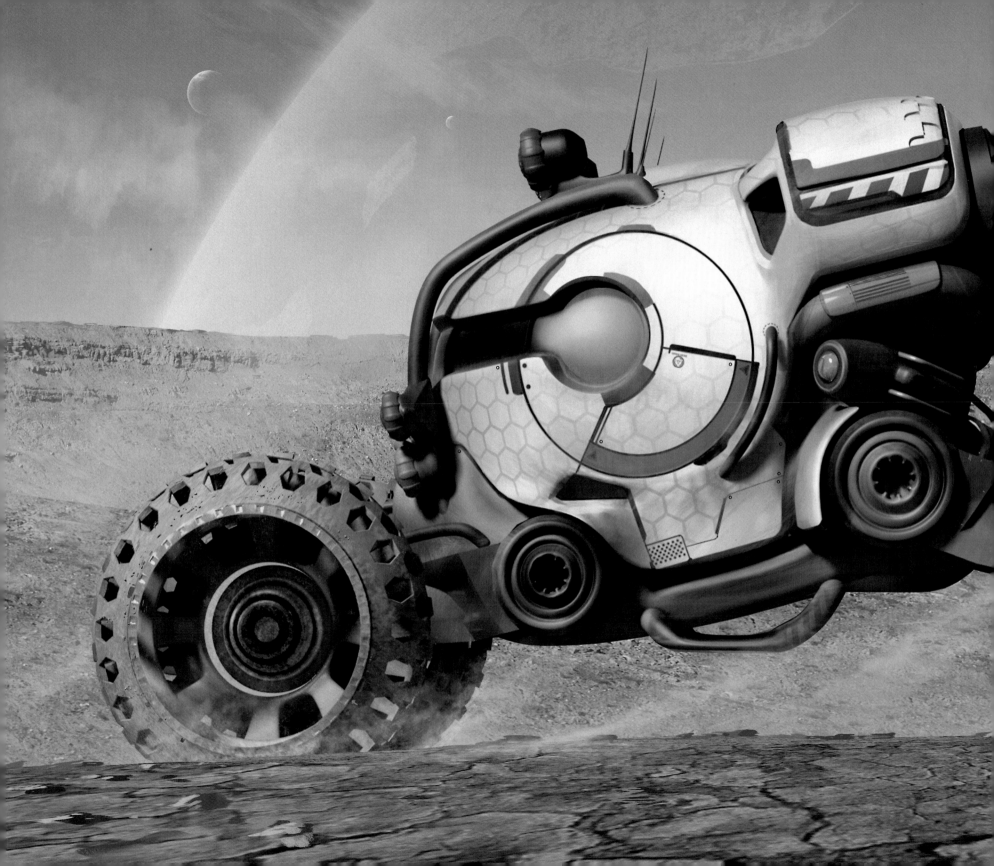

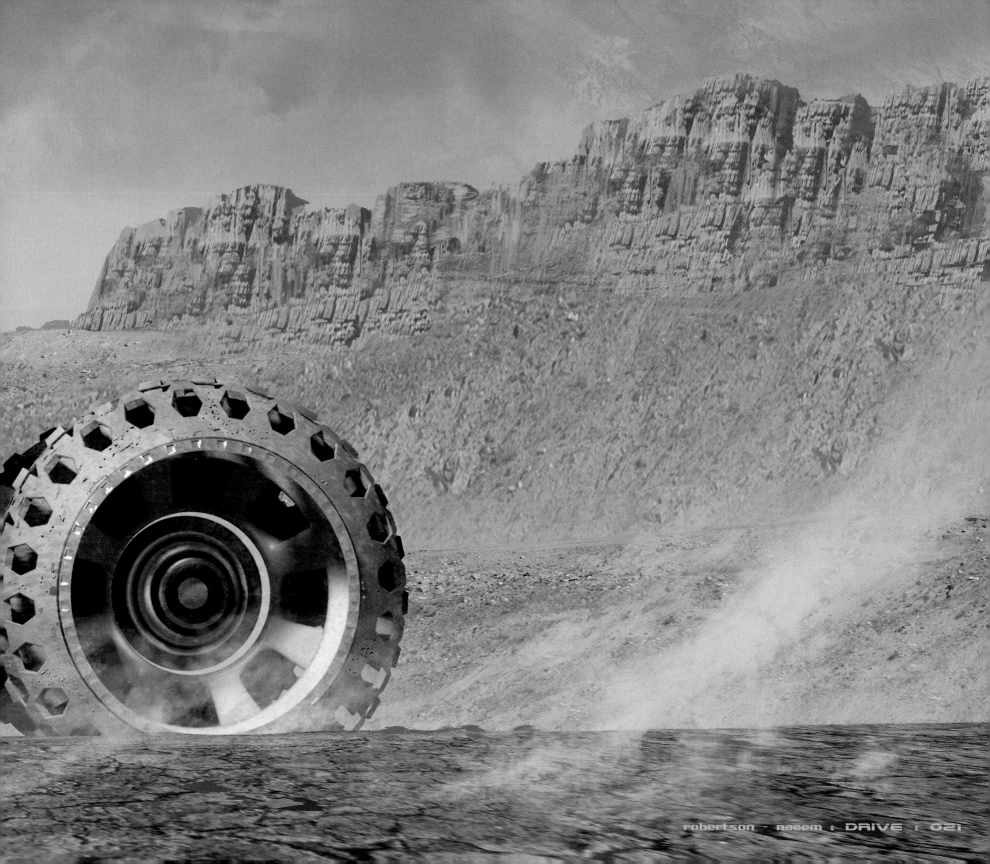

robertson - naeem : DRIVE : 021

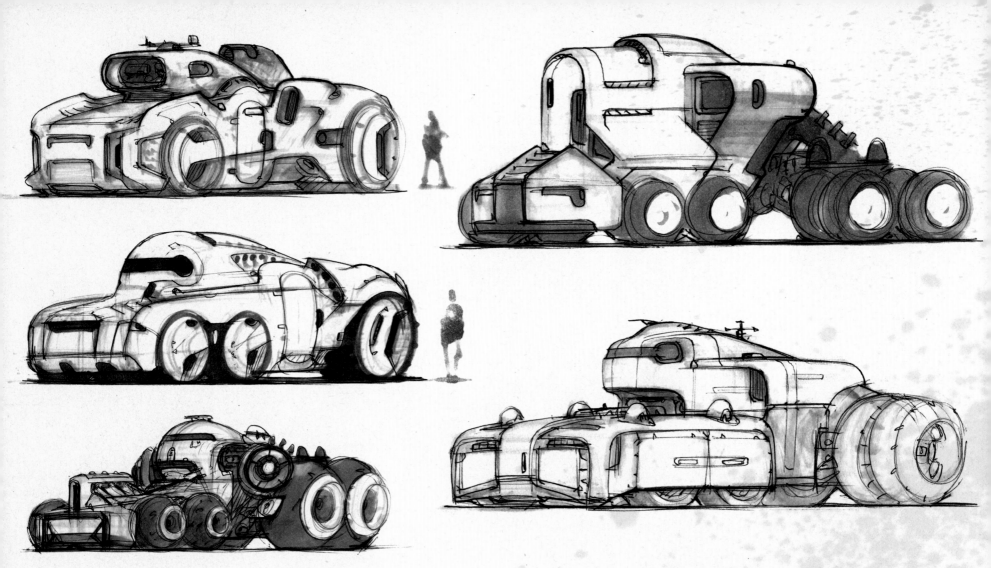

AEROSPACE: Sci-Fi Explorers

Marker and pen sketches show the wide range of designs I like to consider early on for any new vehicle design. The basic idea was to expand on the design of the Explorer XRT-20 on page 31. This vehicle could be even bigger than the XRT-20. The technique used was first to sketch the rough basic form with a very light grey marker and then to add the details with a pen on top of the rough sketch. After scanning the sketches I colorized them in Photoshop and set the layers to "multiply," and finally they were composited onto the toned background of the page.

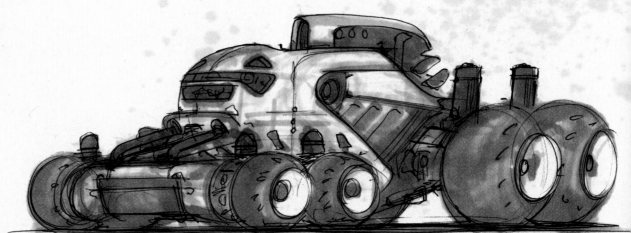

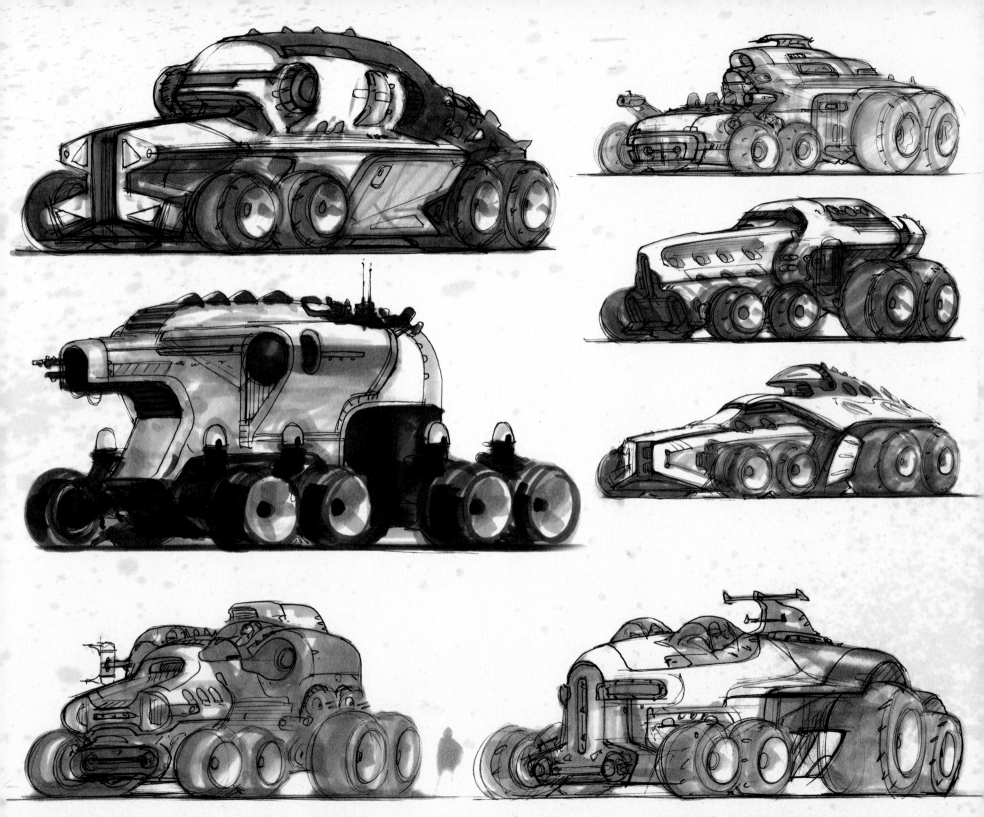

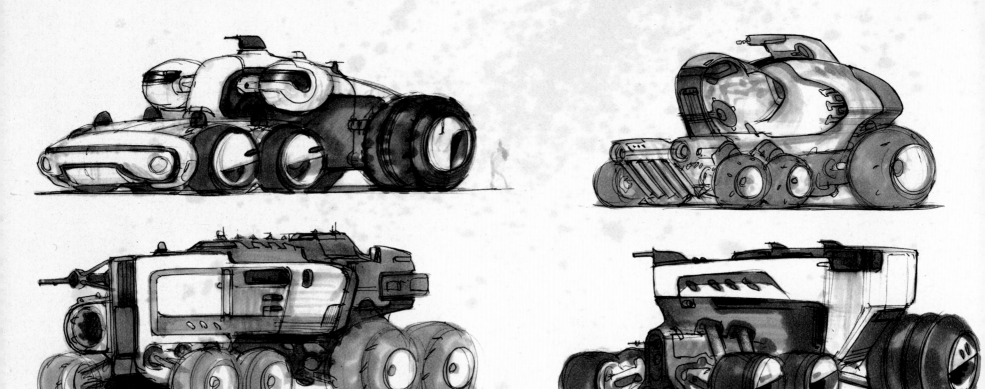

AEROSPACE: Sci-Fi Explorers

More big explorers. The three framed Photoshop sketches to the right feature an idea of having a "matter disruptor" at the front of the vehicle. The most low-tech of these designs being the one immediately to the right. Huge vertically oriented grinding cylinders would have the ability to clear a path through a variety of obstacles which are often encountered while playing games. The explorer on the far page, top, has a more high-tech approach with some sort of super high-tech matter disruptor integrated low at the front of the bumper. The third design would just use brute force to move any barrier or competitor encountered along the way. Again, these sketches all started like the marker and pen ones above, and were then quickly painted over in Photoshop.

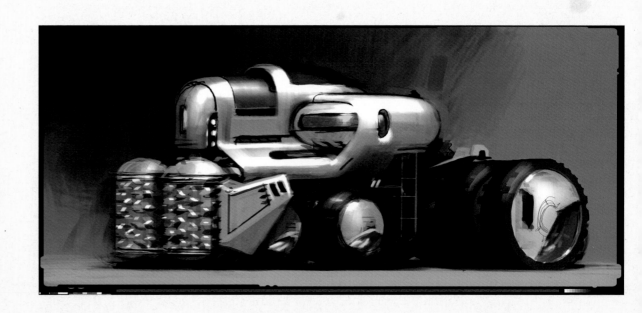

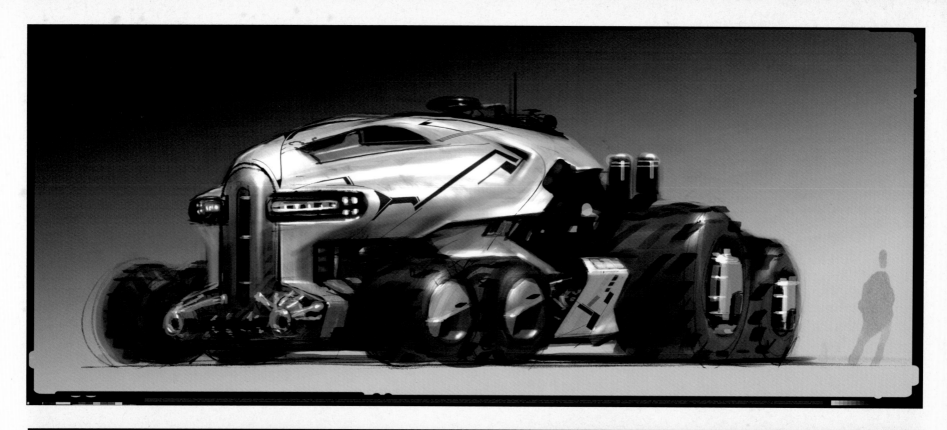

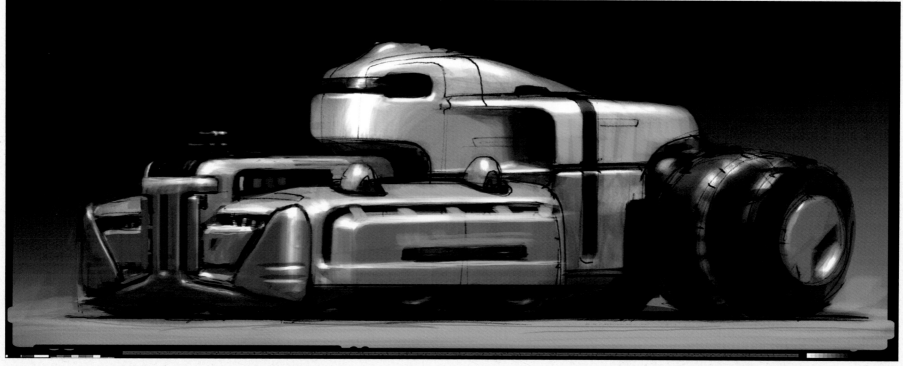

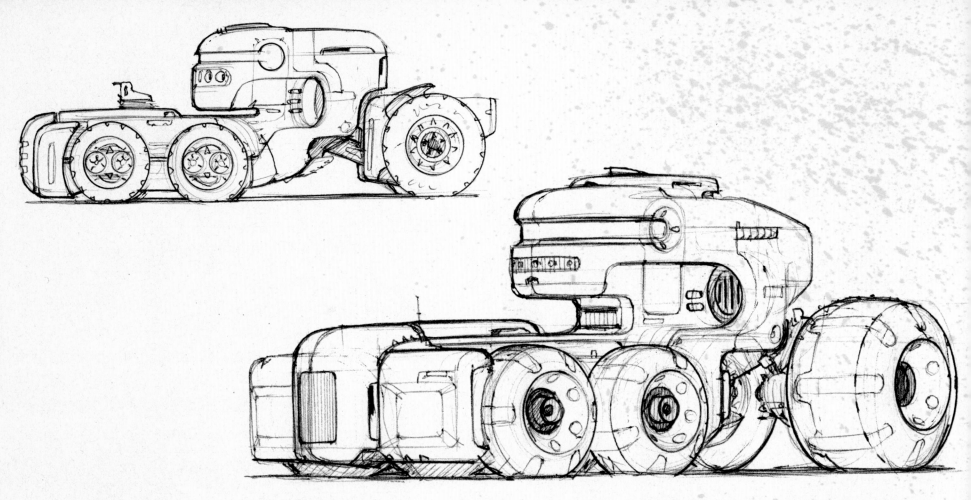

AEROSPACE: Sci-Fi Explorers

These ballpoint-pen sketches investigate more styling options for a heavy duty, exploration-style vehicle. We were having fun with the proportions of the vehicles by playing with the idea of an elevated/floating cabin area for the crew. These sketches lead into the 3D model I blocked out on the next page.

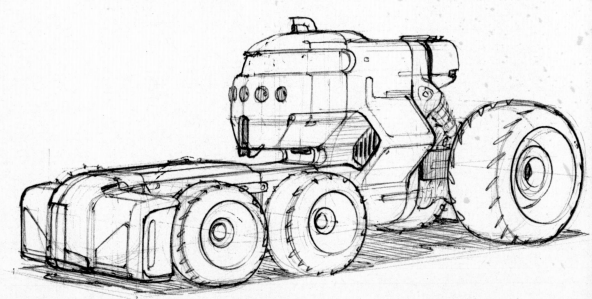

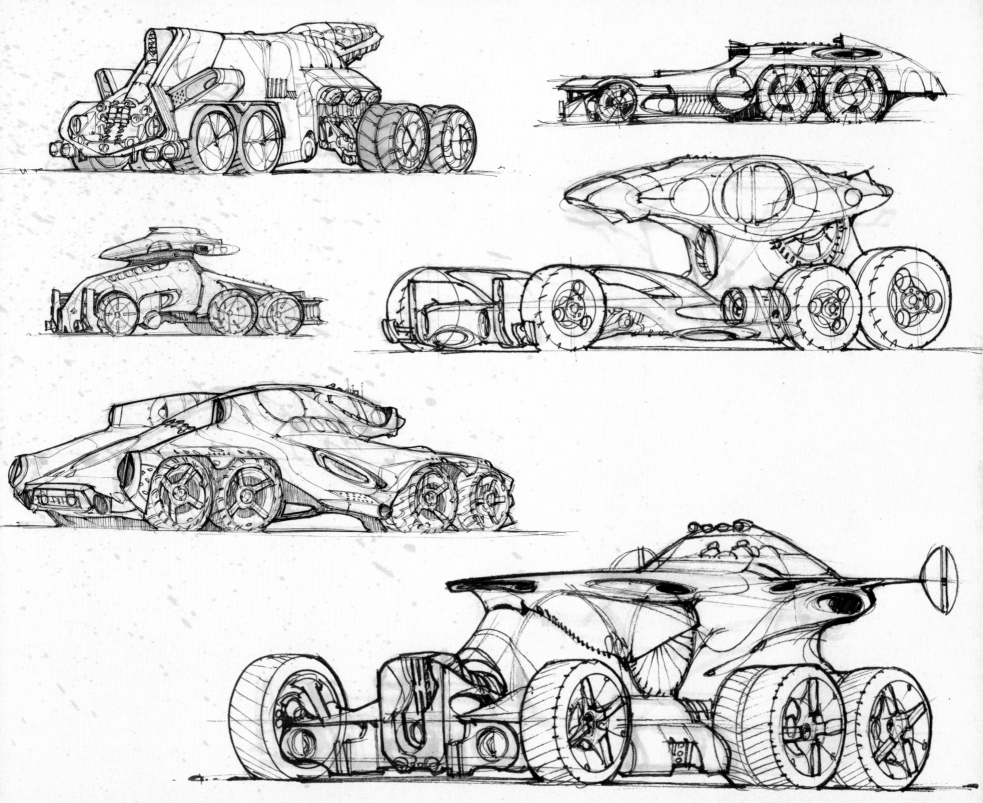

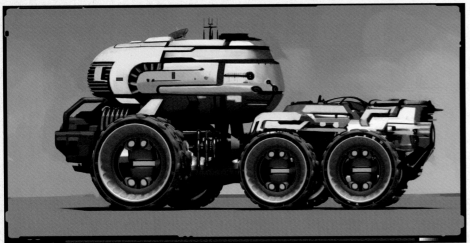

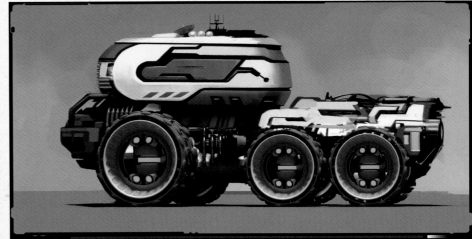

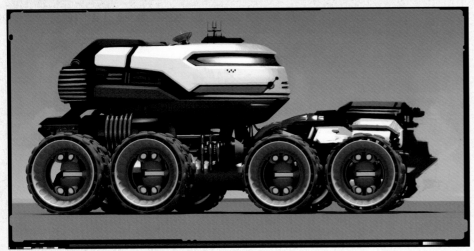

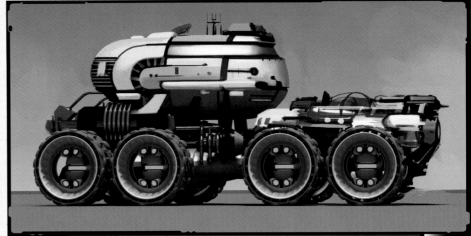

AEROSPACE: Sci-Fi Explorers

The idea of the floating crew cabin was taken a bit further in the four digital paintovers above. A hint of the vehicles' massive scale can be derived from the size of the windows. I imagine that the front wheels on these big boys would be about 6' to 8' in diameter. The sketch to the right is the final ballpoint pen drawing that leads into the renderings on the facing page.

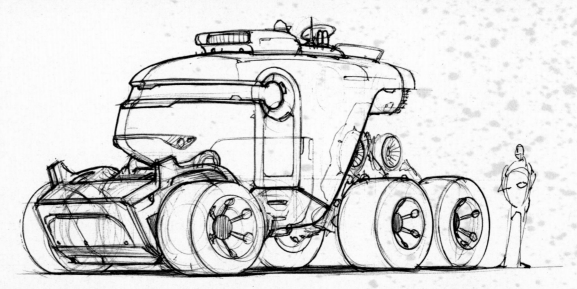

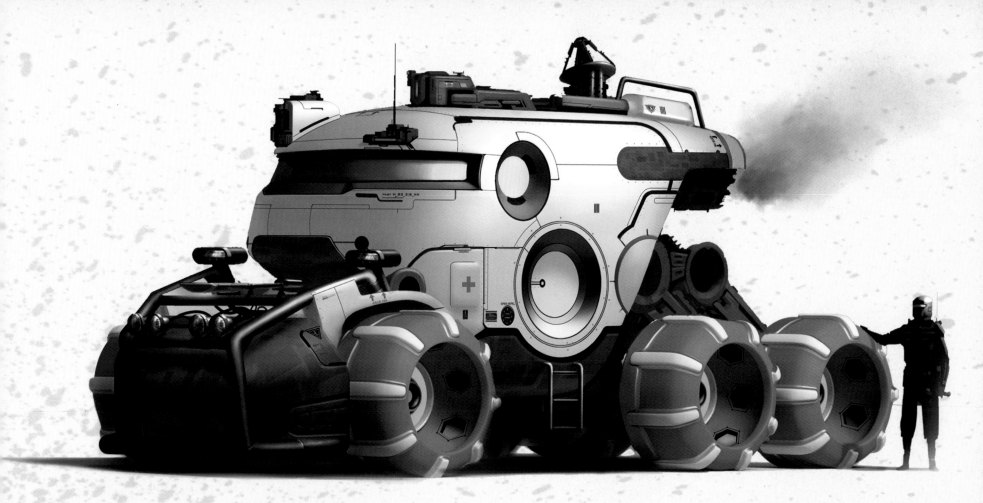

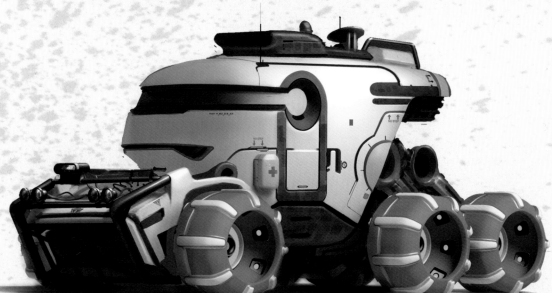

AEROSPACE: Explorer XRT-20

The idea behind the wheels and tires is that they are molded around an aerospace-tech inner frame connected to a drive hub. Being aerospace tech we could freely use as much gold as we liked! After staging the wheels in the correct perspective in modo to match the pen sketch on the facing page, the 2D Photoshop rendering phase commenced. We hit on the circle as our dominant shape with gold-coated glass and white body surfaces to help establish a strong visual aerospace look. This idea of a circular hatch/door is seen on a lot of spacecraft and it carries over nicely here for the design of the Explorer XRT-20.

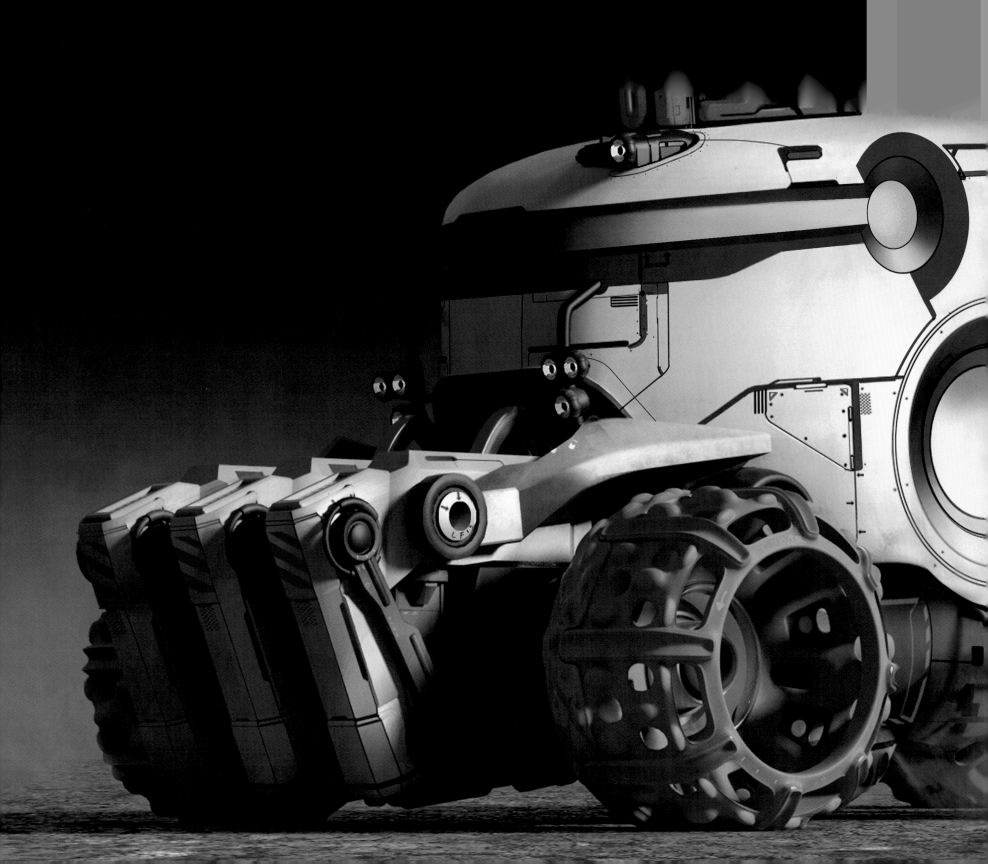

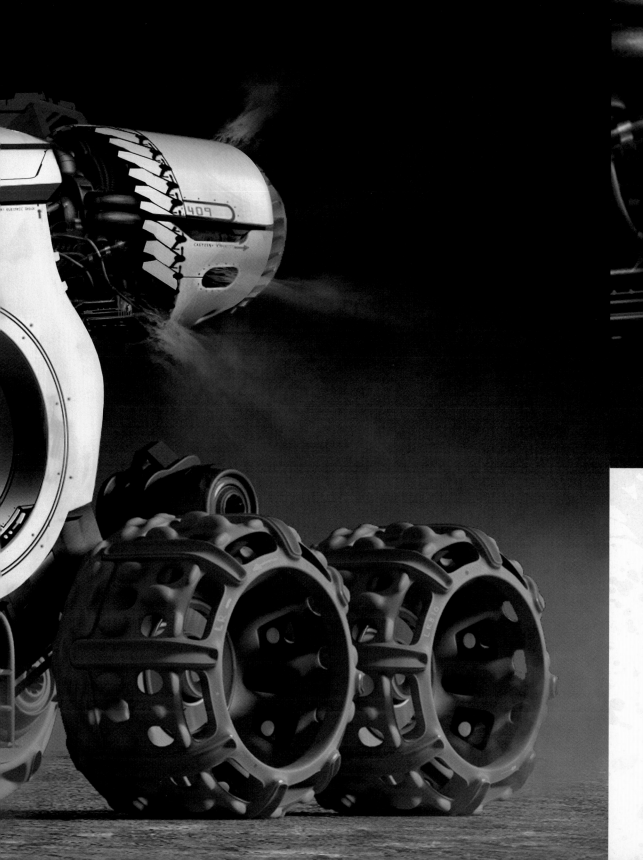
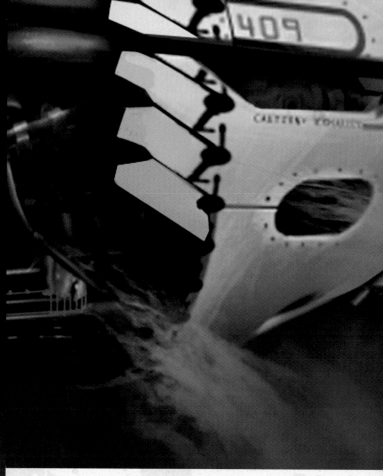

AEROSPACE: **Explorer XRT-20**

After a hard run through the extreme conditions of an advanced game level, the XRT-20 lets off some heat. This is the final front three-quarter rendering for this oversized explorer. The articulating front rigging and suspension arms could make for some entertaining animation as this vehicle maneuvers over rugged terrain, plowing its way through whatever stands in its way!

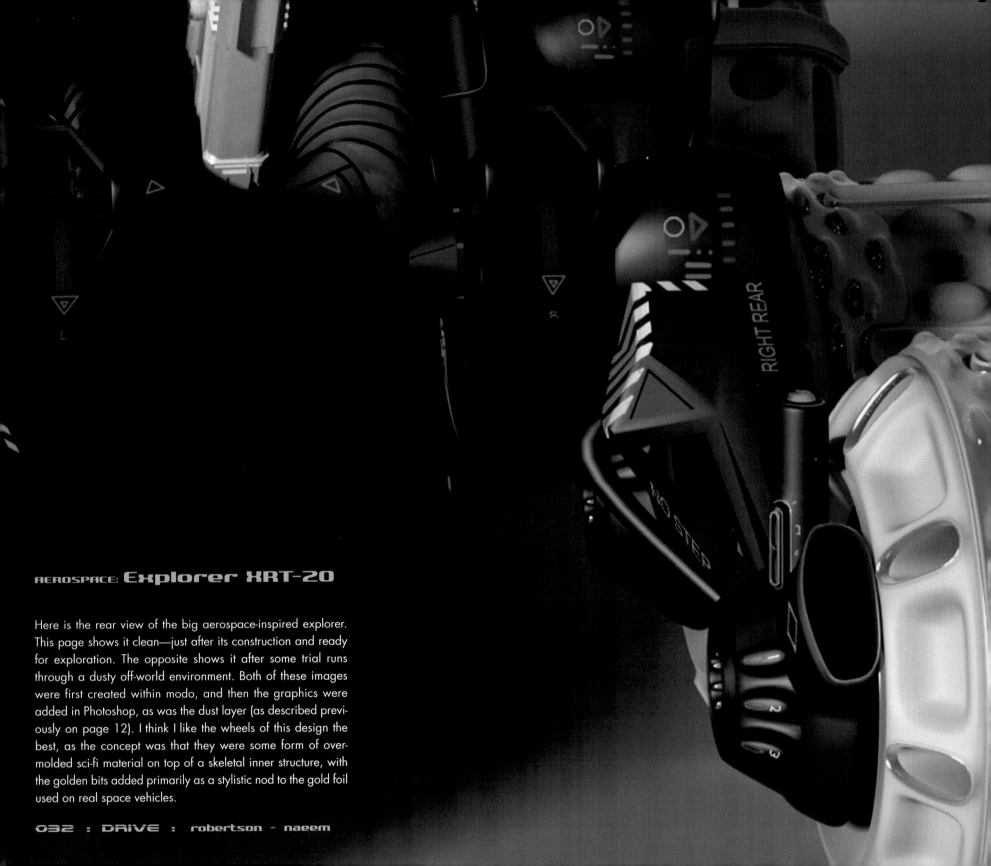

AEROSPACE: Explorer XRT-20

Here is the rear view of the big aerospace-inspired explorer. This page shows it clean—just after its construction and ready for exploration. The opposite shows it after some trial runs through a dusty off-world environment. Both of these images were first created within modo, and then the graphics were added in Photoshop, as was the dust layer (as described previously on page 12). I think I like the wheels of this design the best, as the concept was that they were some form of over-molded sci-fi material on top of a skeletal inner structure, with the golden bits added primarily as a stylistic nod to the gold foil used on real space vehicles.

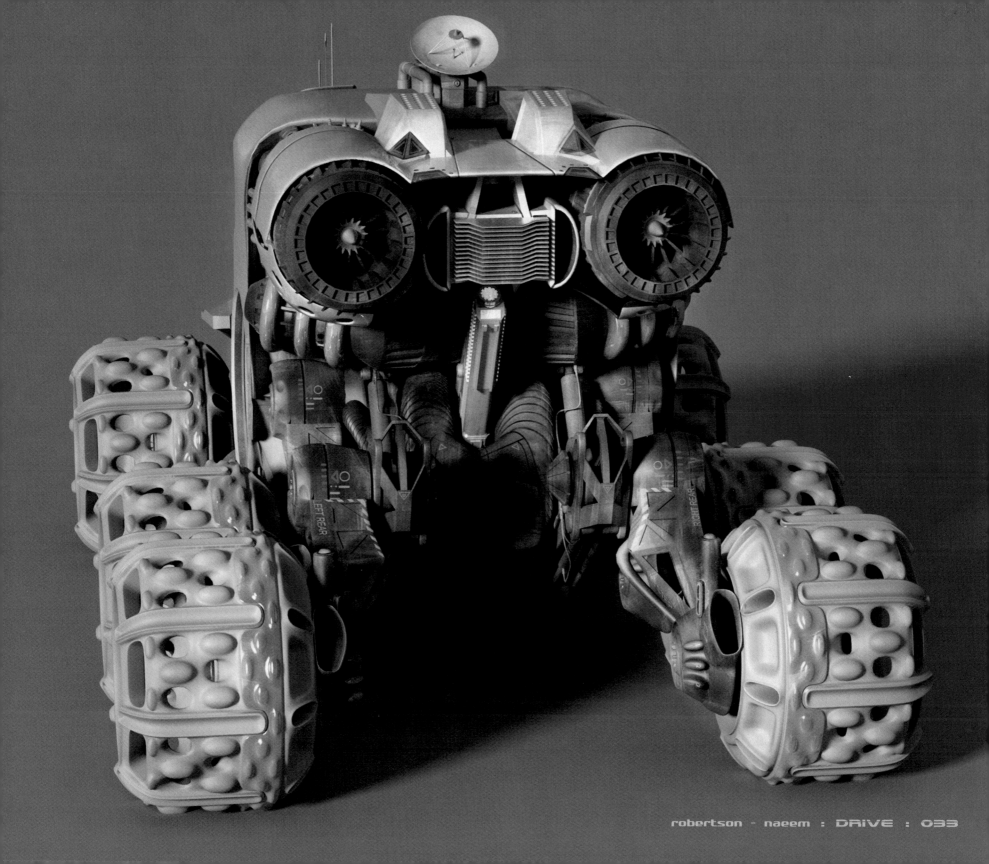

robertson - naeem : DRIVE : 033

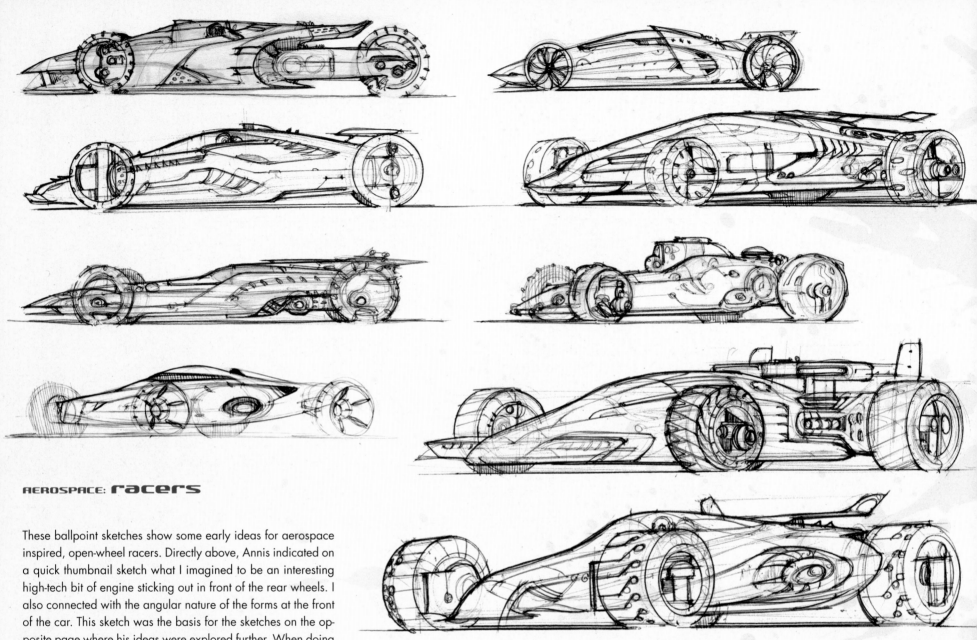

AEROSPACE: racers

These ballpoint sketches show some early ideas for aerospace inspired, open-wheel racers. Directly above, Annis indicated on a quick thumbnail sketch what I imagined to be an interesting high-tech bit of engine sticking out in front of the rear wheels. I also connected with the angular nature of the forms at the front of the car. This sketch was the basis for the sketches on the opposite page where his ideas were explored further. When doing sketches where the focus is on the design of the body of the vehicle, I recommend not spending much time on the design of the wheels and tires, other than making sure they are in perspective and the correct size for the vehicle, knowing that they will be replaced later by much more high-tech wheels done in 3D within modo.

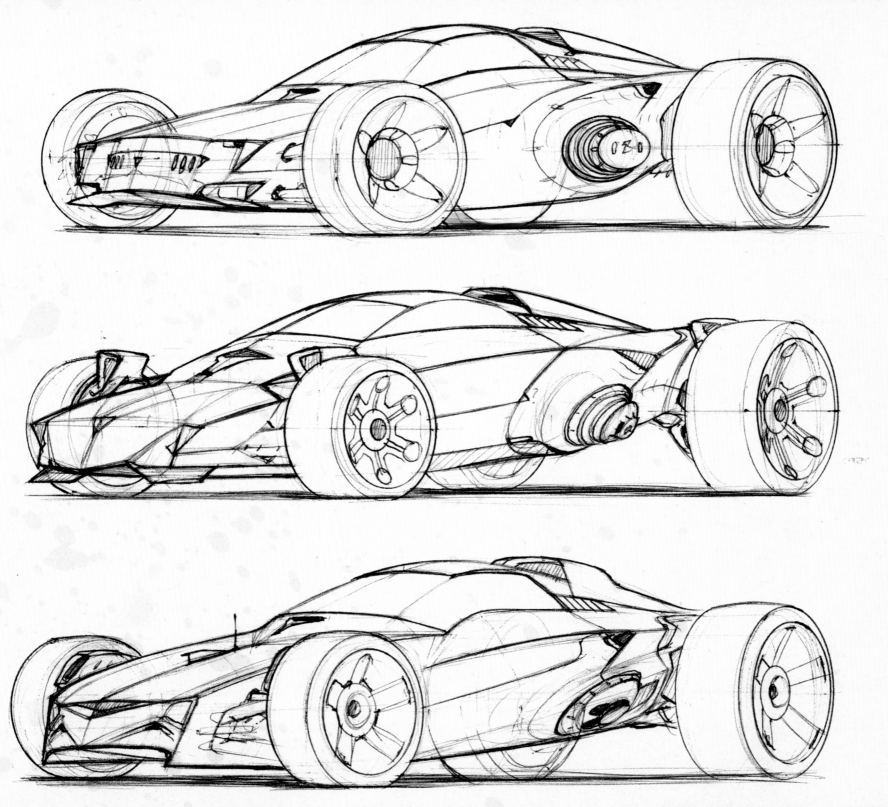

robertson : DRIVE : 035

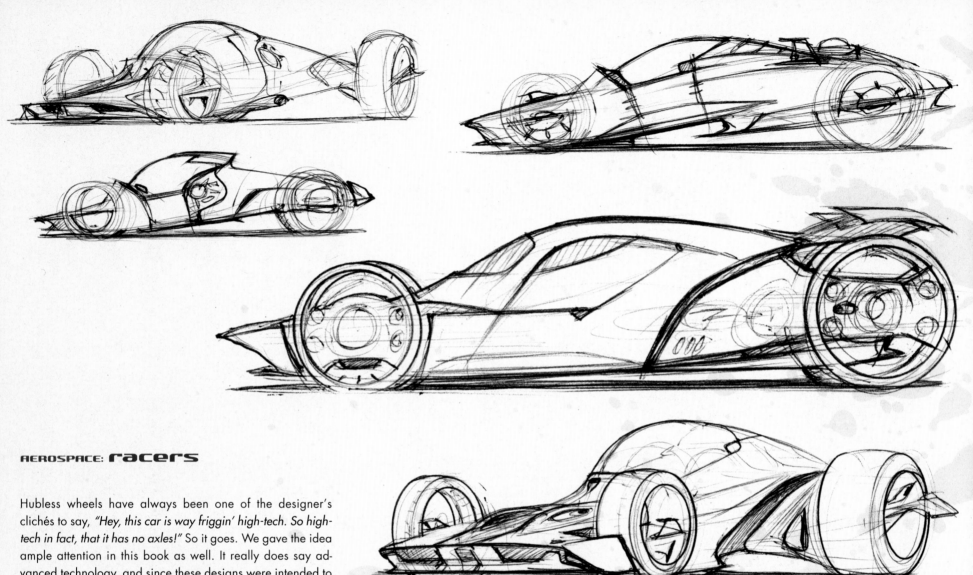

AEROSPACE: racers

Hubless wheels have always been one of the designer's clichés to say, *"Hey, this car is way friggin' high-tech. So high-tech in fact, that it has no axles!"* So it goes. We gave the idea ample attention in this book as well. It really does say advanced technology, and since these designs were intended to live only in the virtual world, we decided to have some fun with the idea. The sketches were done in ballpoint pen and then colorized after scanning.

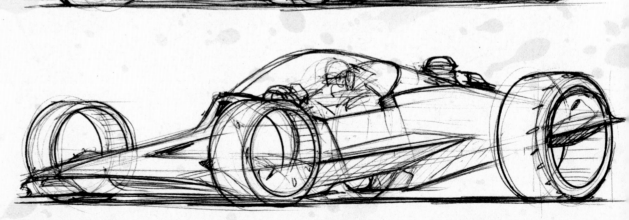

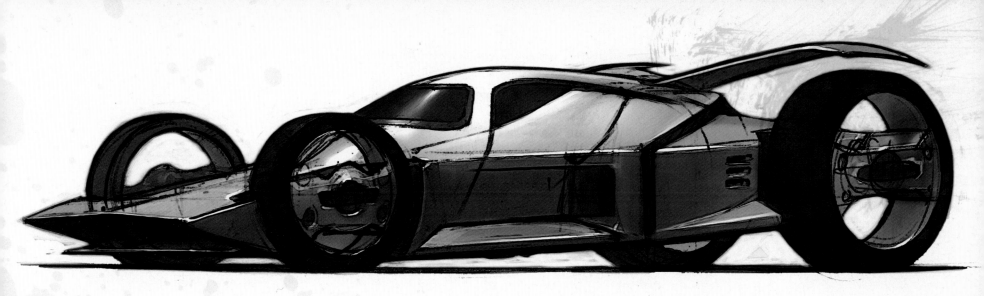

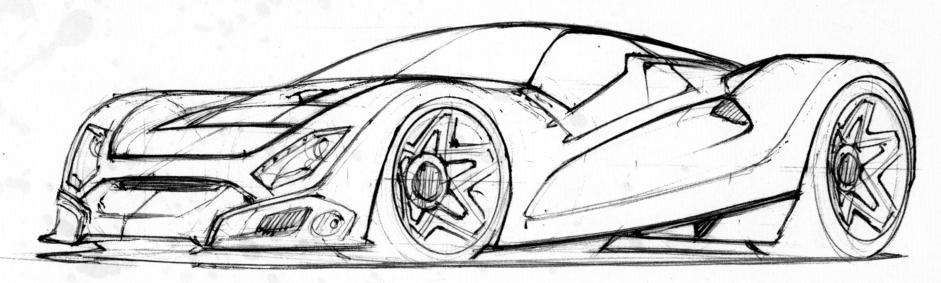

AEROSPACE: racers

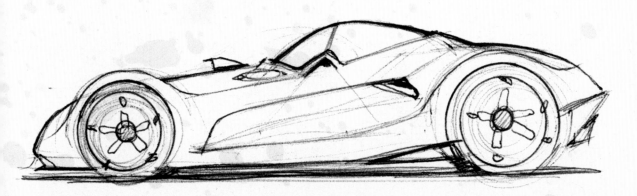

More quick pen sketches and one with a little value added in Photoshop. The line sketches explore the idea of what would be big, golden bubble-glass-domed cabins with a little angular accent breaking into the form where a door release lever would go. Also I like the idea of adding a little aircraft-inspired fin to the hoods as maybe a radio antenna or some other device.

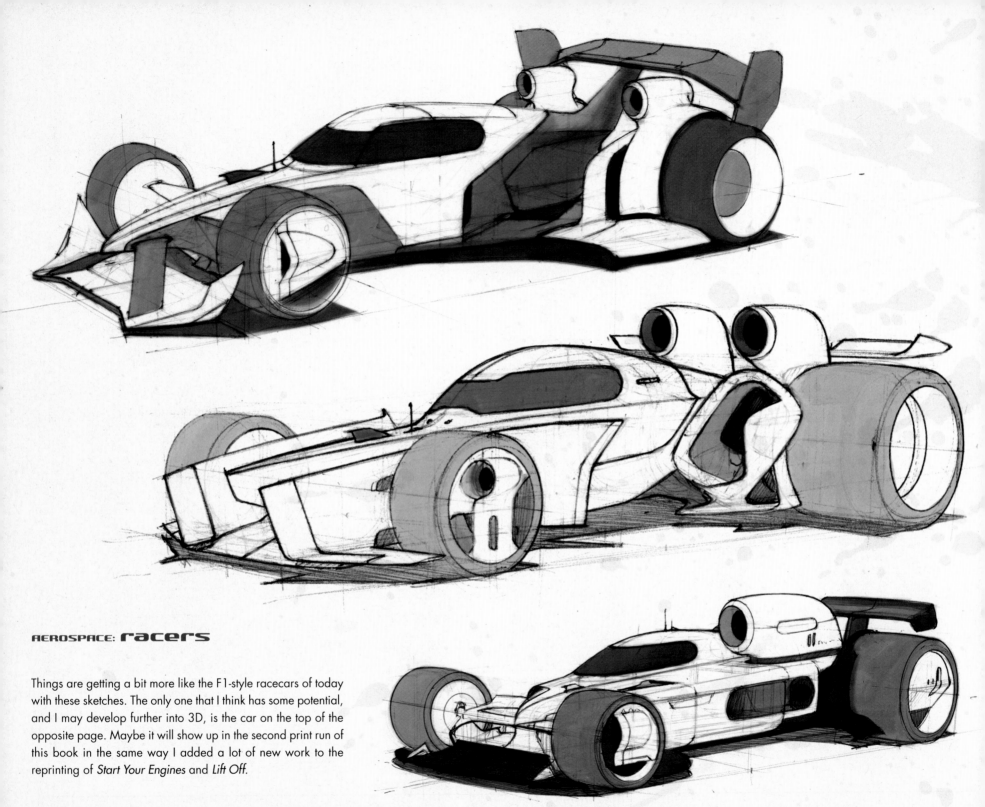

AEROSPACE: *racers*

Things are getting a bit more like the F1-style racecars of today with these sketches. The only one that I think has some potential, and I may develop further into 3D, is the car on the top of the opposite page. Maybe it will show up in the second print run of this book in the same way I added a lot of new work to the reprinting of *Start Your Engines* and *Lift Off*.

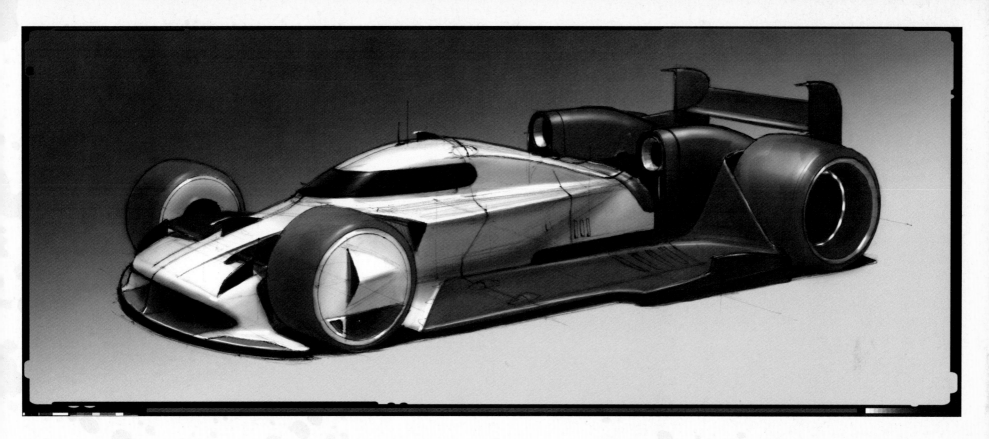

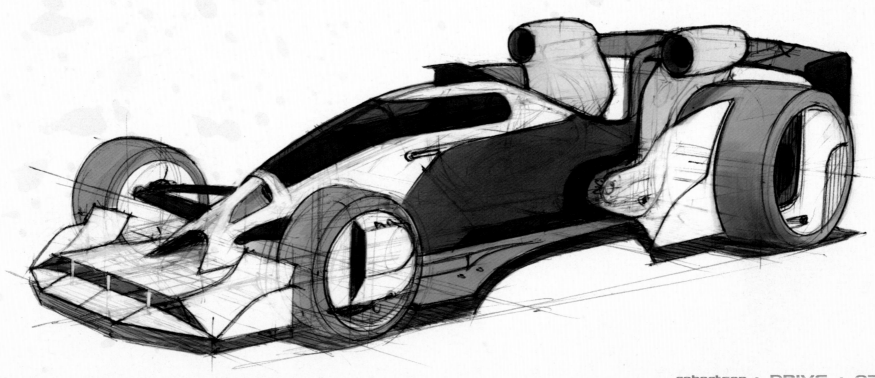

robertson : DRIVE : 039

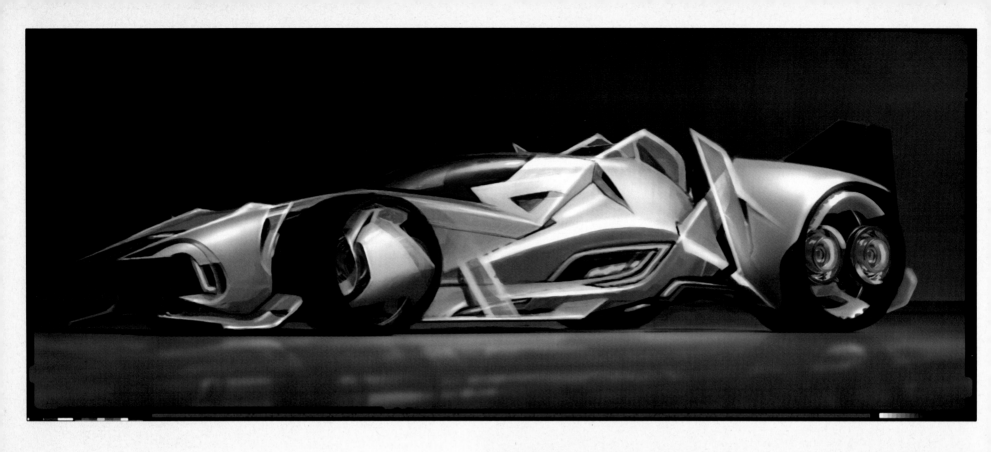

AEROSPACE: extreme racers

The color sketch above started life as a 3D rendering in modo. Then by layering a series of custom brush stamps in Photoshop, I was able to find the design direction. For me, this is a new way of working on a vehicle design and it has helped me to create forms I would not have easily drawn by hand. The other color sketches were contributed to this book by my very talented friend, Steven Olds, and are his interpretations of the above line sketch with an aerospace color palette.

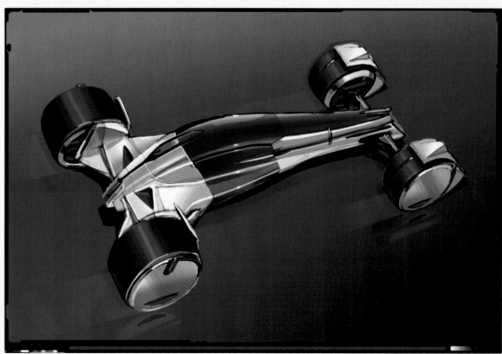

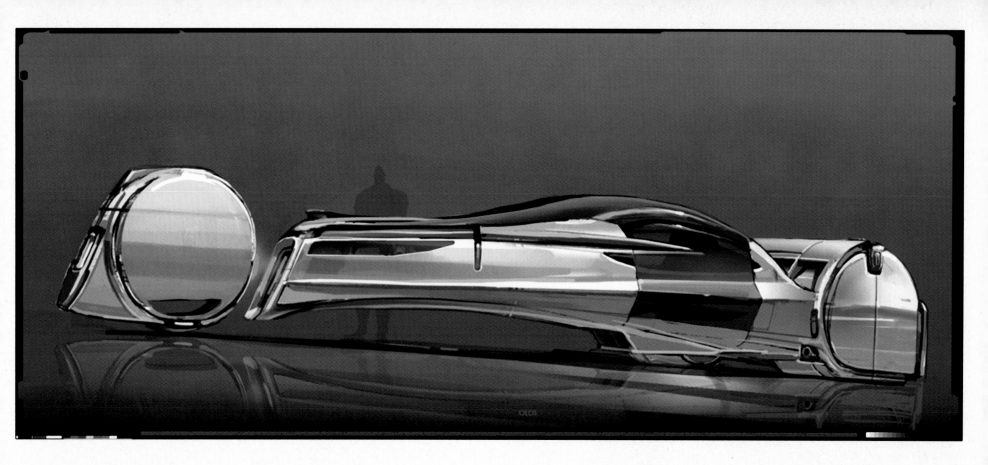
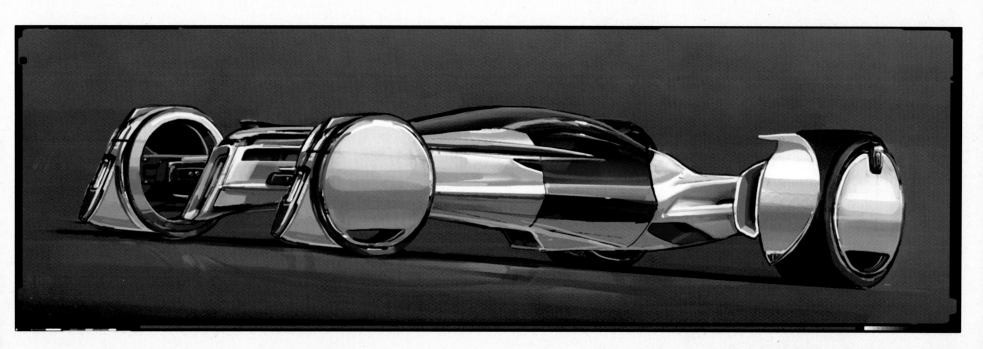

olds : DRIVE : 041

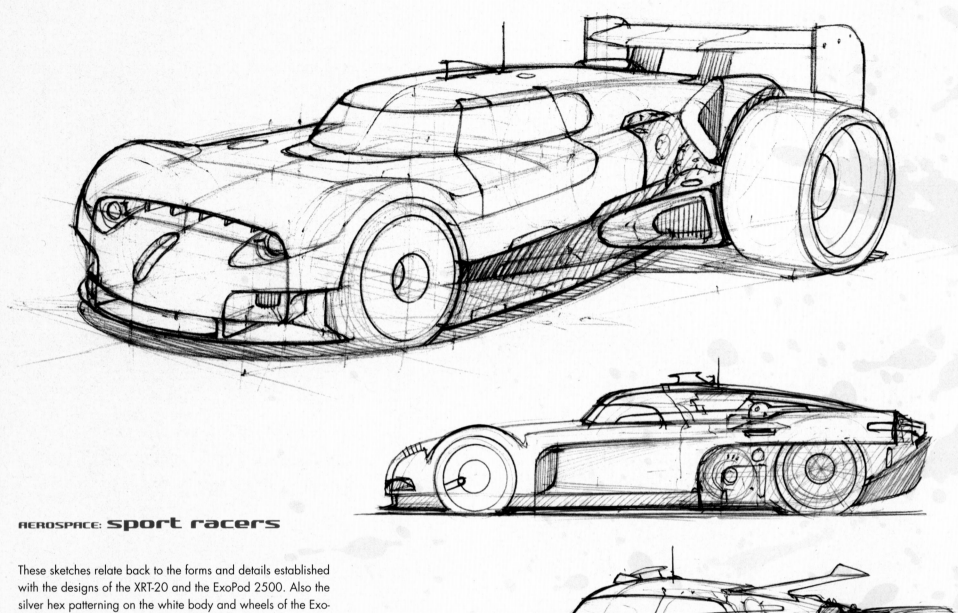

AEROSPACE: sport racers

These sketches relate back to the forms and details established with the designs of the XRT-20 and the ExoPod 2500. Also the silver hex patterning on the white body and wheels of the ExoPod was brought over as another styling cue to tie this sports-car concept back to the look of the earlier vehicles in this chapter.

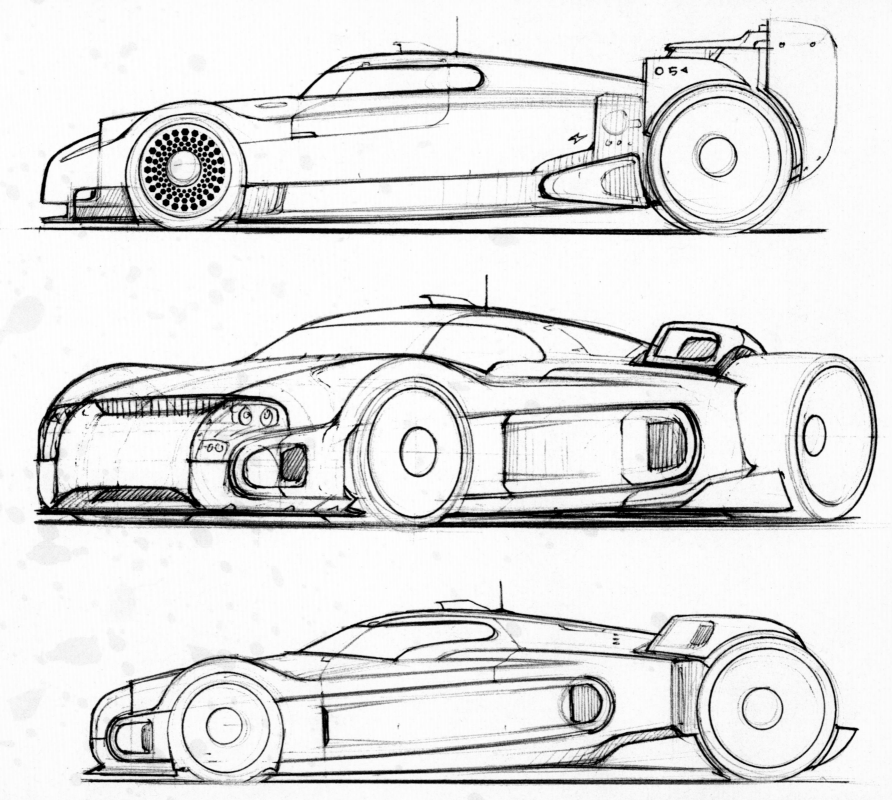

054

robertson : DRiVE : 043

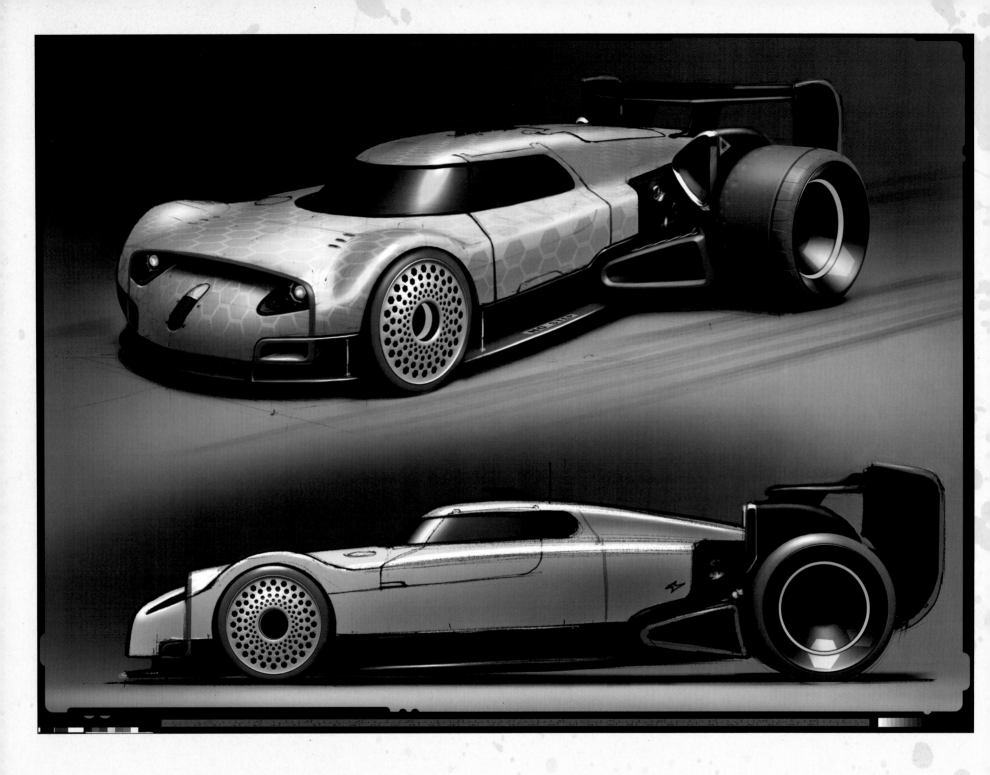

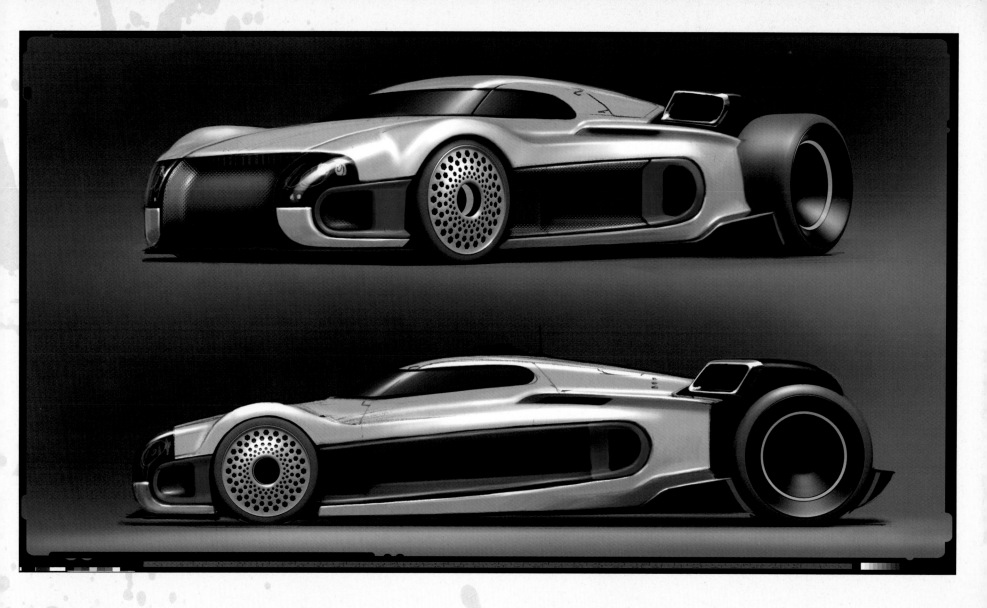

AEROSPACE: **sports racers**

Realizing the sketches in color really helped to connect them to the other vehicles in this aerospace family. With the matte black tech areas, white body color with silver hex pattern, gold-coated glass, blue accents and round shapes this design was now ready to be further explored in 3D.

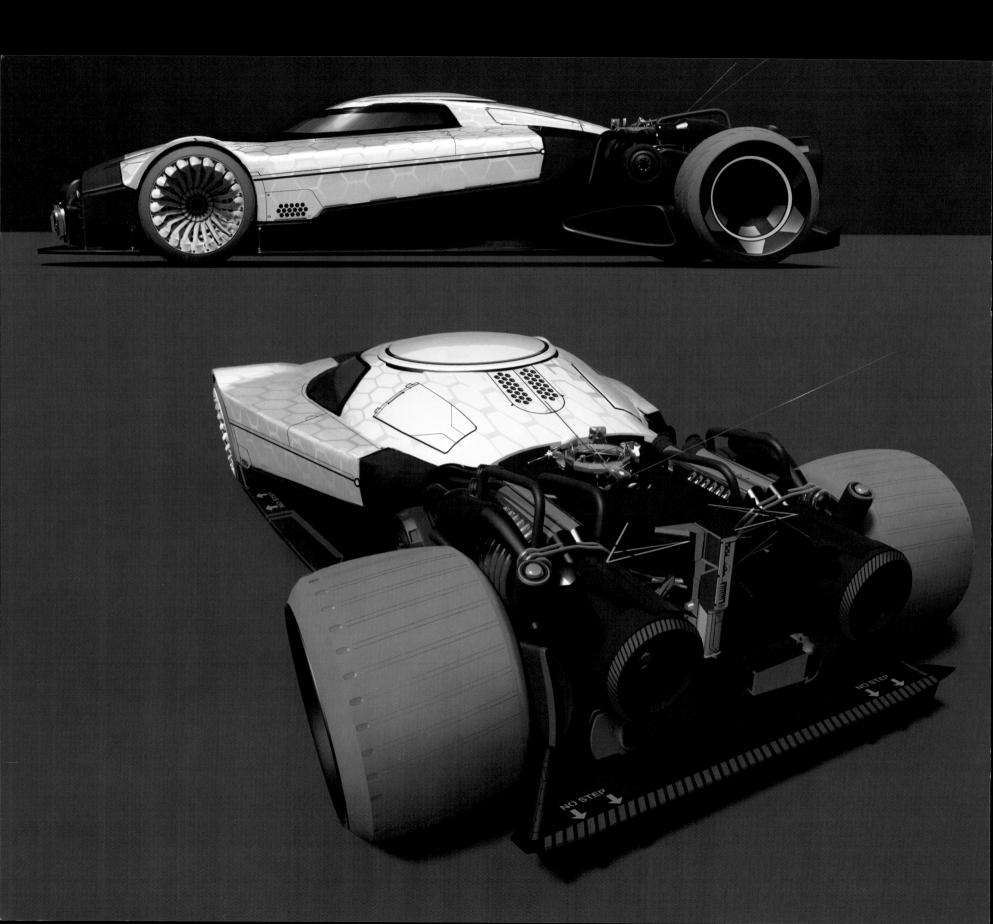

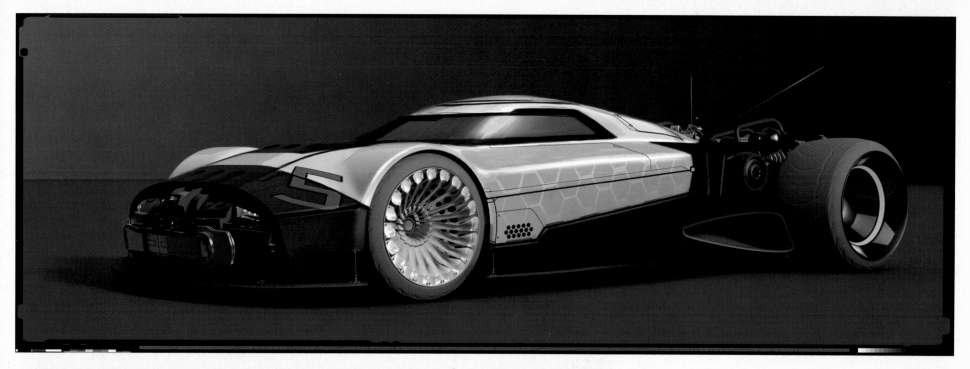

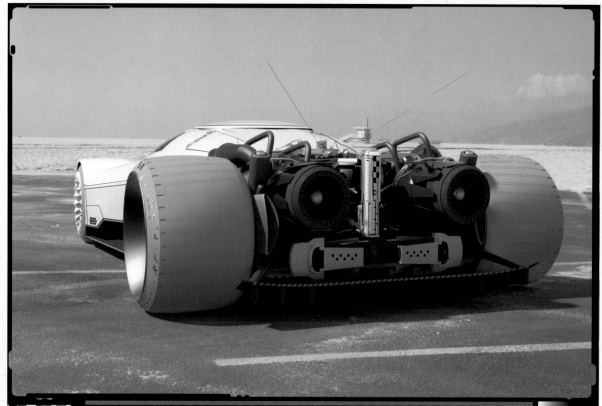

The sketches from the previous page were my guide when building the 3D model of this design in modo. The version here explores an overly tech front end and a circular hatch on the roof, flanked by air brakes slightly to the rear for a fun, animated feature when the car brakes. A few nice color details were added by Annis to help complete the renderings. My own modeling skills still have a ways to go before I have the ability to quickly model any design I can image. What we gained most from the introduction of a 3D program to the production pipeline was the speed and accuracy to assign very real looking materials to my so-so models and set them into very nicely lit environments, giving us great base renderings to paint over, adding the cut lines, design details, graphics, and weathering in Photoshop. The other two areas that I enjoyed the most by working in modo were the ability to quickly explore a variety of proportional studies for each design and the ability to play with different camera lenses in staging the renderings. Oh yeah, and never having to render photo-real-looking wheels again is fantastic!

As game-vehicle styling goes it's hard to beat the visual impact of a faceted, tough-looking military vehicle. An angular form language always says to people, "I'm an aggressive thing, be warned!" During this chapter we took this idea of faceted surfacing, unconventional proportions and packaging to create a series of military inspired vehicles that convey a strong personality and attitude of power and aggression across our three very different vehicle types. Our efforts were not to put big weapons on the vehicles to convey this idea of power but to see if we could achieve the desired attitude through the manipulation of proportion, silhouette, stance, graphic shapes, cut lines, material combinations, color, value and graphic detailing. Basically we approached the styling exercises with these design topics in mind, as we do for the concept design of almost anything, and set off to create new and interesting vehicles that hint back to their military cousins, some more successfully than others, but all with strong attitude and character first and foremost.

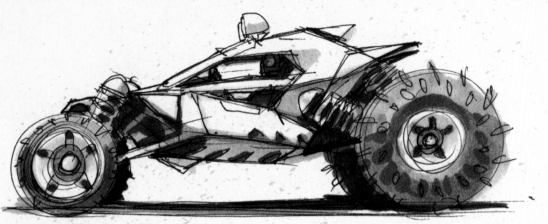

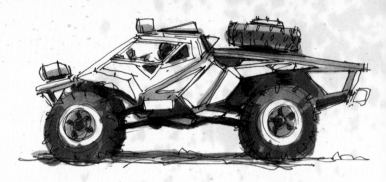

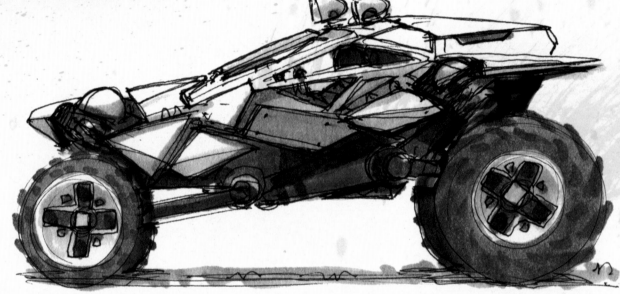

MILITARY: off-roaders

These quick marker and pen concept sketches exploring the potential design directions of a military looking off-roader started out with the same drawing technique I have used for years. As I did these sketches, the main goal of using faceted forms and trying to hit on the design topics mentioned on the previous page were at the front of my mind. When first jumping into the development of a new vehicle, most of my sketches start out in side view or whatever view I can most easily and quickly understand and explore its form. When moving from one sketch to the next, an emphasis is put on moving the big elements of the vehicle around in different combinations of size and shape. For instance, if one off-roader has the driver at the front, I might move them to the rear in the next sketch. If one has a mid or rear engine placement, on the next sketch I might try the placement of the engine at the front. When you have full control of the concept of the vehicle early on, this mental process makes it easy to quickly generate a very wide range of ideas. As long as I make sure to use straight lines, faceted forms, and feature ample ground clearance, the design should start to work as a tough looking off-roader.

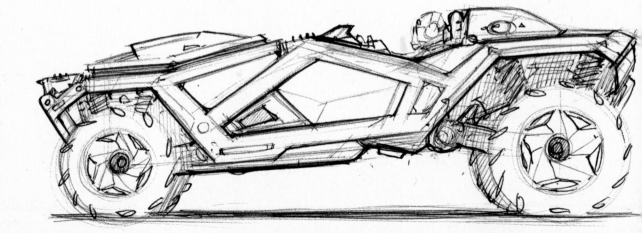

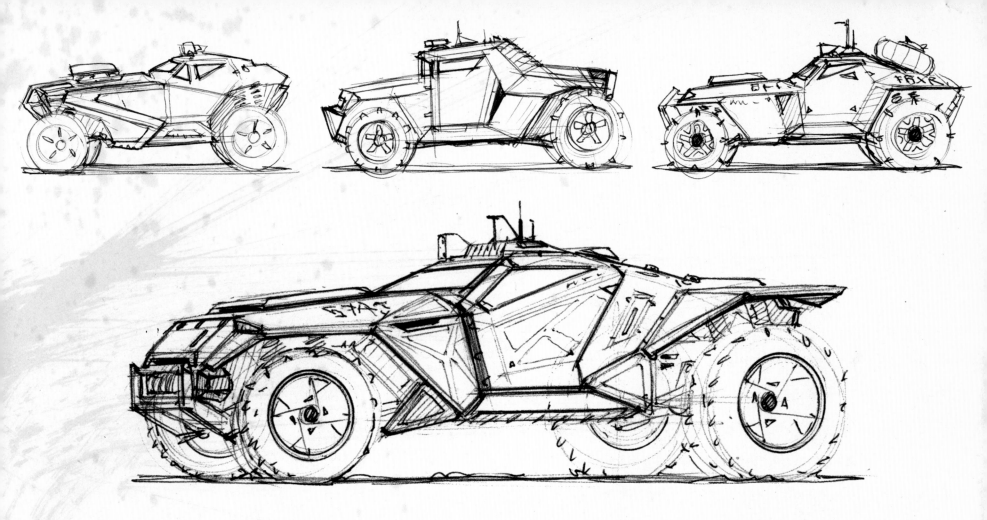

MILITARY: **off-roaders**

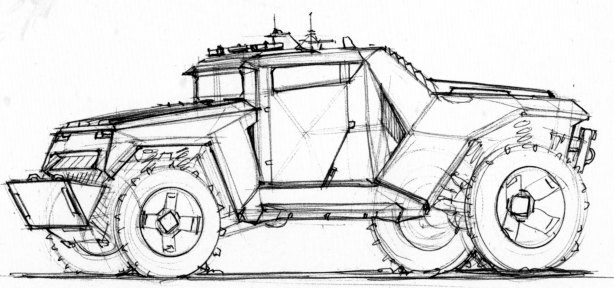

The sketches on this page do a decent job of showing the thought process just mentioned. Take for instance the two big sketches on this page, one has a sloped windshield and the other has a more vertical windshield. Other than that they are very similar to each other. This is the sort of procedural exploration of the arrangement of all the elements that make up the intended vehicle concept that happens from sketch to sketch.

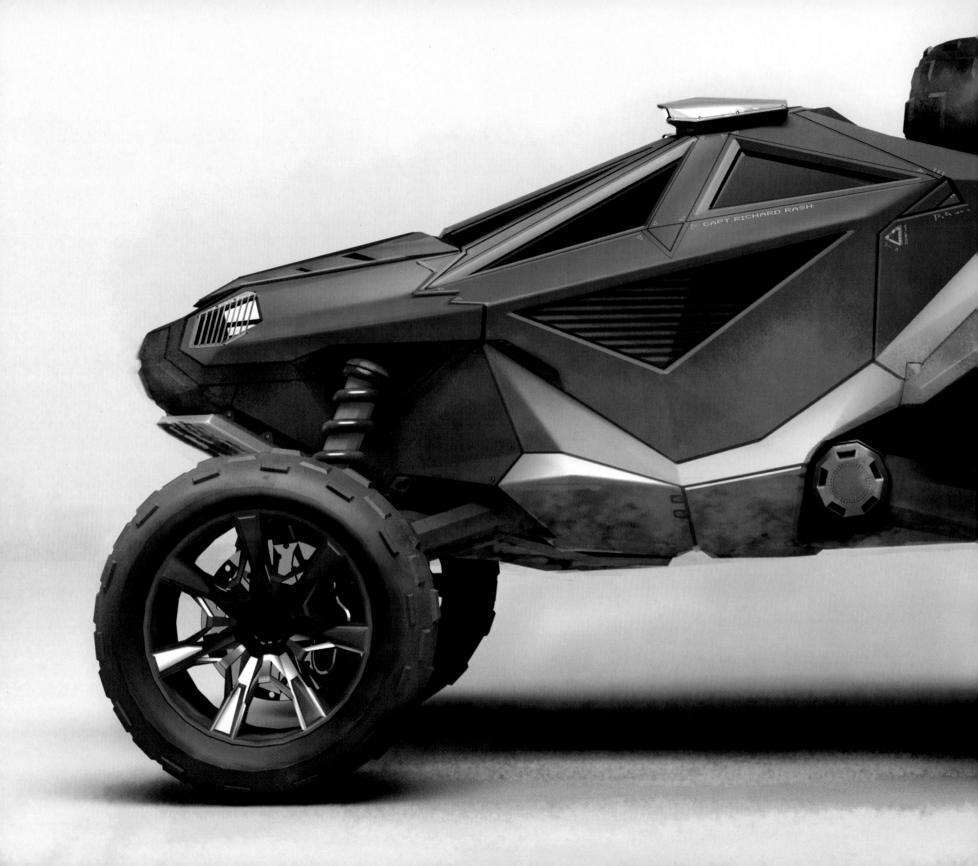

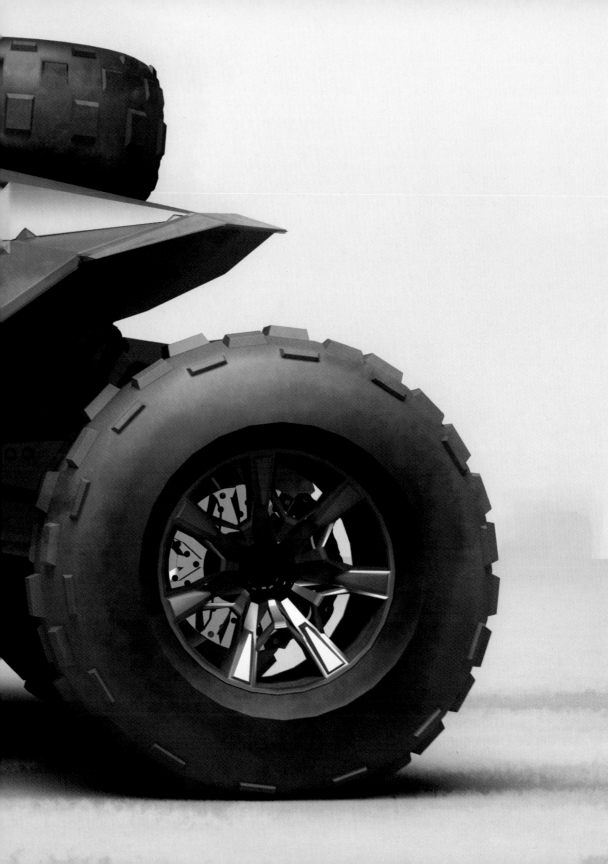

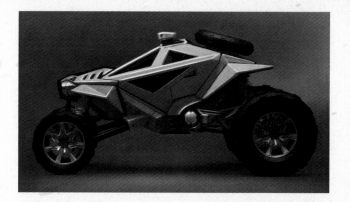

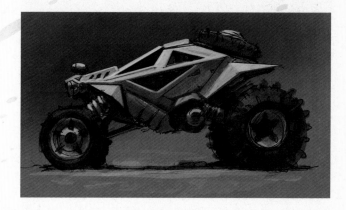

MILITARY: **BR-X30**

This design came from a quick marker sketch like those on the previous pages. The sketch directly above was painted over in Photoshop. The one at the top has had even more refinement done to the surfaces, and 3D wheels were added in modo. The rendering to the left represents one of my first attempts to model a vehicle in modo. Needless to say, it had quite a bit of clean-up done in Photoshop after the modo base rendering was complete. Through not only the basic military-green color of the vehicle, but the angular faceted forms, the BR-X30 conveys the attitude we wanted for this chapter. Whether for a sports car or an off-roader, open-wheeled vehicles just visually work!

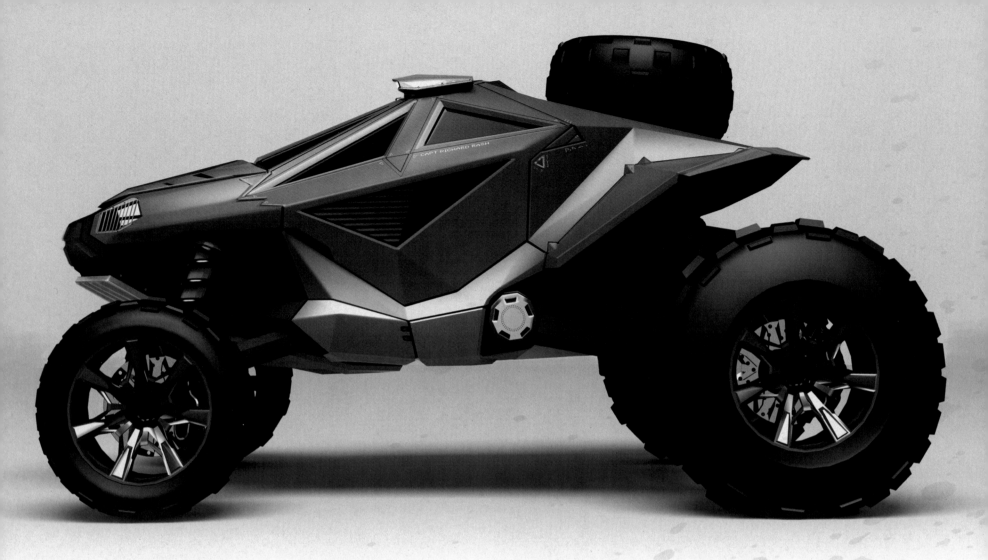

MILITARY: **BR-X30**

Above is the "clean version" of the rendering on the previous page. I'm hoping that for those of you creating your own concept designs through a similar process, you'll find it helpful to see how much of the dirt and weathering was added in Photoshop by comparing this image to the dirty one.

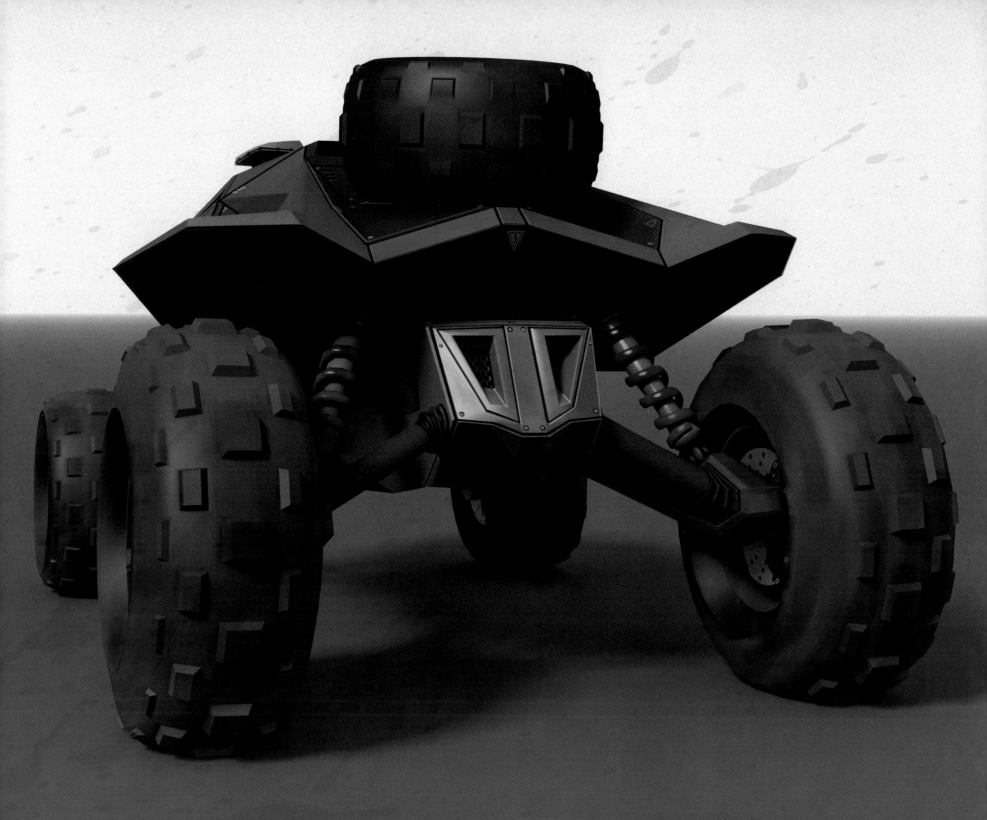

robertson : DRIVE : 055

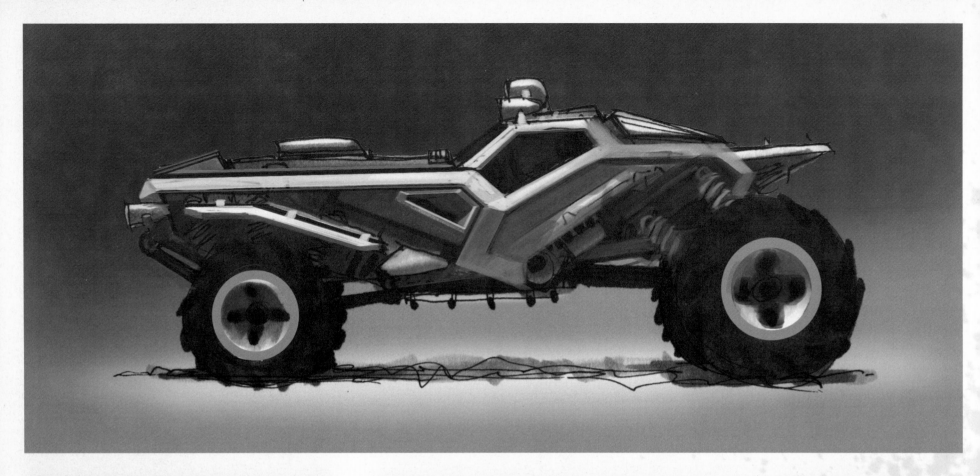

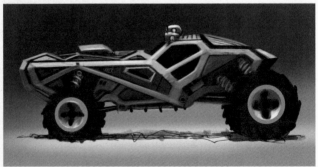

MILITARY: off-roaders

The sketches here started out as quick marker and pen sketches which were then scanned and refined a little bit in Photoshop. The design direction on the right really pushed beyond our goals and is a bit too sci-fi, albeit fun.

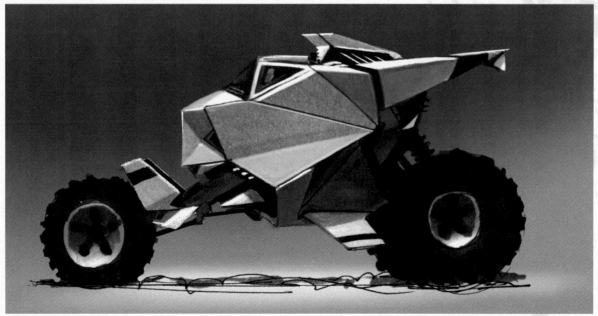

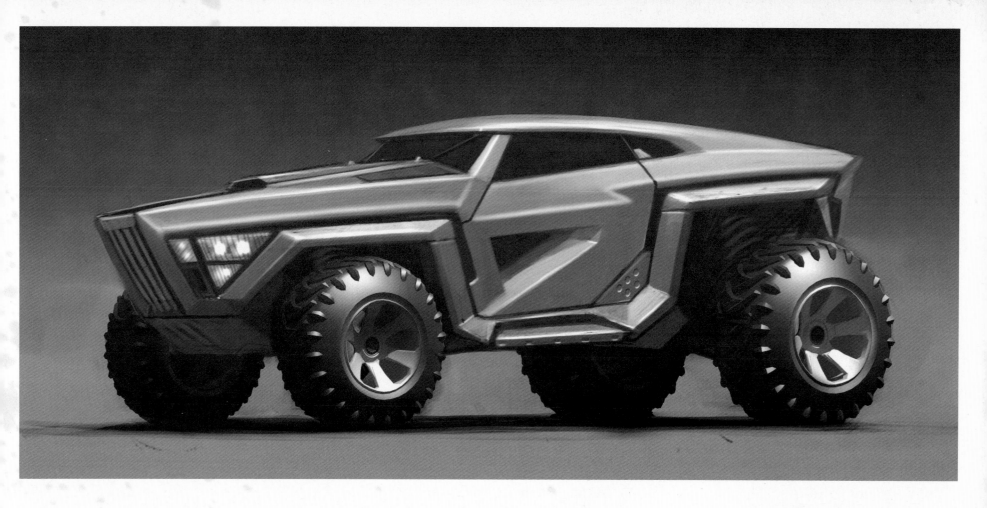

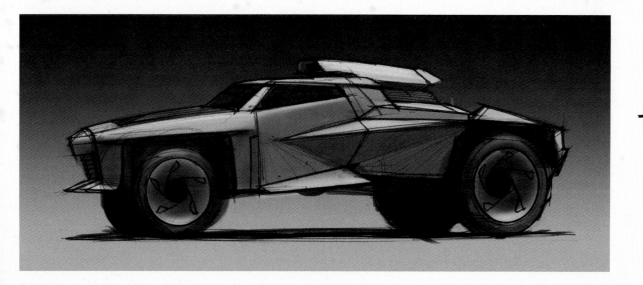

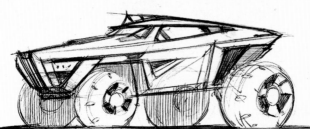

MILITARY: off-roaders

Annis was on to something with the thumbnail line sketch directly above. Then I added some real-looking wheels and tires in modo and did a quick paintover in Photoshop, to create the rendering at the top.

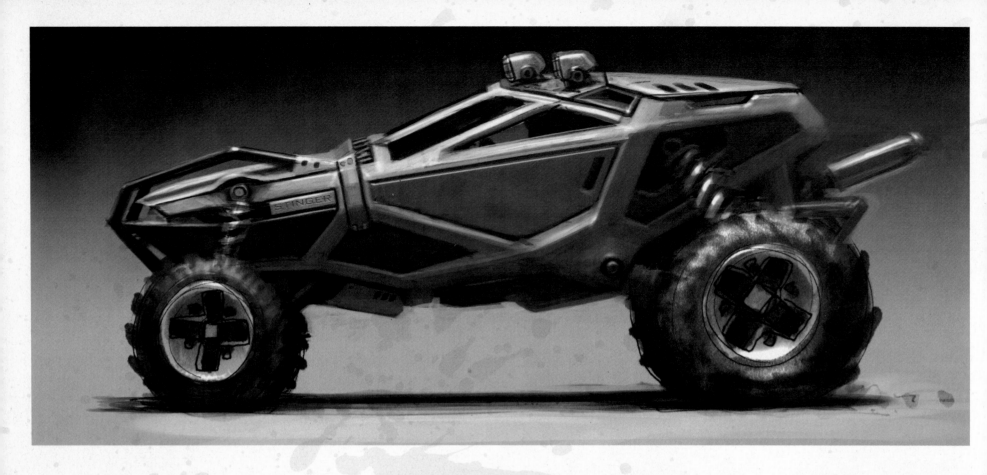

MILITARY: Recon 250

We liked the stylistic direction of an exposed chassis frame, with small, separate panels attached to form the body. After deciding on this direction, I worked up the vehicle in modo as seen in the rendering to the right. Danny did a nice job of weathering it up in Photoshop, as seen on the opposite page. I imagined this off-roader to be some sort of fast recon vehicle, driven by only one, with the engine set just behind the driver and ahead of the rear-wheel centers.

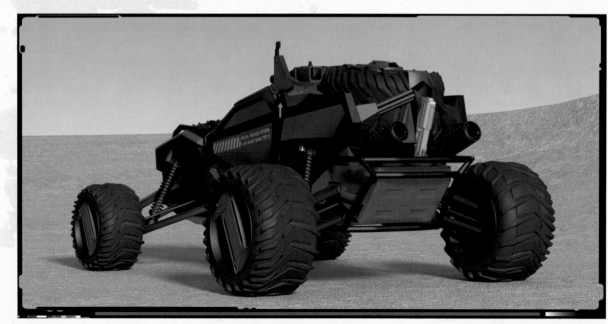

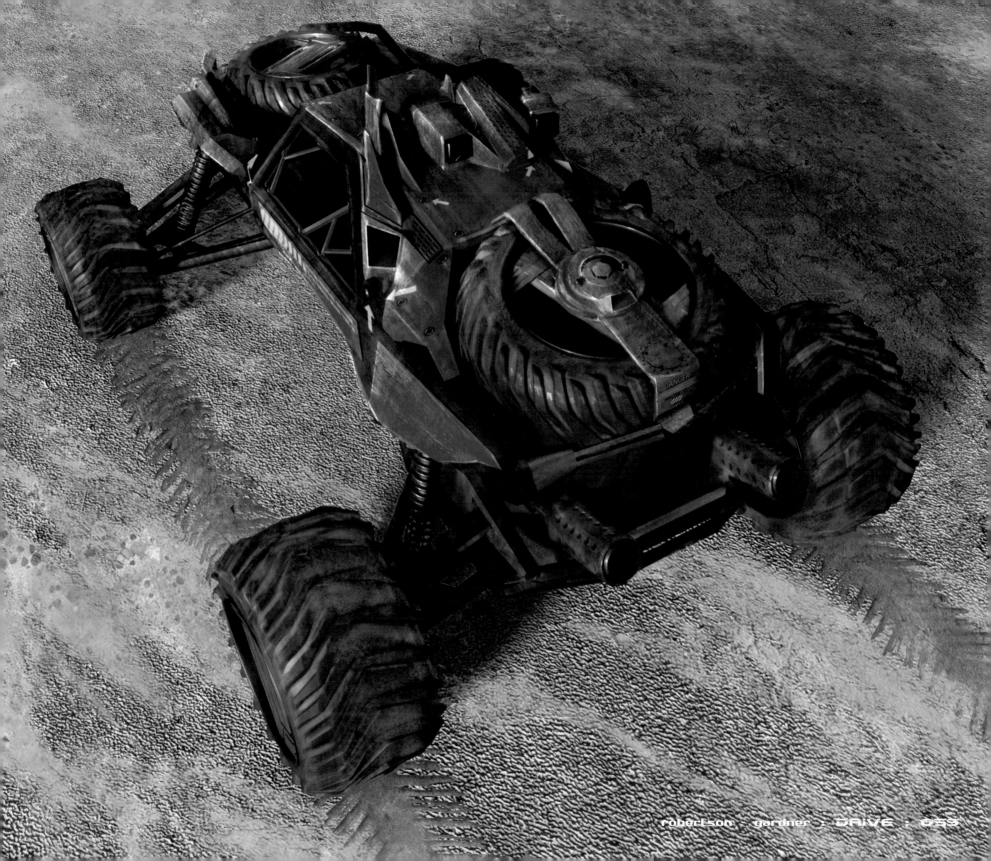

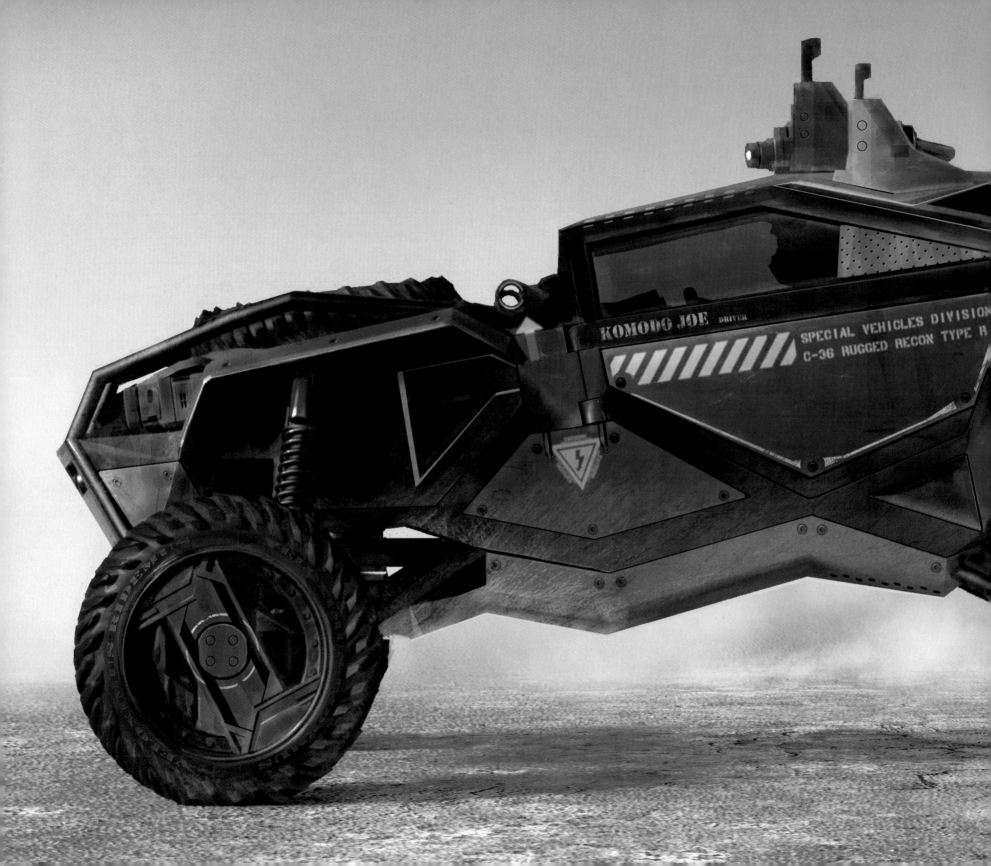

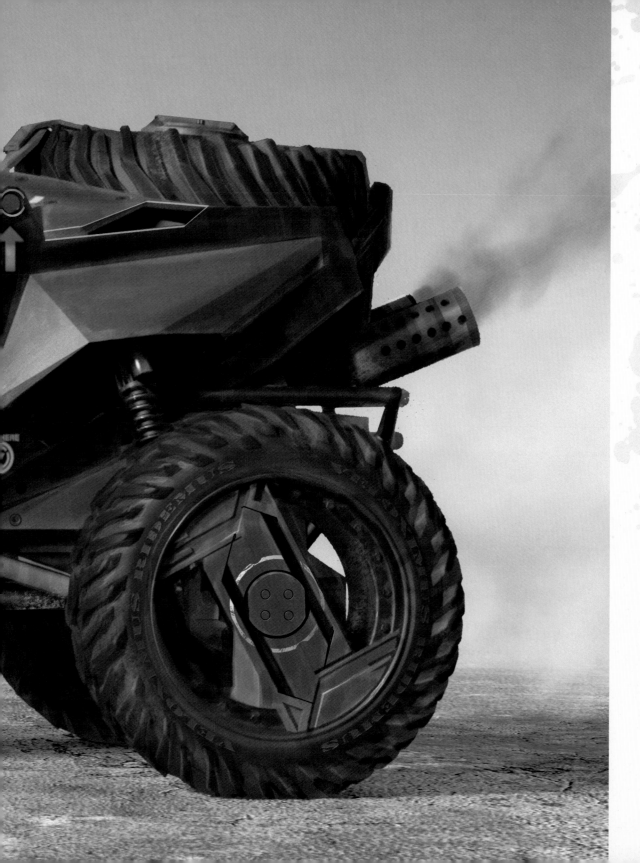

MILITARY: **Recon 250**

In addition to the exposed frame, a "notched" silhouette, hubless wheels and helicopter pick-up points, located either side of the driver's door, round out the design elements of this vehicle. Carrying spare front and rear wheels and tires helps to give the illusion of preparedness for the Recon 250. Of course, you can't go wrong by adding a few perforations here and there and a bit of stenciled type for some obligatory tech style!

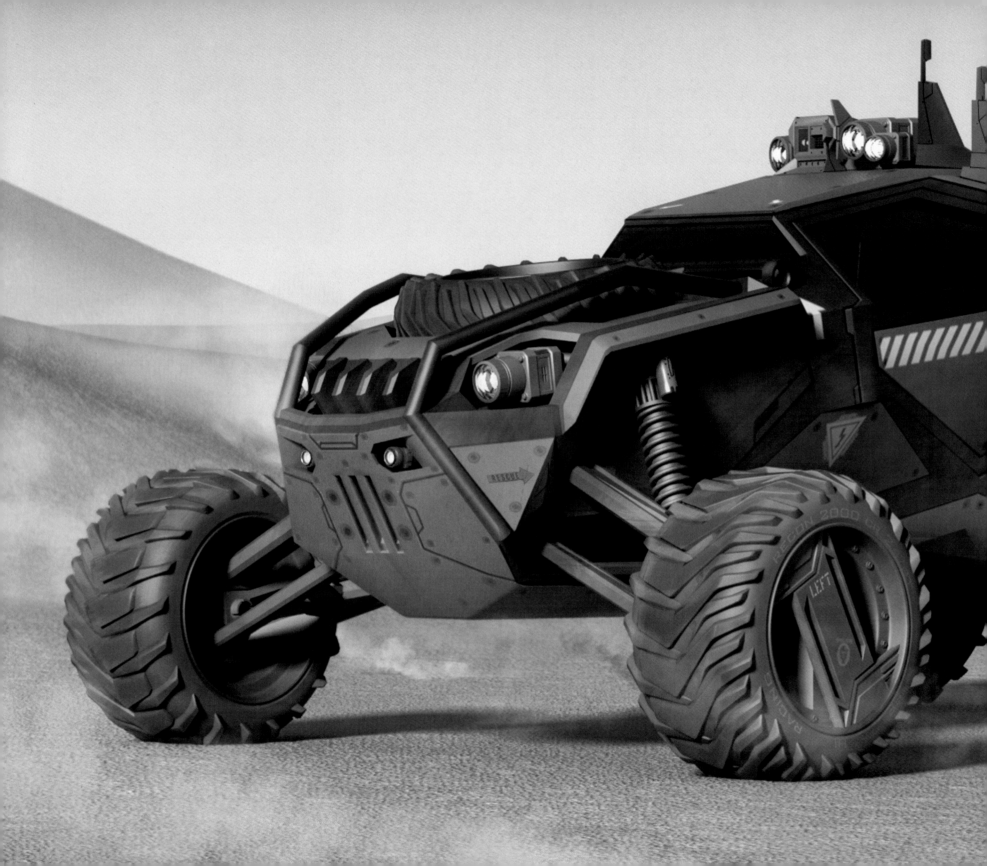

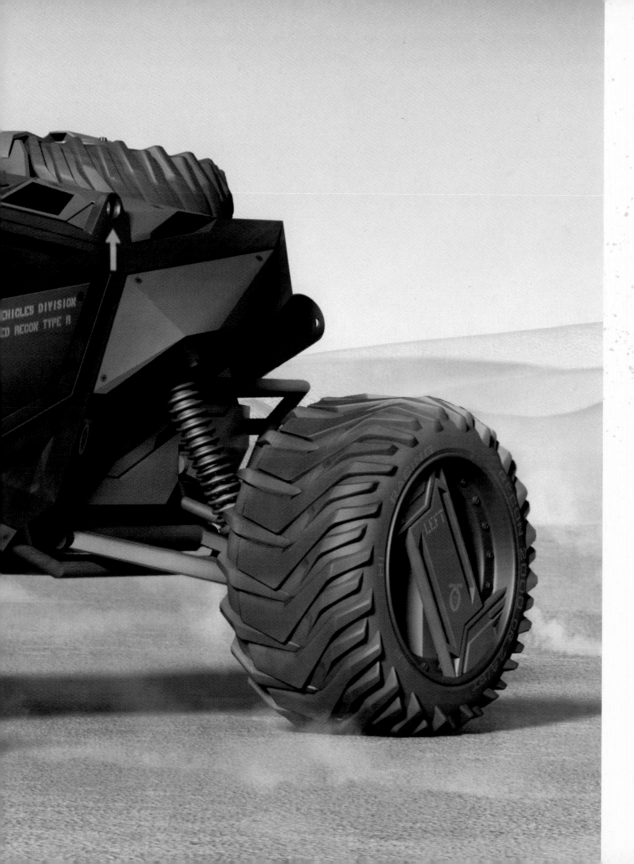

MILITARY: Recon 250

After making a quick recon pass of the desired area, the driver would communicate back to HQ with the use of some tech comm. gear mounted on the roof. Two stocky antennae that keep with the faceted aesthetic of the whole add a little more visual interest and detail to the silhouette. As with the previous page this vehicle was modeled and rendered first in modo, and then weathered up in Photoshop.

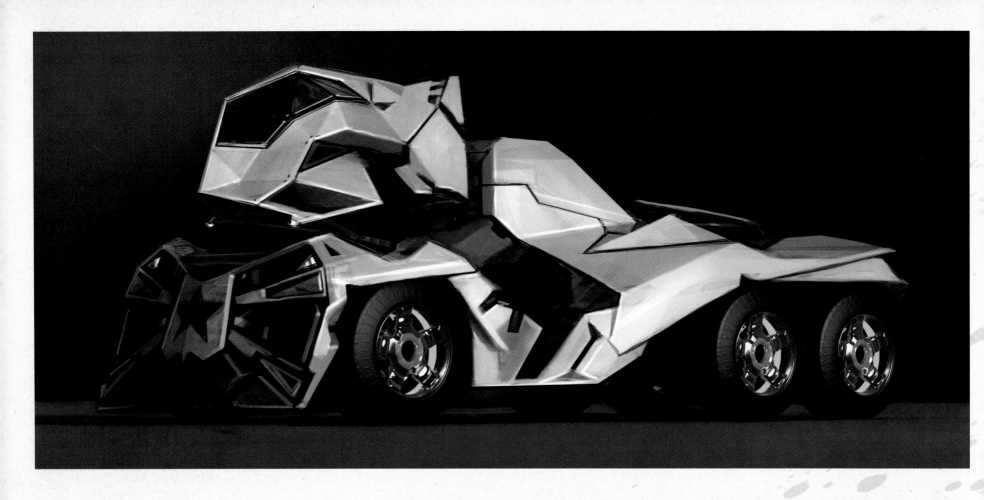

MILITARY: **bruiser sketches**

The faceted truck sketches on this page were done by first creating a base rendering of six wheels in modo. We used this to establish perspective. Then we digitally painted over the base rendering. This sped up the process and lent realism to the sketch. I used a lot of my angular custom brushes in Photoshop, initially collaging many layers on top of each other, and then adjusting the opacity of the layers to see new styling directions emerge. As a visual direction emerged from the clutter, time was then invested to paint over the top of the layers and refine the forms. Annis' rendering on the opposite page (top) shows what this kind of sketch this looks like early on in the Photoshop painting process.

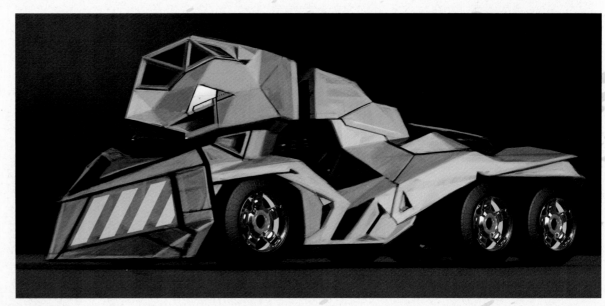

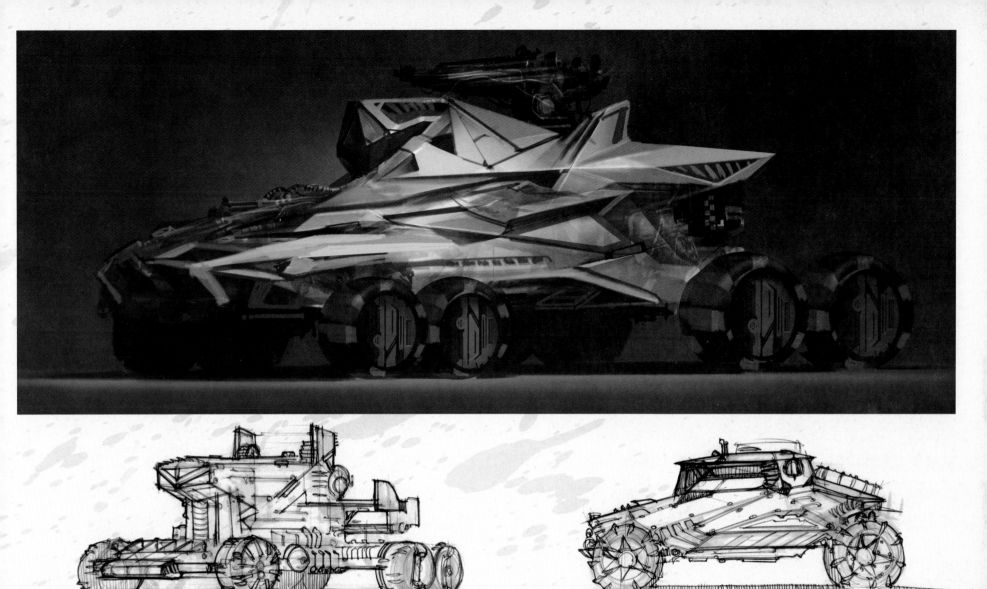

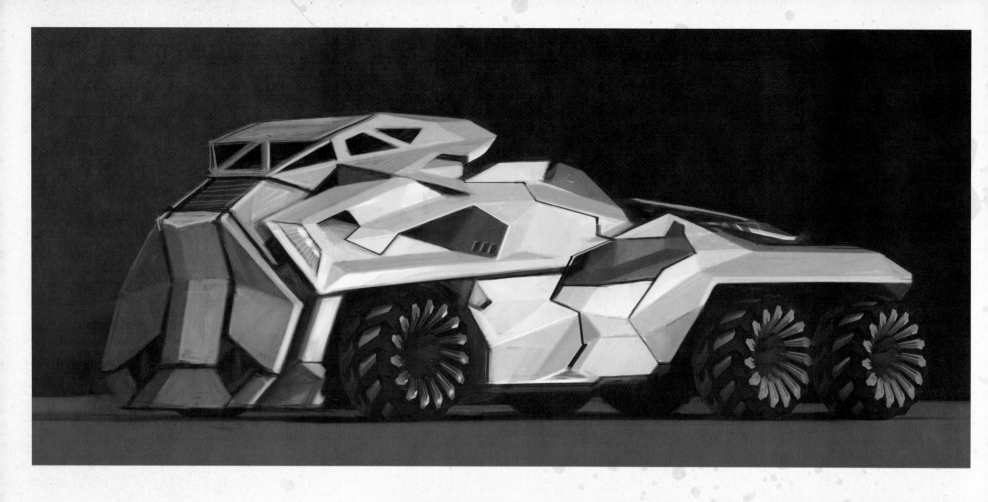

MILITARY: *bruiser sketches*

The top study was intended to be some sort of sci-fi semi-truck. By keeping the chassis layout of a semi-truck that we are already familiar with, and then investigating the faceted form language on top of this package, it should be easier to relate to the vehicle visually, although, I'm still not sure where the doors would go? This happens a lot in early sketches where most of the focus is on the invention of a fresh visual aesthetic and not on the practical/functional features of the vehicle beyond the fact that it has wheels...and a crew cab in the case of the semi. The sketch to the right is another example of this exercise in trying to find a fun aesthetic. This is some sort of utility vehicle that has been modified for racing. I was trying to develop a very strong, almost literal "face" for the front of vehicle.

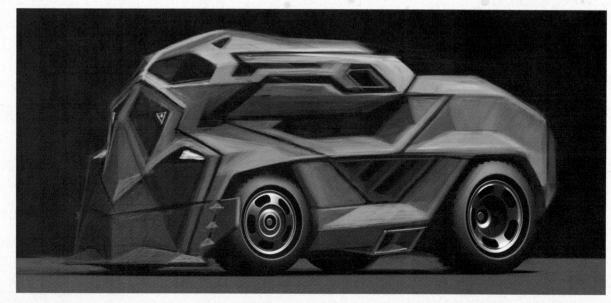

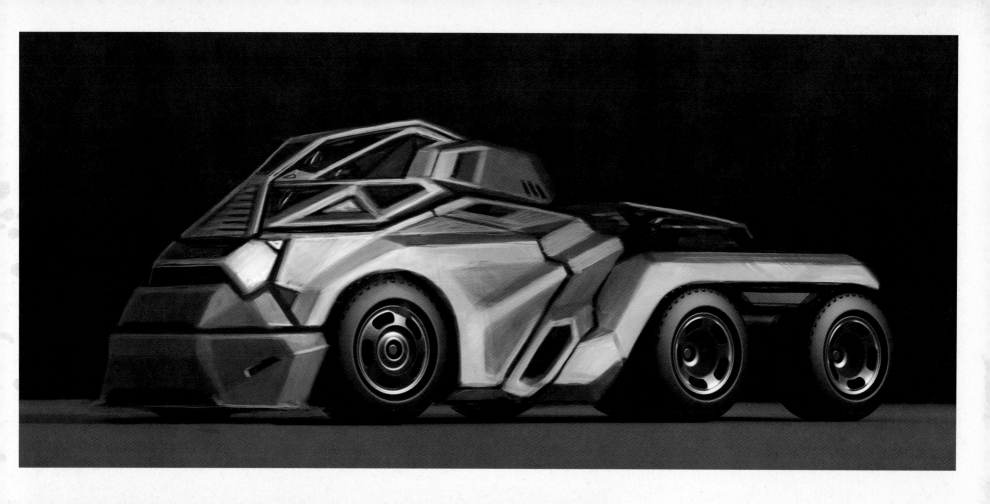

MILITARY: bruiser sketches

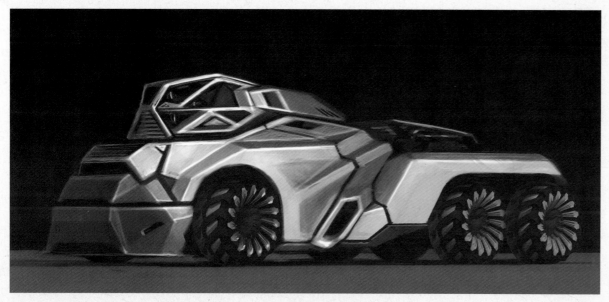

We continued the idea of creating a sci-fi semi-truck with a couple more sketches. The faceted form language we had decided on for this military-inspired group of vehicles was applied to this slightly lower and seemingly faster truck concept. The cabin of this bruiser is intended to seat only one driver, no passengers. The sketch to the left explores the idea of tweaking the cabin profile to relate back to the more vertical windshields that run throughout this chapter. I've always liked the attitude of semi-trucks that have big, flat front surfaces and seem to say to the air they speed through that they are so powerful there is no need to worry about aerodynamics, as their brute force is more than enough to take them to any speed they desire. On the next page is a monster of a truck Annis and I realized as some sort of huge, military utility vehicle.

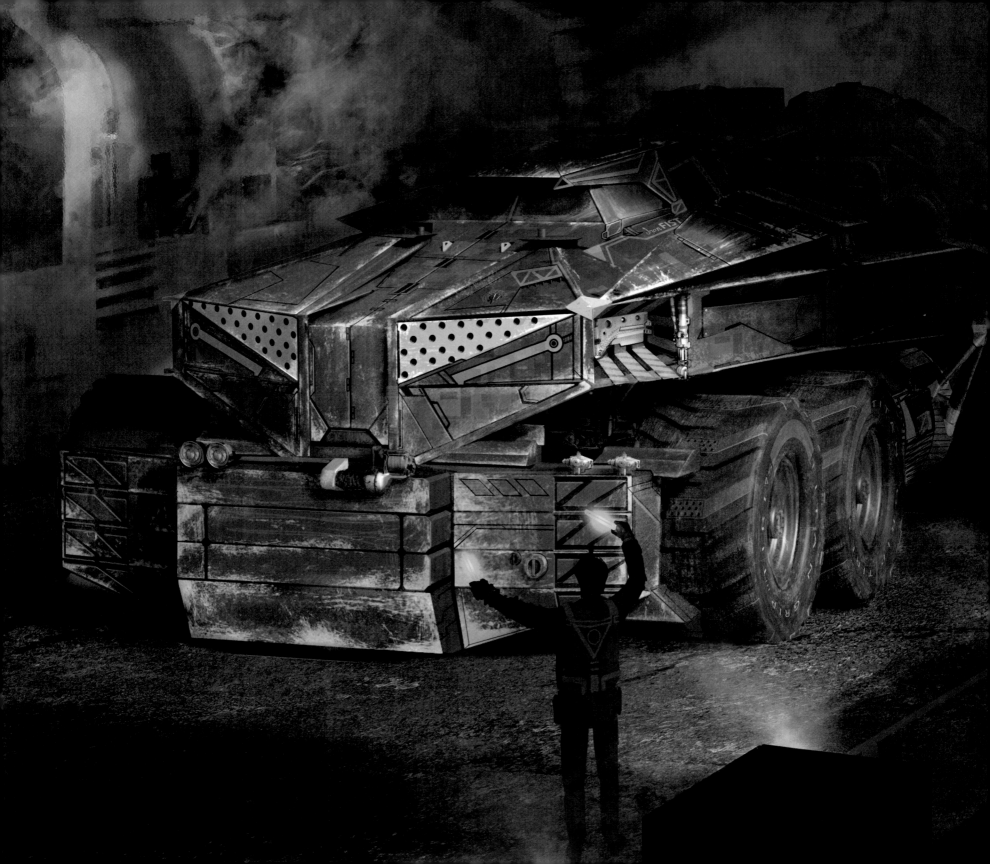

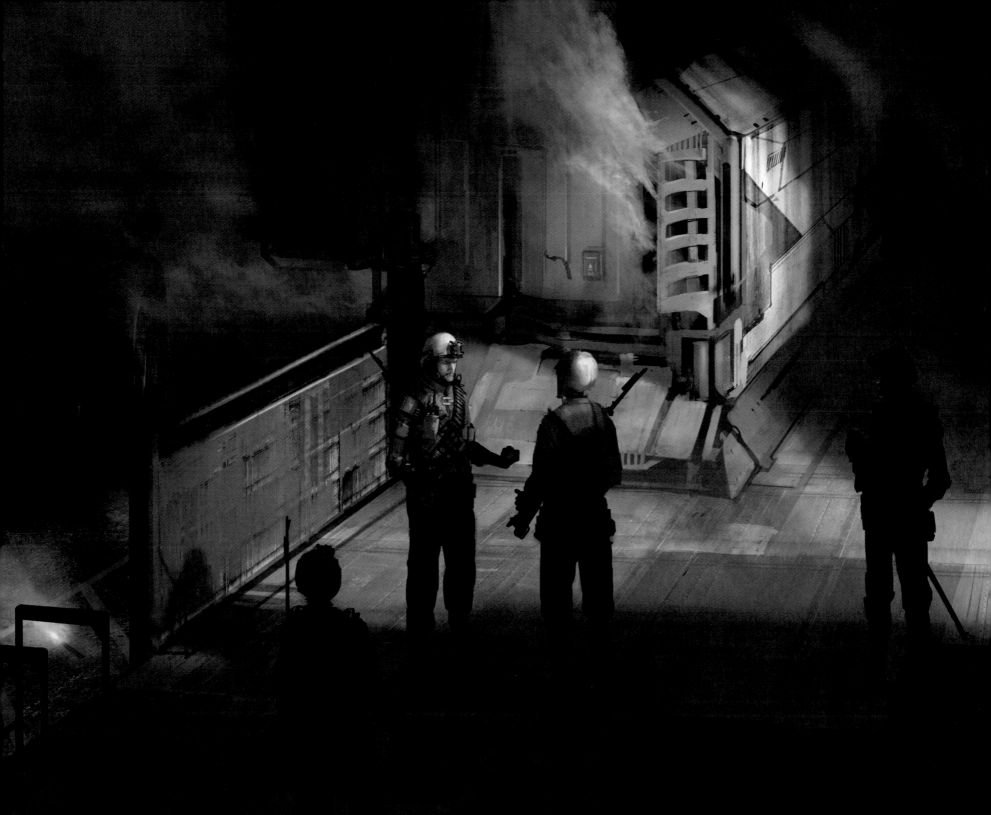
robertson - naeem : DRIVE : 069

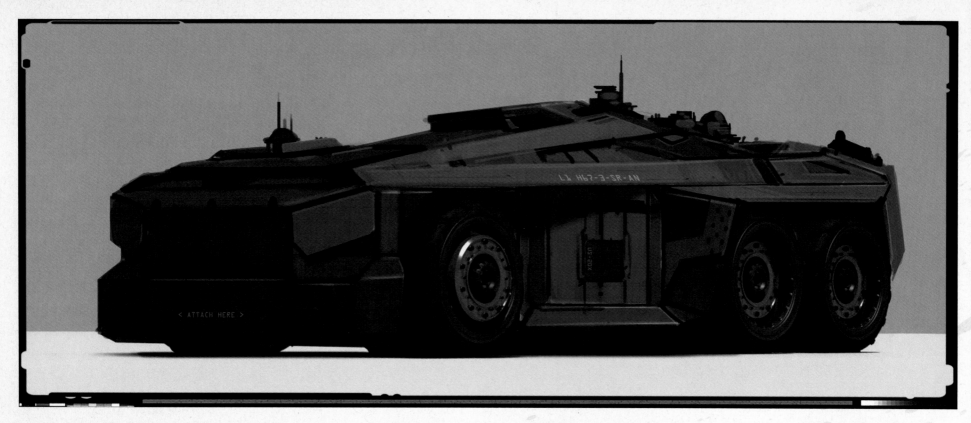

MILITARY: BR-1 Heavy Escort

The sketches to the right started as an homage to Syd Mead's APC vehicle design for the movie *Aliens*. Annis did the color sketch above on top of the sketch to the lower right, and based on this I jumped into modo to build a loose digital model that I painted over in Photoshop to create the vehicle design on the opposite page, also known as "The Brick!" Again you see the vertical windshield and the exposed frame elements as the most relied upon stylistic cues used to tie this vehicle to the others in the chapter. On this page you can see that I did think about the doors—in this case from the beginning as they are a big part of the fun of the design. I imagined that the scale of the vehicle and the presence of such large wheels would be accentuated by having to walk between the front and rear wheels to get into it.

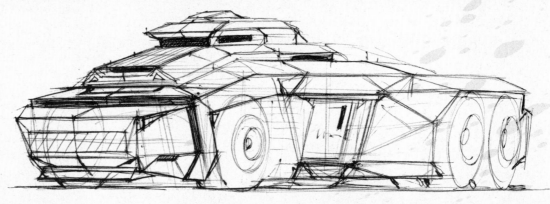

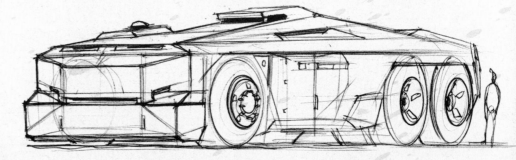

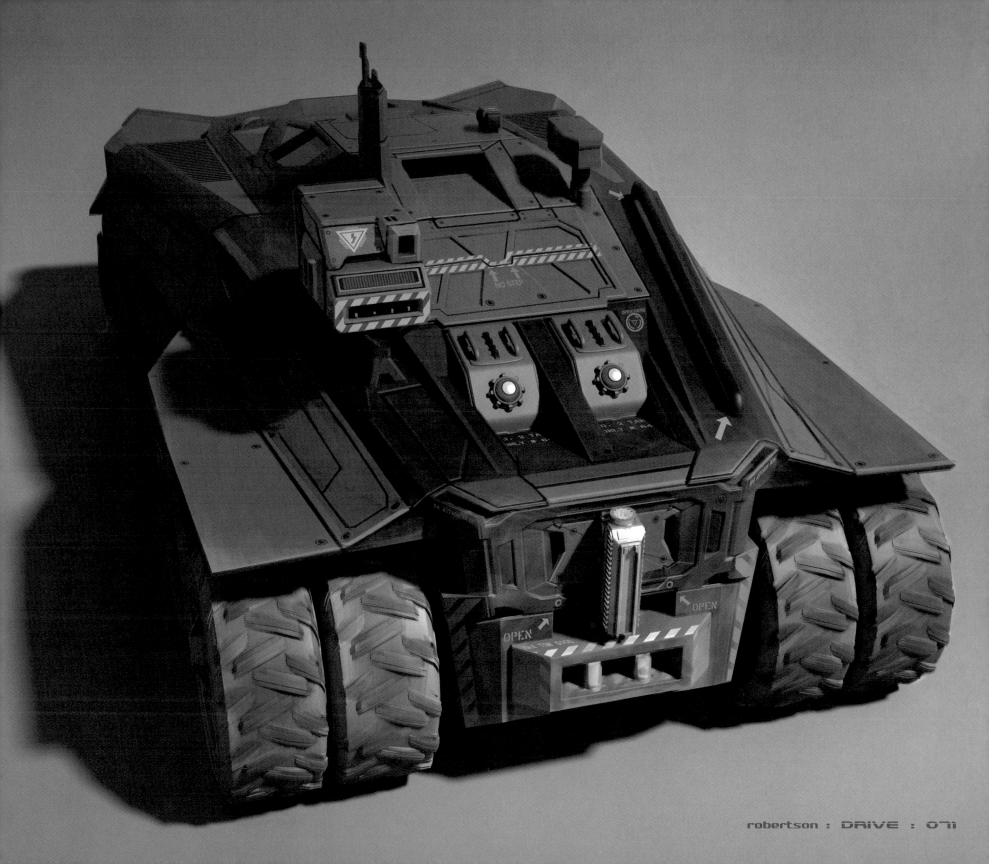

NO STEP

OPEN HERE

OPEN

OPEN

robertson : DRIVE : 071

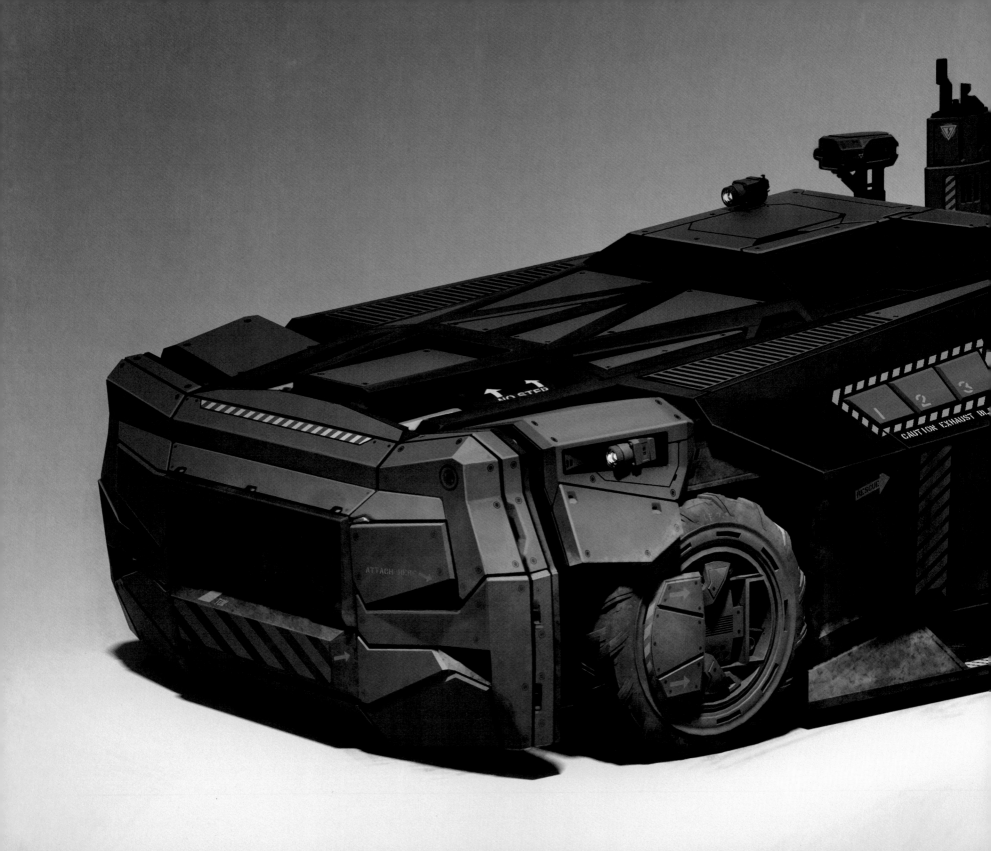

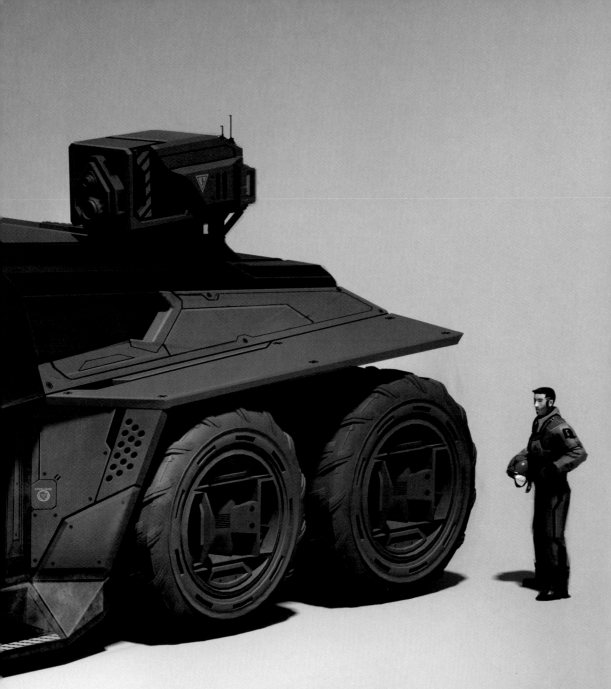

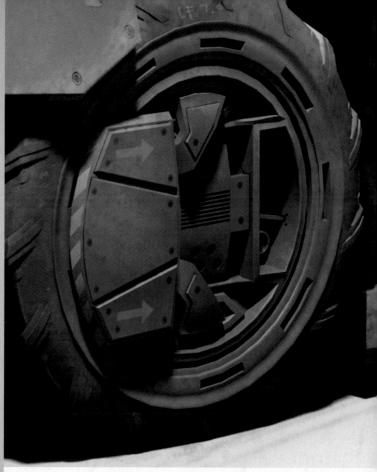

MILITARY: BR-I Heavy Escort

This beast was designed to be a heavy duty barrier-buster that would clear the way for other vehicles to follow through the holes it could create by blasting parked cars and other debris out of the way with its hydraulically-powered "punching" front bumper. The wheels are of the new "B-class hubless" style recently declassified by the military and which are now finding their way to many of the privateer racing teams around the world. They are more durable than the previous designs and house additional drive motors within their massively ringed hubs. When something blocking your route, just call in "THE BRICK."

MILITARY: Desert Scorcher

OK, this one is just pure fun! Take a small crew cab with a vertical windshield, place it over a turbine engine of some questionably functionable nature, attach six wheels, add a big bumper to the front and stand back to see what happens!

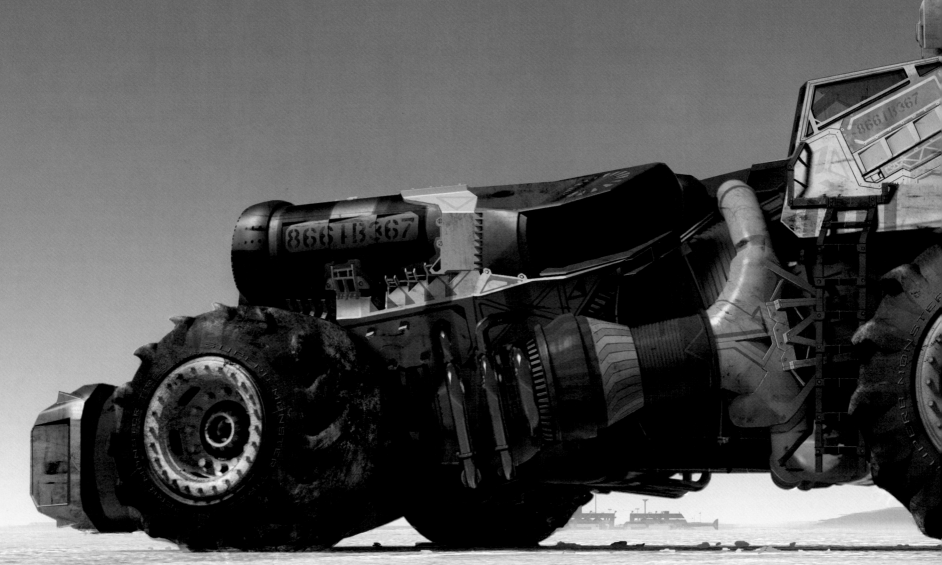

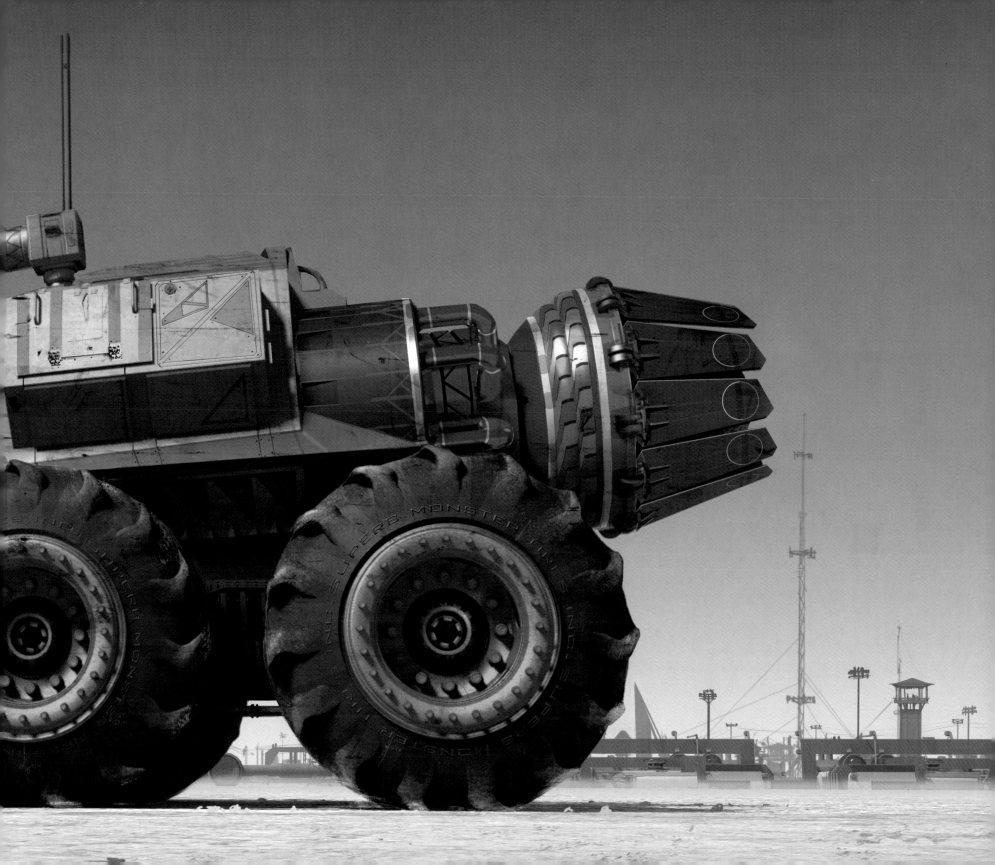

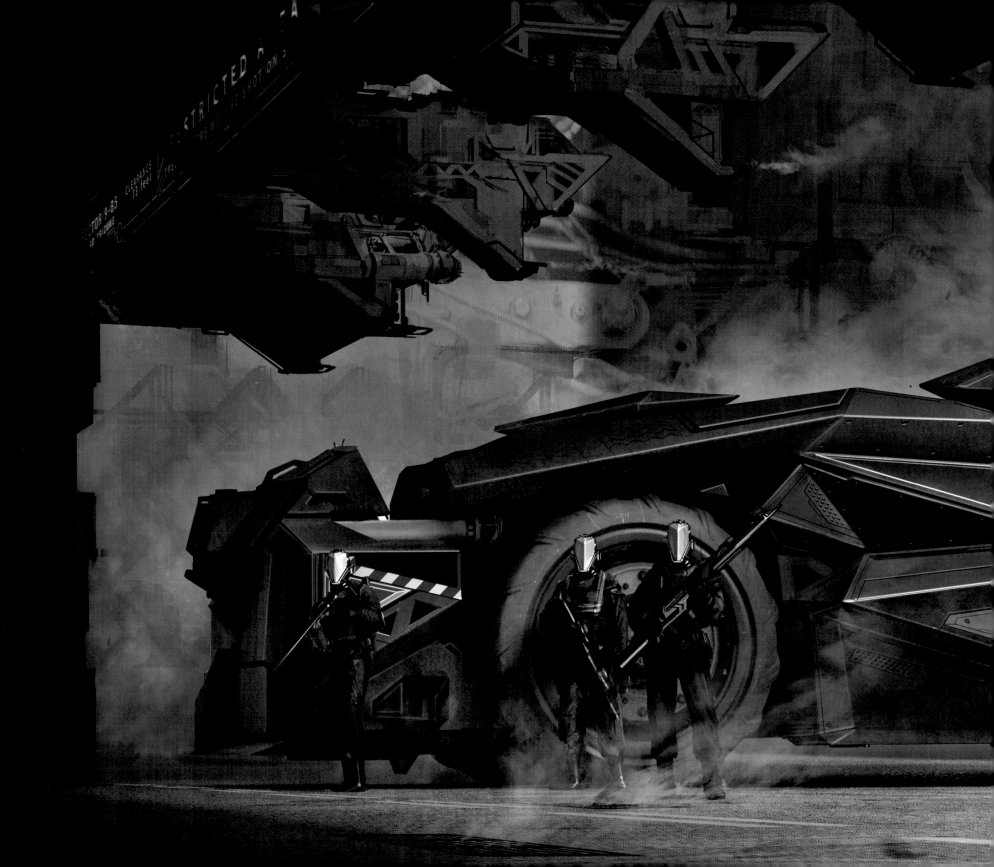

Black Ops' answer to "The Brick" is this monster. While it may not have the high-tech hubless wheels of the BR-1, it more than makes up for it with a significant barrier-busting bumper design of its own.

RESCUE

LT. N² SQUARED

CAUTION!

NO STEP

NO STEP

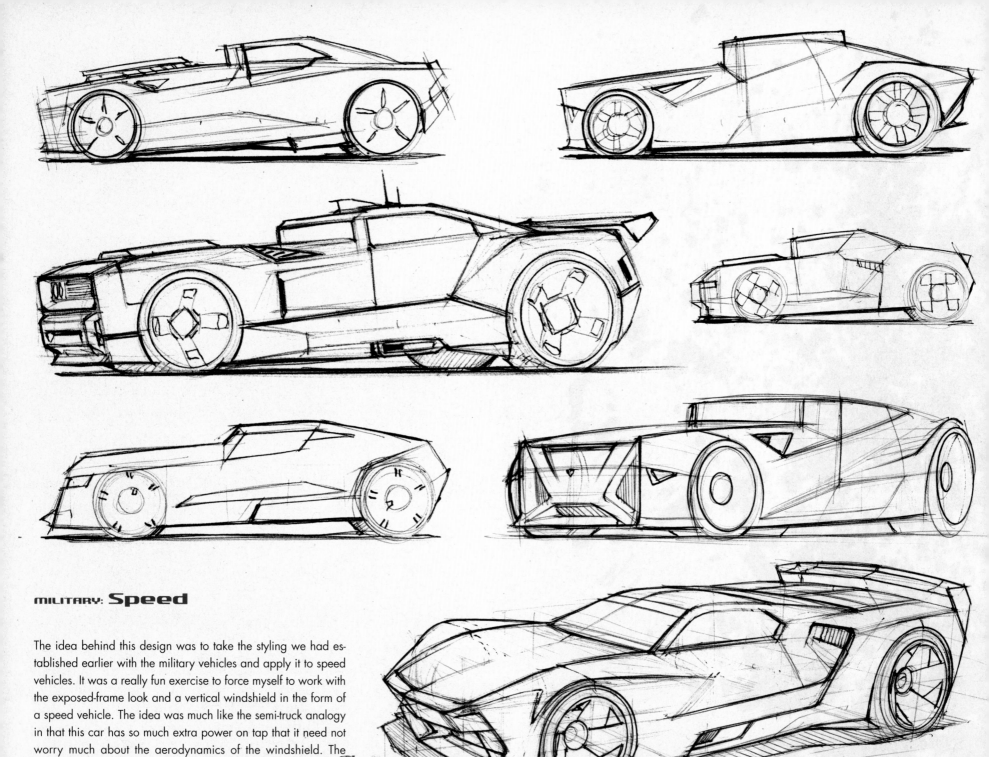

MILITARY: Speed

The idea behind this design was to take the styling we had established earlier with the military vehicles and apply it to speed vehicles. It was a really fun exercise to force myself to work with the exposed-frame look and a vertical windshield in the form of a speed vehicle. The idea was much like the semi-truck analogy in that this car has so much extra power on tap that it need not worry much about the aerodynamics of the windshield. The sketch at the top of the opposite page is the basic design I built into a quick 3D model on the following pages.

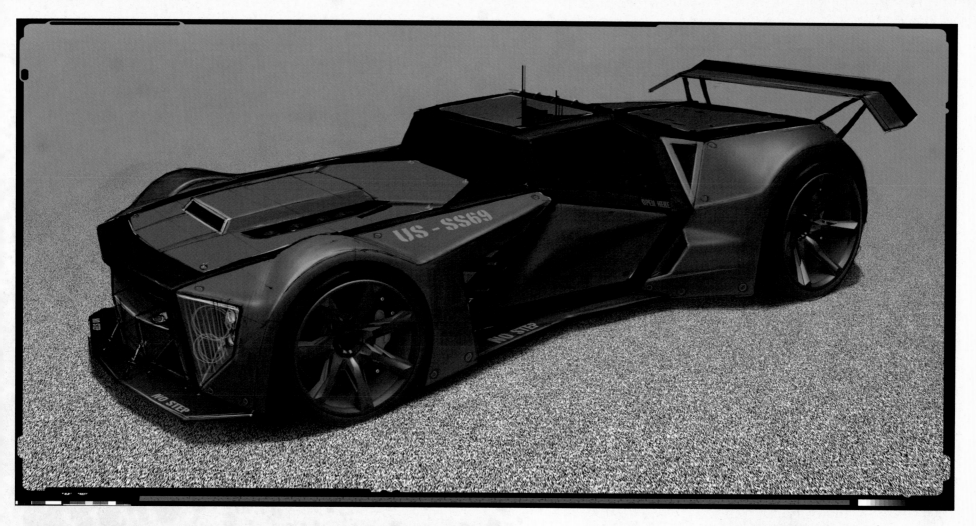

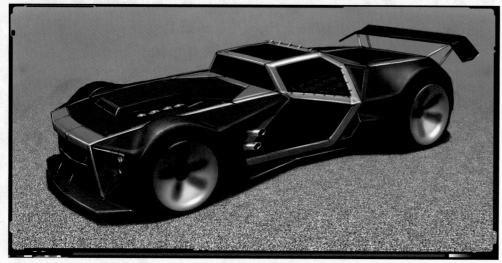

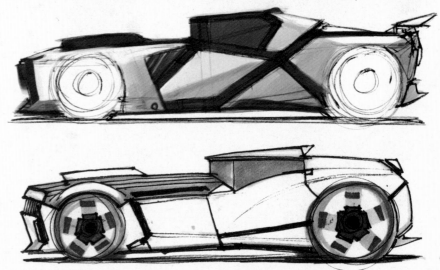

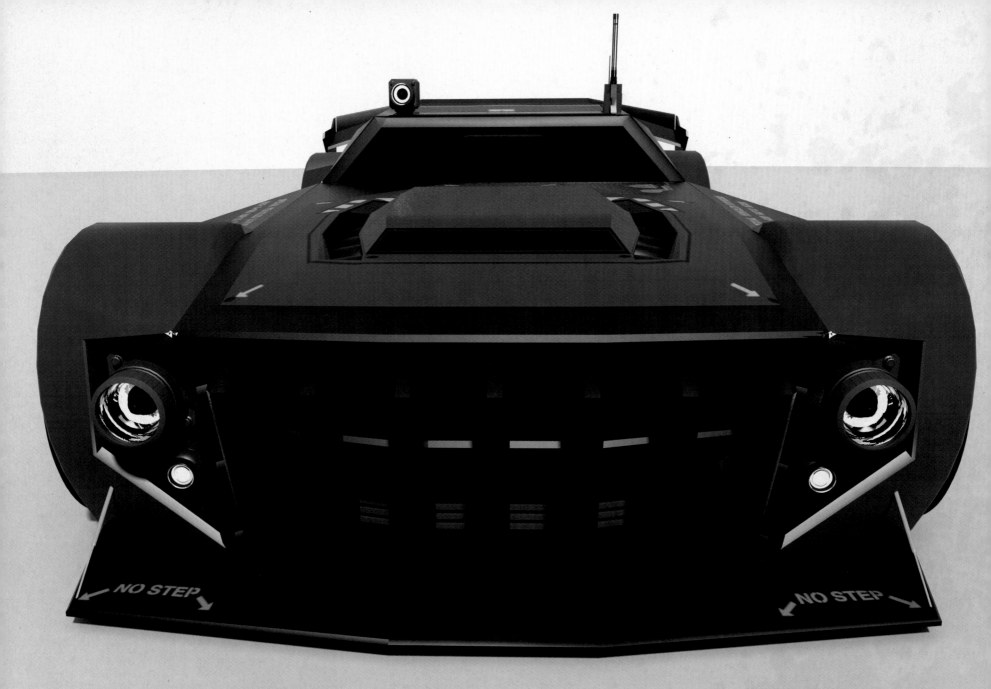

MILITARY: Weekend Warrior

The renderings on these pages and the next two are of the base-sketch model out of modo, before any Photoshop work. I always imagined this car as the creation of some wacky, talented Army mechanics with too much time on their hands!

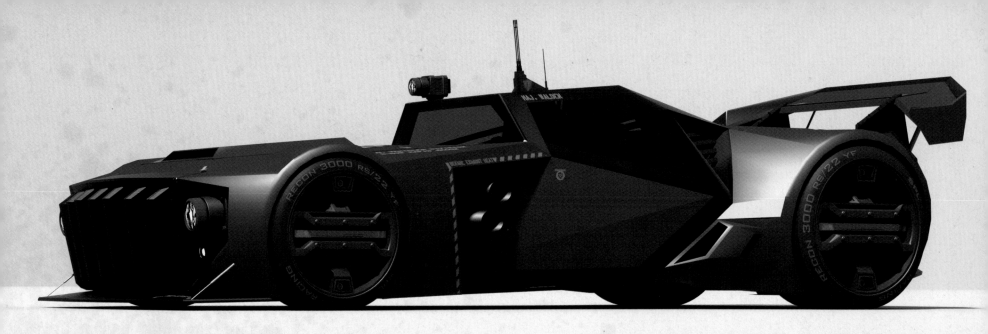

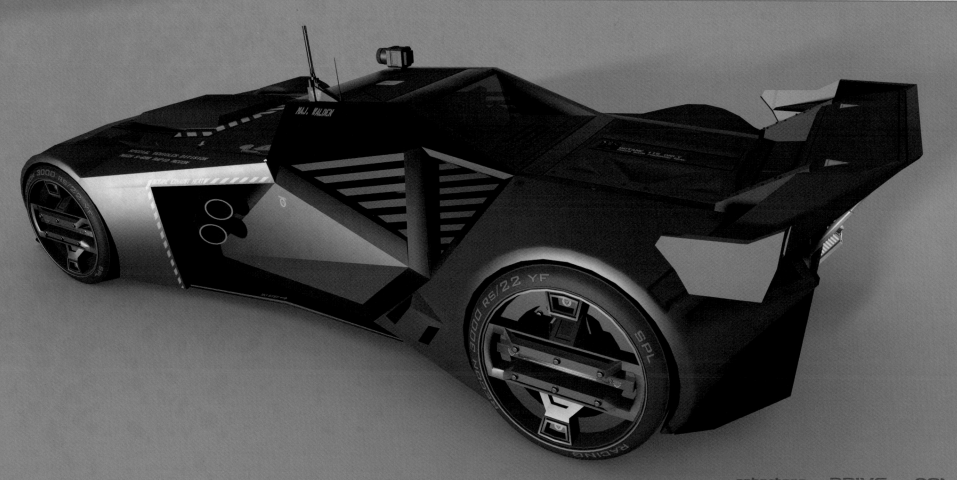

robertson : DRIVE : 081

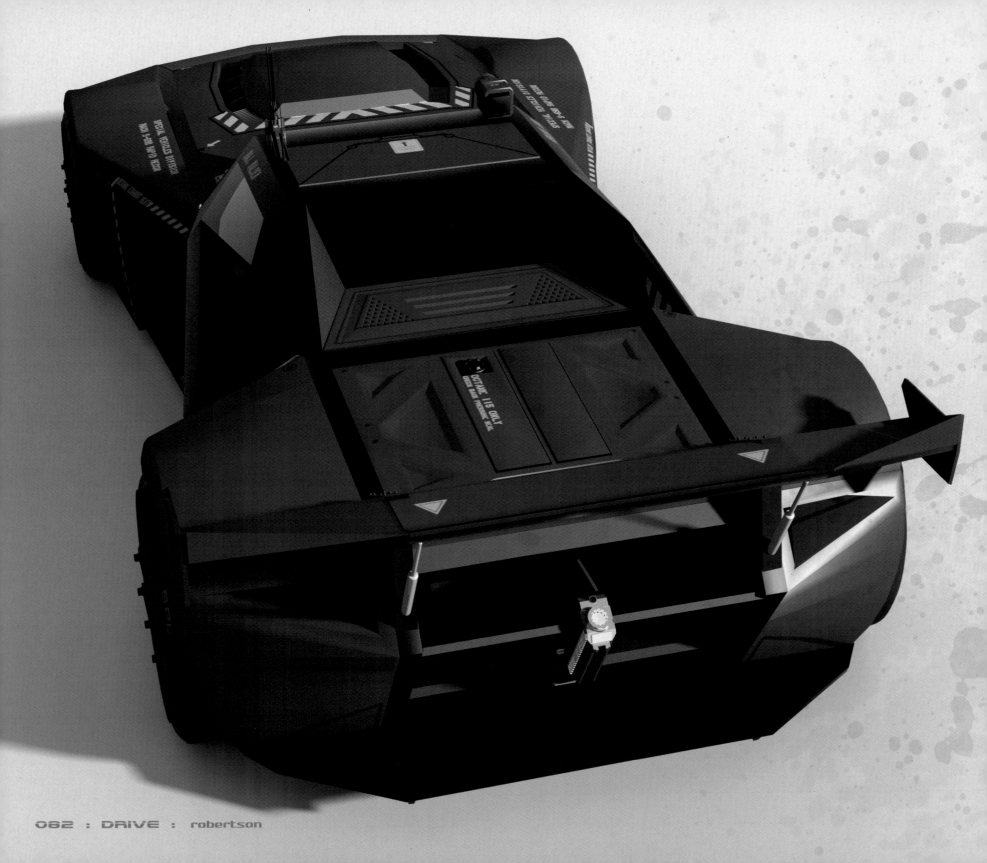

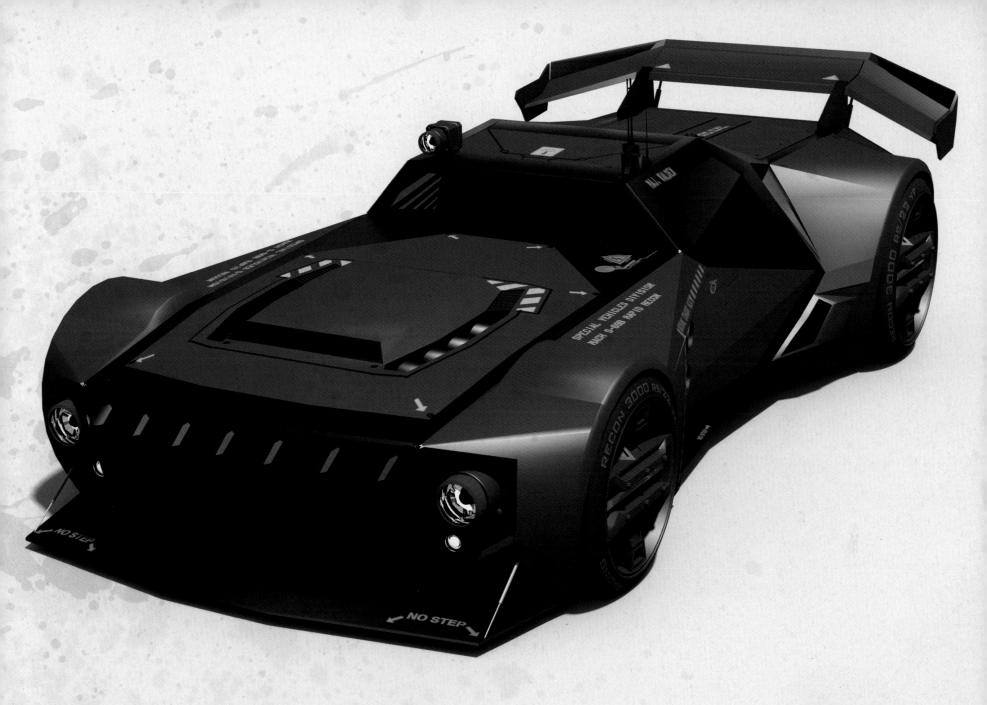

SPECIAL VEHICLES DIVISION
MACH 5-600 RAPID RECON

RECON 3000 R5/22 VF

RECON 3000 R5/22 VF

NO STEP

← NO STEP

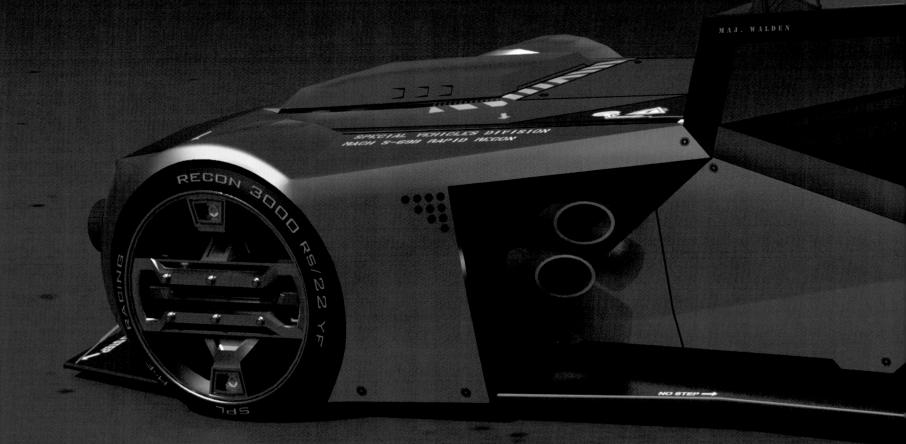

Text visible on the vehicle image:
- MAJ. WALDEN
- SPECIAL VEHICLES DIVISION
- MACH S-600 RAPID RECON
- RECON 3000 RS/22 YF
- RACING
- SPL H-F
- NO STEP →

MILITARY: Weekend Warrior

After rendering in modo, Annis did a nice pass in Photoshop bringing the brute force, military muscle car to life!

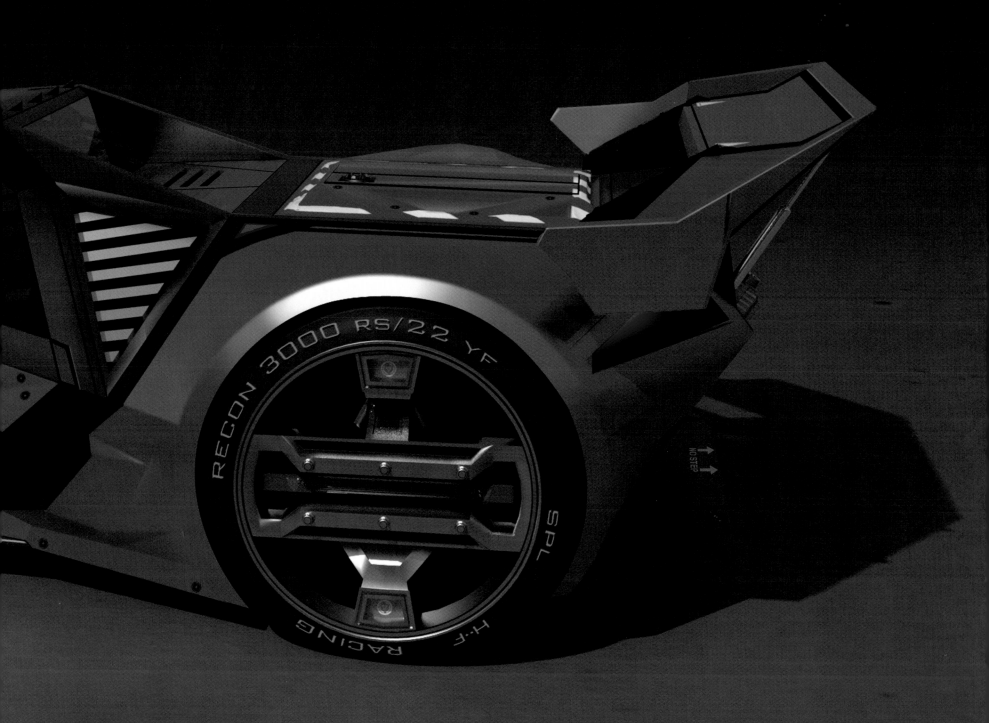

NO STEP

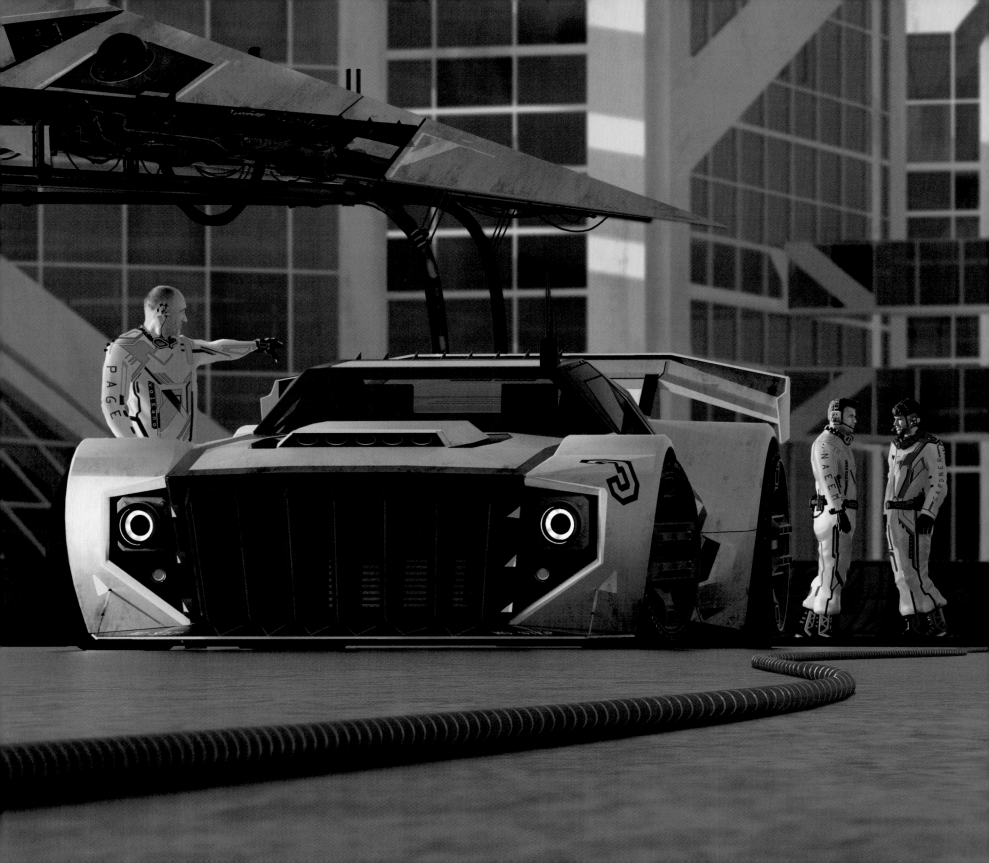

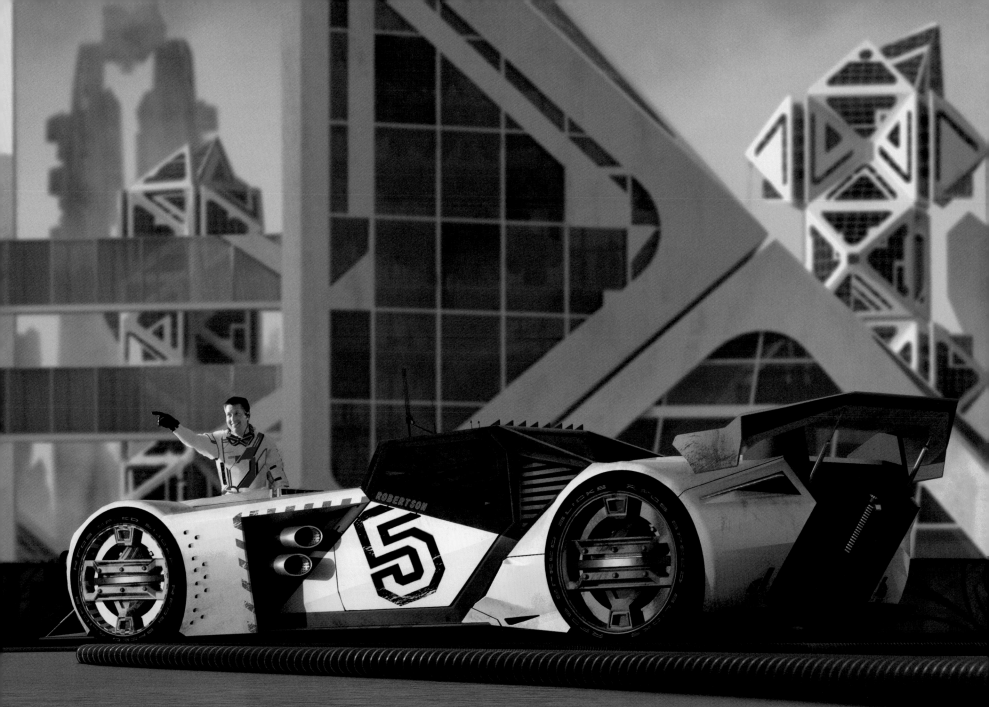

MILITARY: **Weekend Warrior**

Of course, once they built one, they had to build two. Then the race was on!

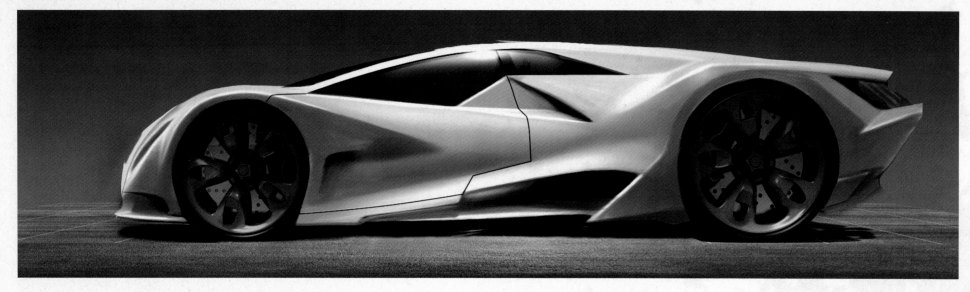

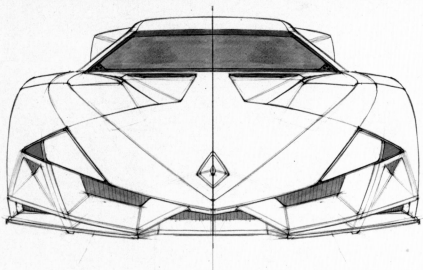

MILITARY: SSR S-12

Done earlier on, before hitting on the exposed frame and vertical windshield style, this design takes a more traditional approach and explores the simple idea of adding some angularity and soft faceting to a mid-engine sports car. The concept started with the value sketch above, done in Photoshop on top of a modo rendering of four wheels and a ground plane.

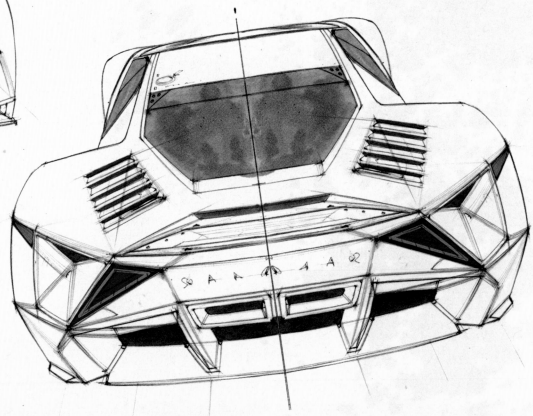

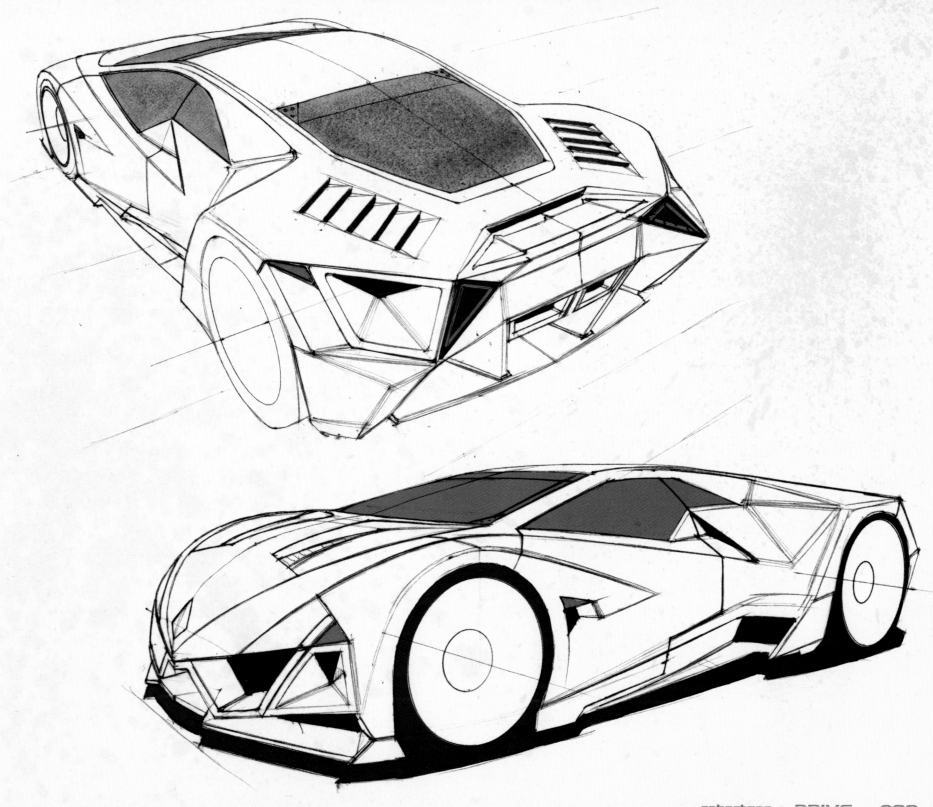

robertson : DRIVE : 089

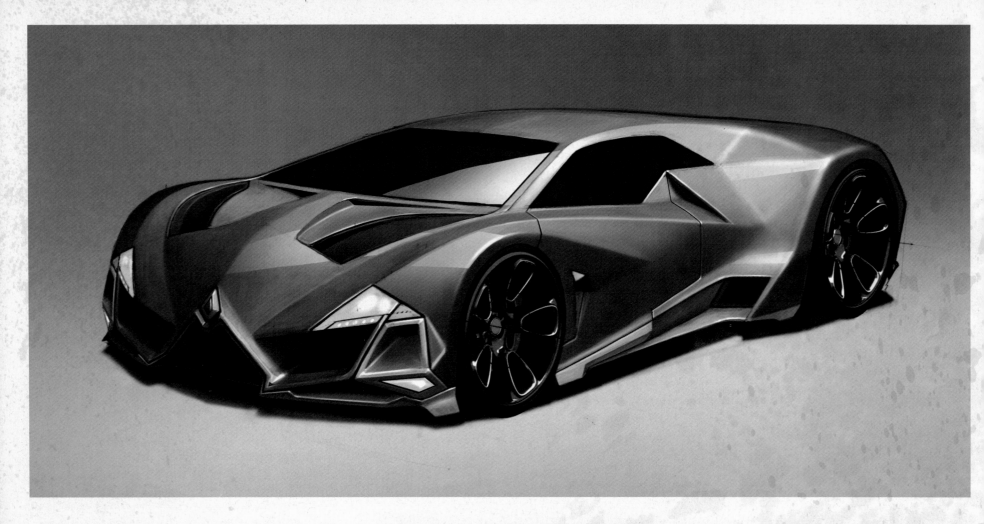

MILITARY: SSR S-12

The sketch above is a version of the concept from the previous pages put into a front three-quarter perspective view. This sketch started as a traditional ballpoint pen drawing I did over a print-out of the base chassis rendering which was nothing more than a ground plane and four wheels. The value and rendering of the forms were done next in Photoshop. The design to the right and the facing page was a revision of the one above to explore an even more faceted surfacing of the car body.

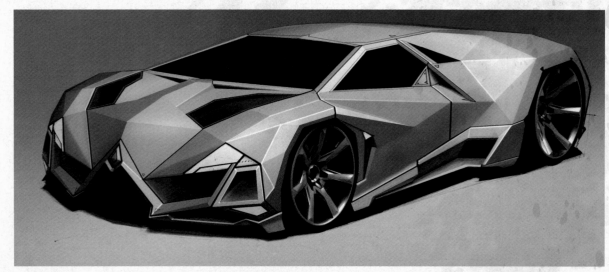

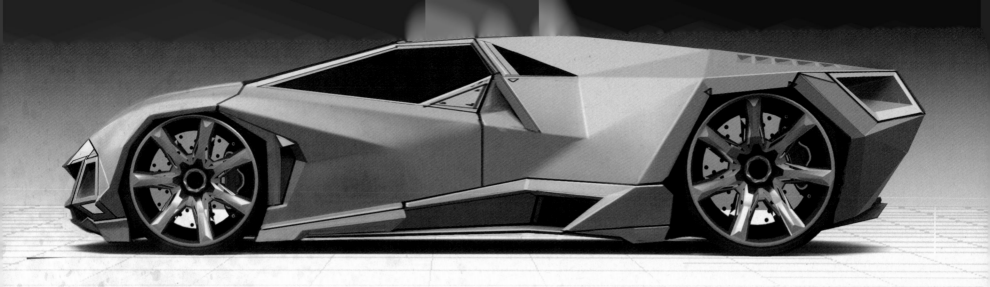
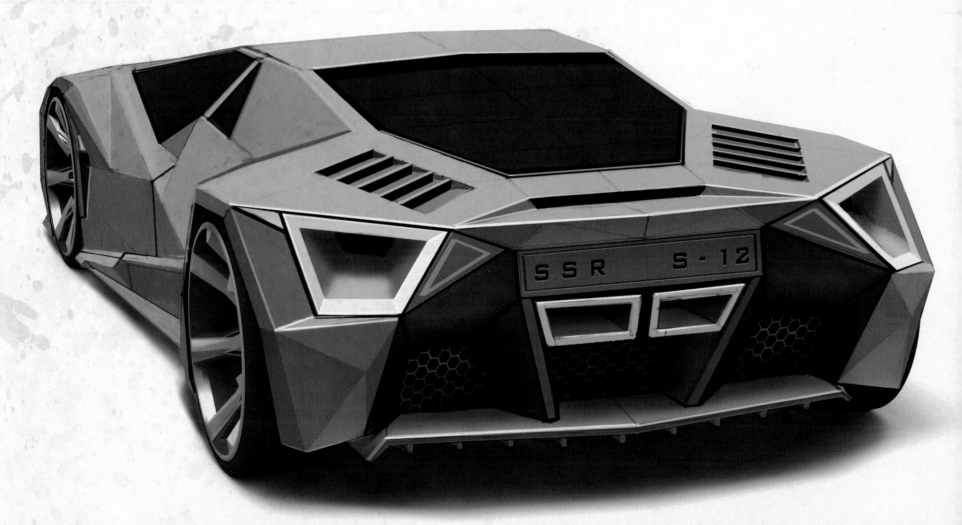

SSR S-12

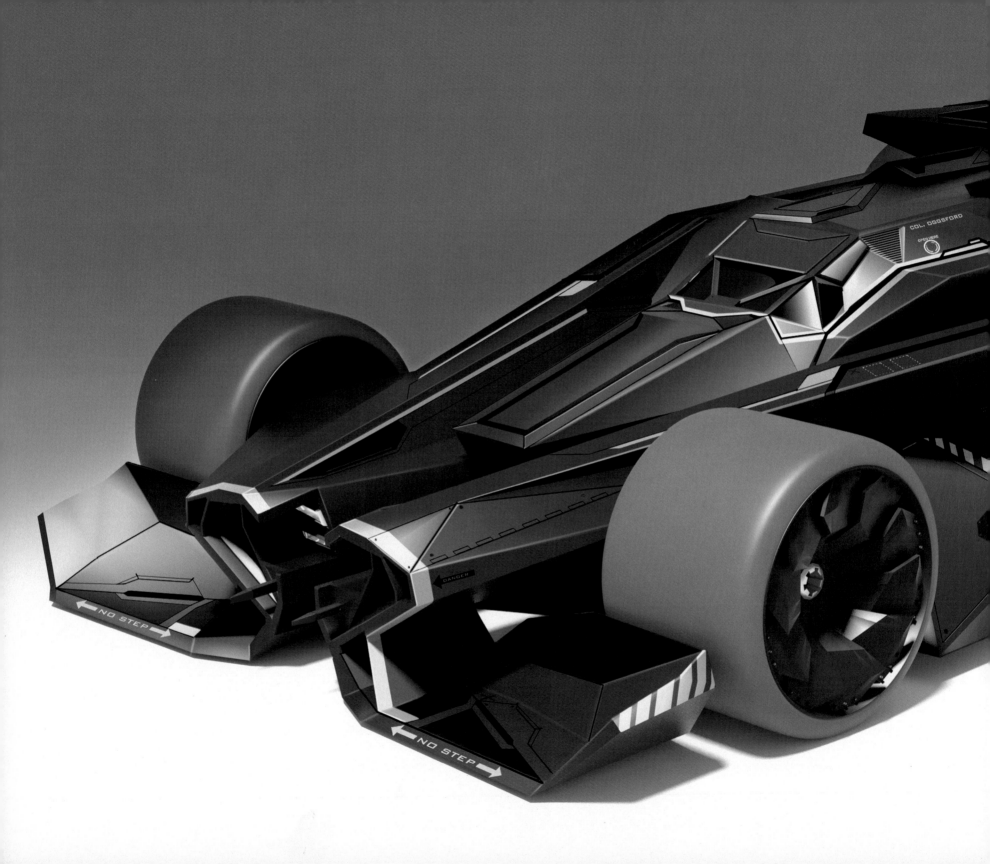

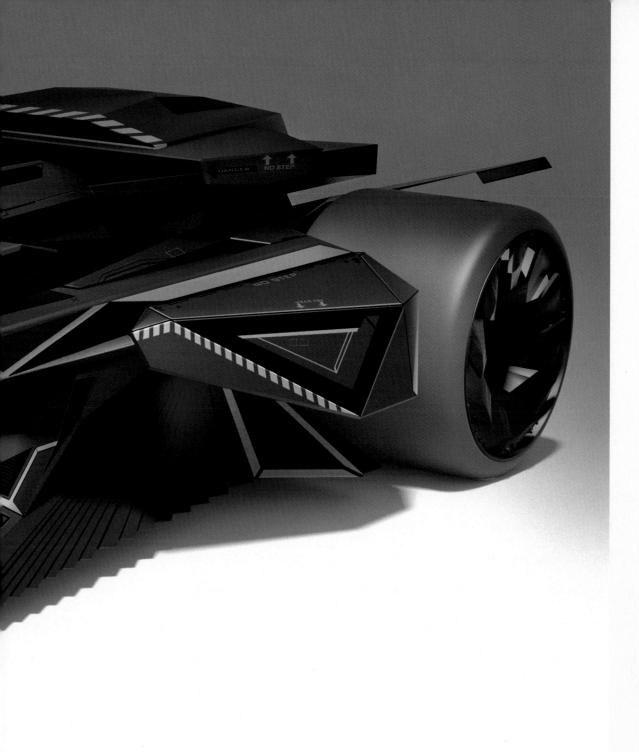

MILITARY: **Black Magic**

This is the last, and most futuristic, imaginary racing vehicle in our military chapter. So of course this car has the obligatory sci-fi glowing, blue-light energy source along with classic military-style stenciled graphics to help place it in the future yet keep it familiar within the styling theme of this chapter. Annis did a really nice detailing pass on this hyper-faceted, open-wheel race-car concept. There were no sketches for this car and it was one that I mocked up directly in modo as a loose assembly of simple, faceted forms to make the car. The raw rendering out of modo looked like the image below, before all the detailing in Photoshop.

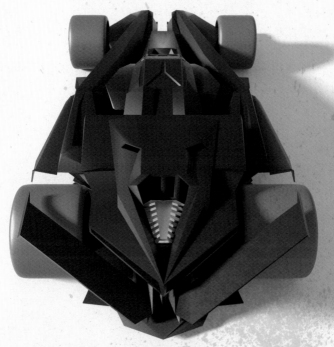

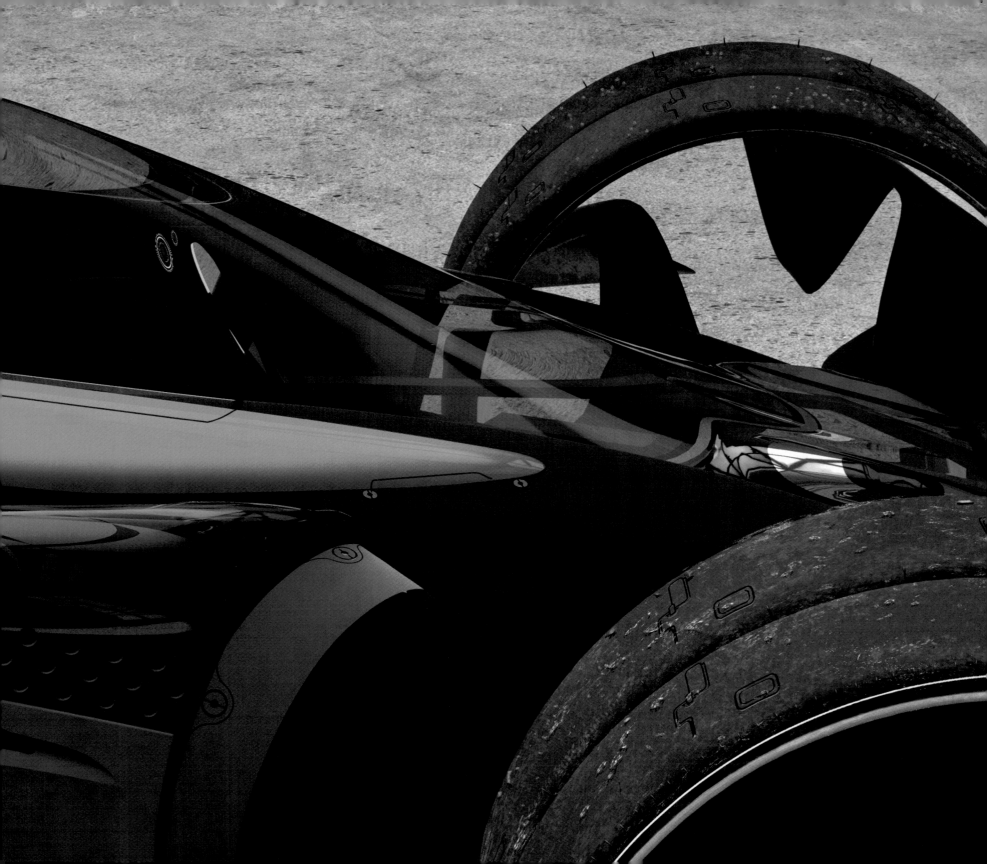

PRO SPORT

Our third chapter is a kind of catchall styling exercise which we are simply calling Pro Sport. The vehicles in this chapter have a very wide range of styles and are not meant to relate to one another stylistically as closely as the designs in the first two chapters. Our goal was to imagine these vehicles in the same categories: speed, off-road and heavy duty, but to let our imaginations run wild to explore whatever we thought would be fun to see in a video game of the future. In a few cases the vehicles could possibly exist in our world of today...with a little more refinement and engineering effort. We have done a lot of sports cars in this chapter, from muscle cars to mid-engine super cars to open wheel sci-fi racers. Basically we just had fun. We even threw in a motorcycle near the end as we moved into our off-road concepts.

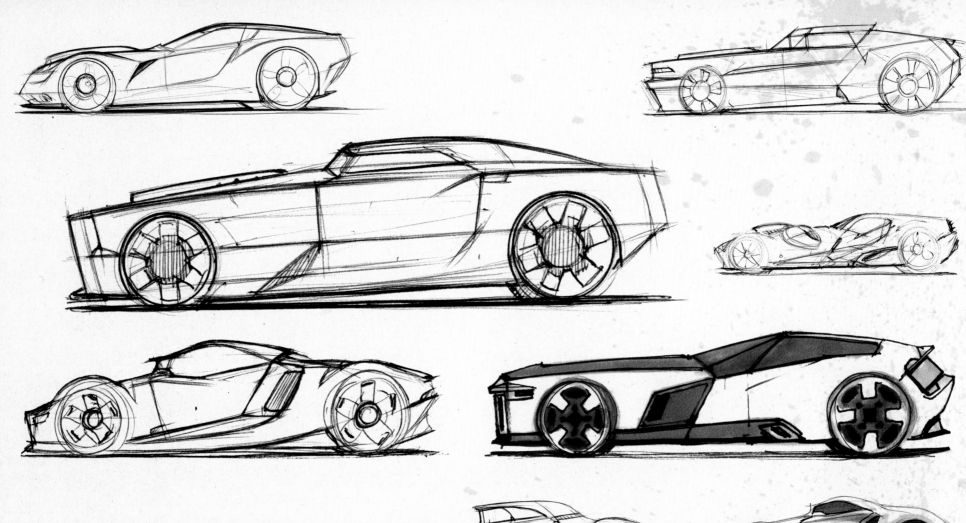

PRO SPORT: speed sketches

Ballpoint pen with a little marker work is how I got started on the sketches for Pro Sport. You can still see some of the influence of the earlier military sports-car proportions hanging around on this page. I'm not crazy about any of these design directions, but I always need to do some warm-up sketches along the way to finding a new visual style and I'm happy to share a few examples of this process here.

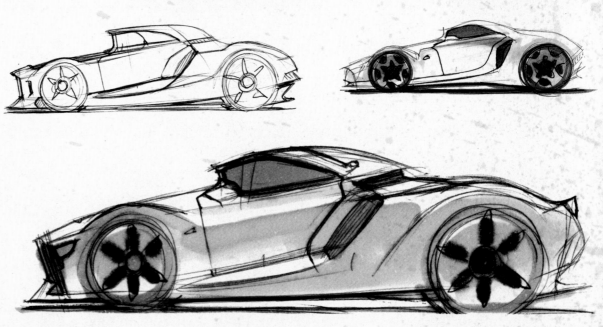

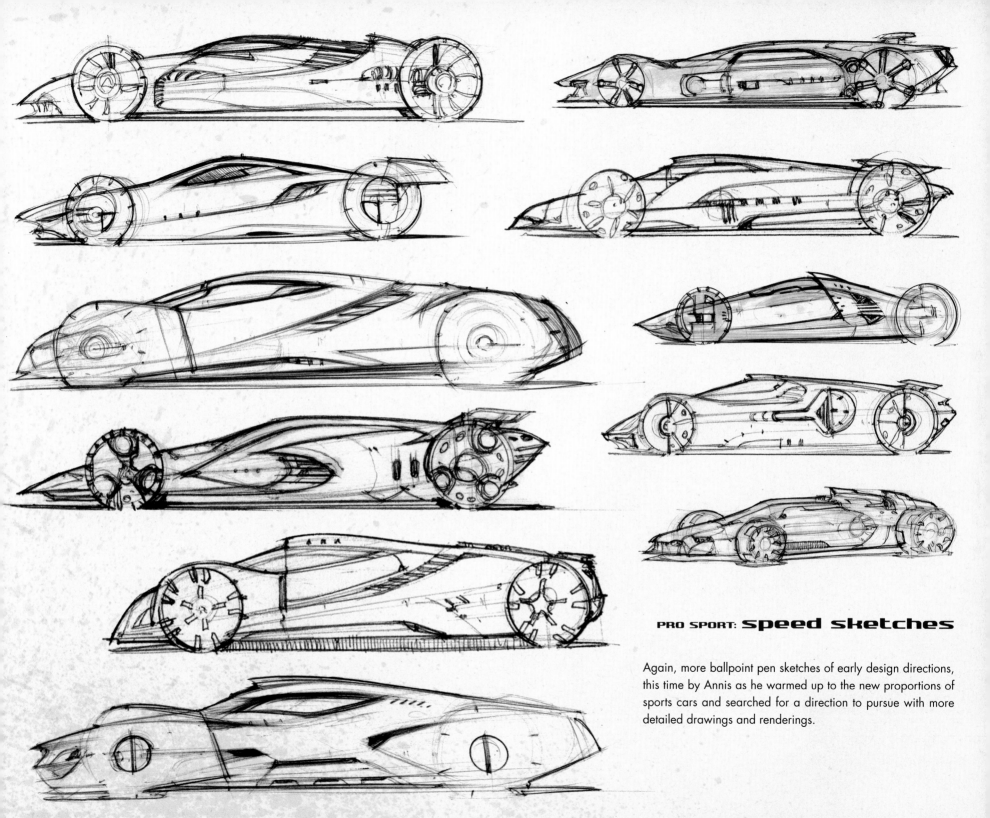

PRO SPORT: speed sketches

Again, more ballpoint pen sketches of early design directions, this time by Annis as he warmed up to the new proportions of sports cars and searched for a direction to pursue with more detailed drawings and renderings.

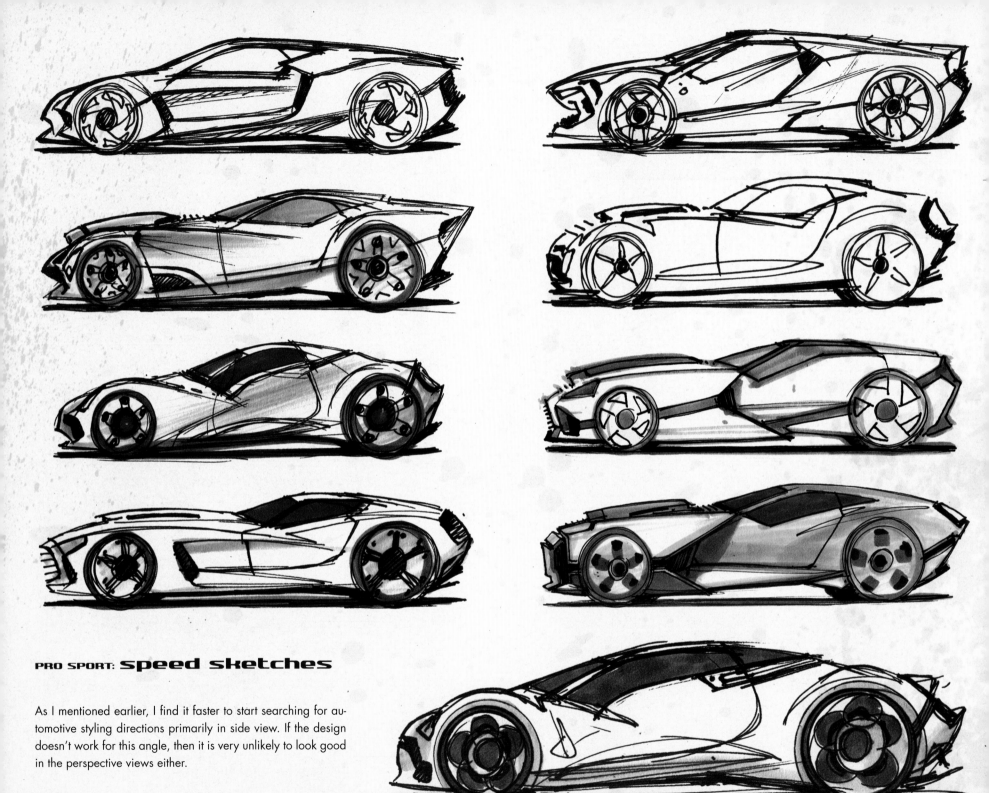

PRO SPORT: speed sketches

As I mentioned earlier, I find it faster to start searching for automotive styling directions primarily in side view. If the design doesn't work for this angle, then it is very unlikely to look good in the perspective views either.

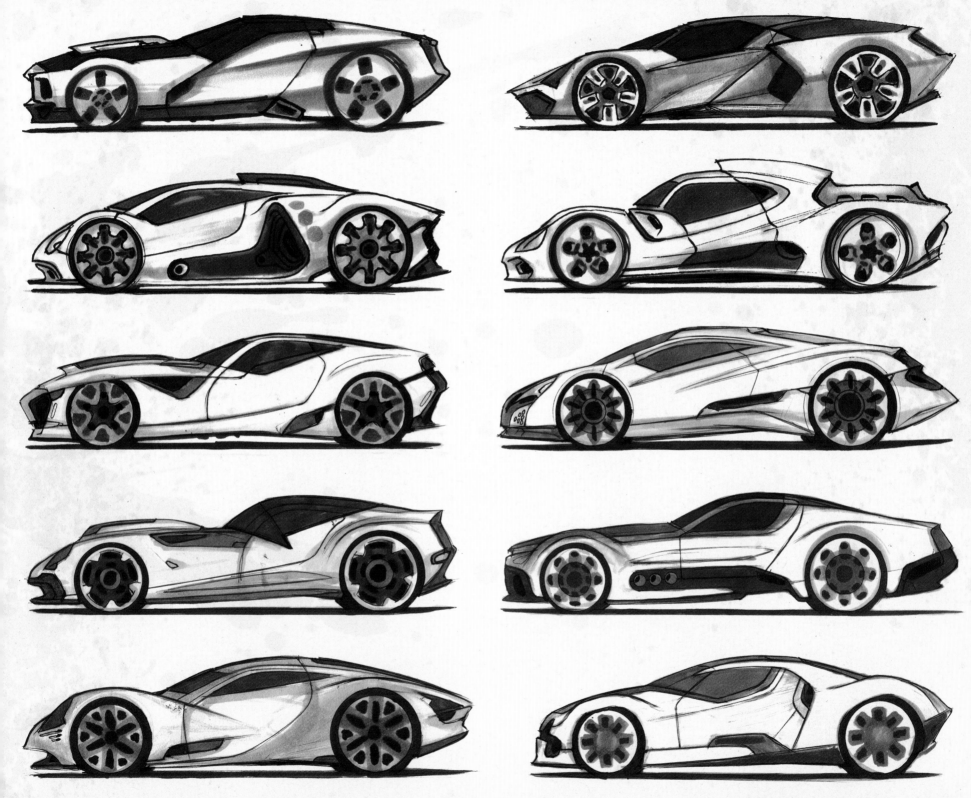

robertson : DRIVE : 099

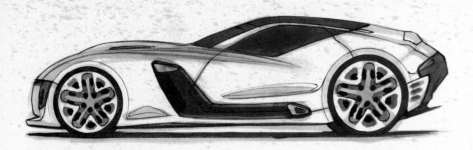

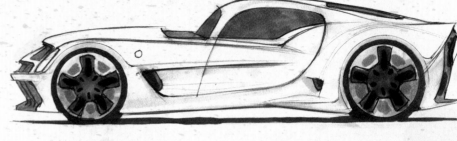

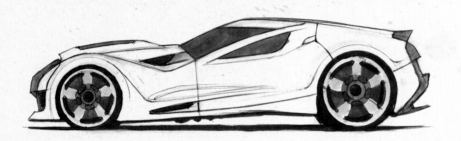

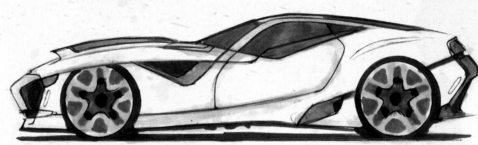

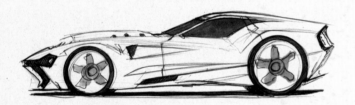

PRO SPORT: **speed sketches**

After finding a concept I like, I scan the sketch and open it in Photoshop, where I add some wheels I've modeled and rendered in modo, and then add value to the sketch to define some of the transitional forms and graphics. I really enjoy the rendering of the form in Photoshop, as it gets me close to the feeling of sculpting a real clay model once I get into the rhythm of it. At this early stage of development I work mostly with a hardedged elliptically shaped brush, set to "pressure sensitive," with a low opacity. I also tend to do these types of sketches in gray scale and sometimes colorize them later as I've done here.

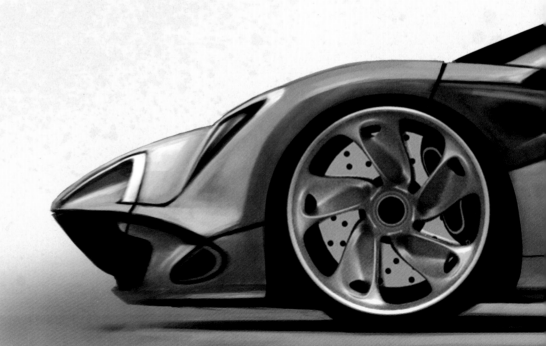

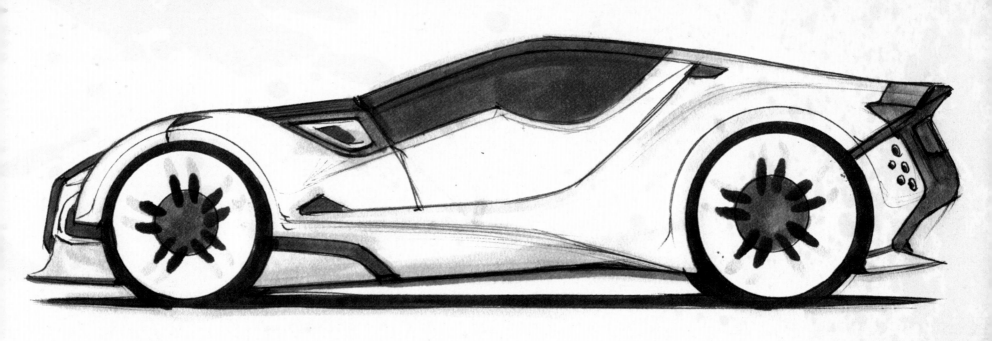
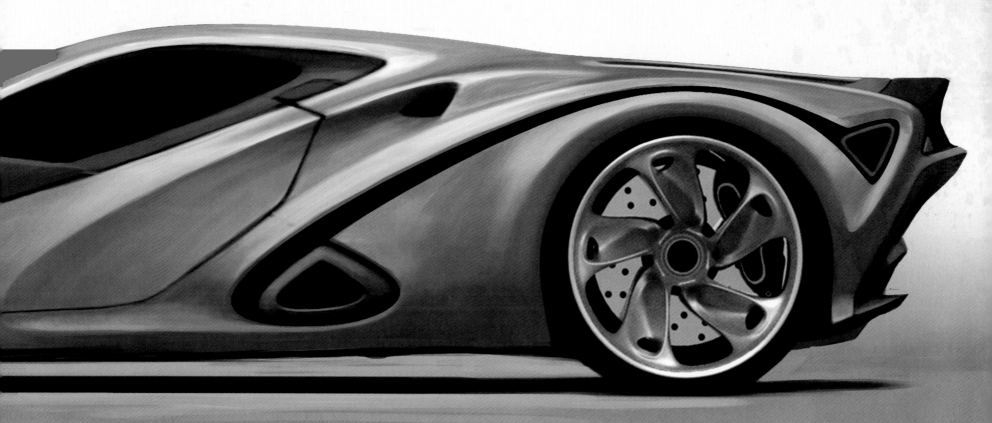

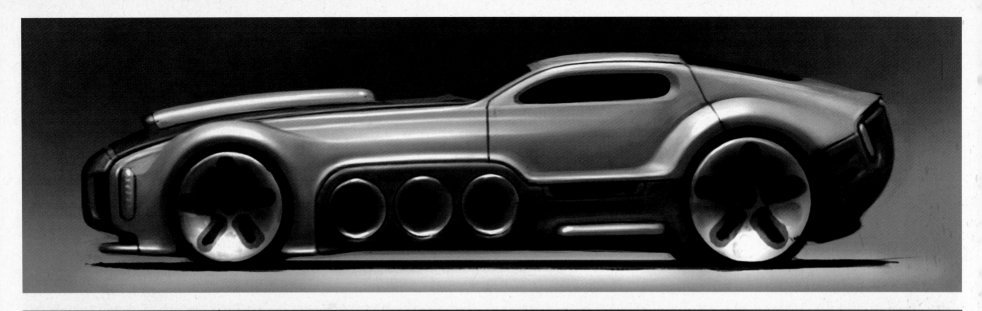

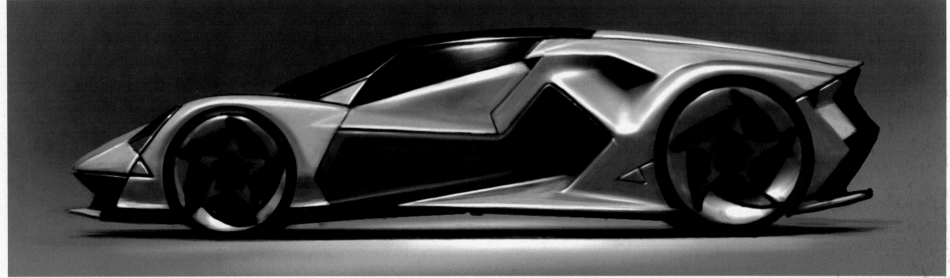

PRO SPORT: **speed sketches**

More of the same style sketches here, this time done even quicker with more of the underlying base marker sketch showing through.

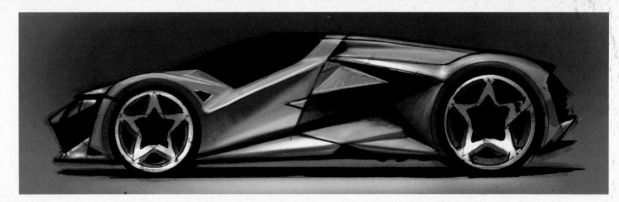

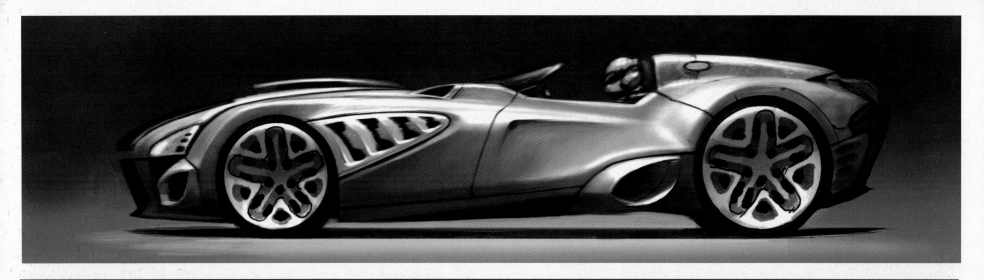

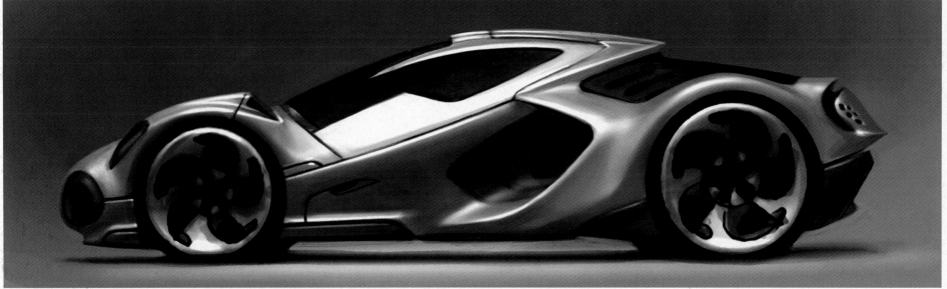

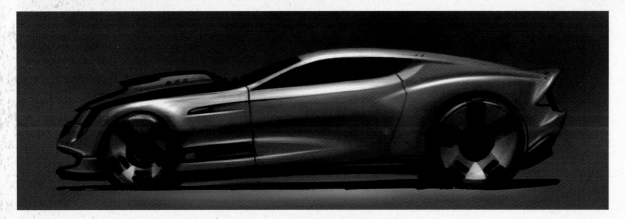

PRO SPORT: **speed sketches**

These styles range all over the place, which makes doing a book like this really enjoyable for us. The center car on this page makes it through to a more finished level in the upcoming pages.

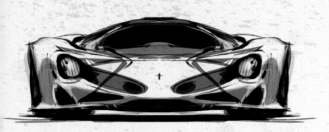
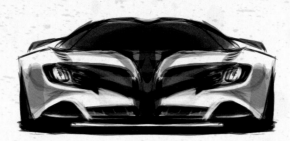
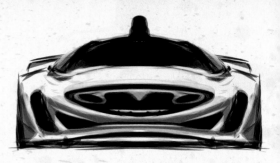

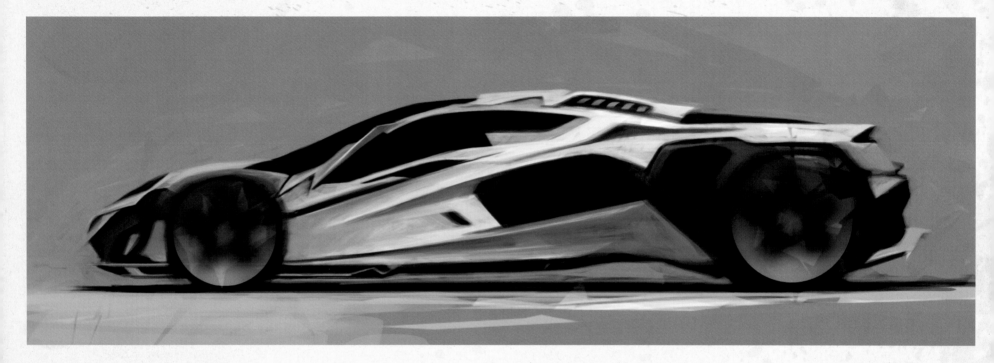

PRO SPORT: **Alchemy**

Alchemy is a very interesting, free, drawing program I have used for a couple of years to generate a lot of styling "happy accidents" through the use of their innovative, abstract sketching tools. The loose sketches on these pages were done in this program. It is a little hard to control the results when doing a sports car but if I can look through the innate complexity of the sketches, occasionally I'll find some fresh visual directions I would have been unable to create otherwise.

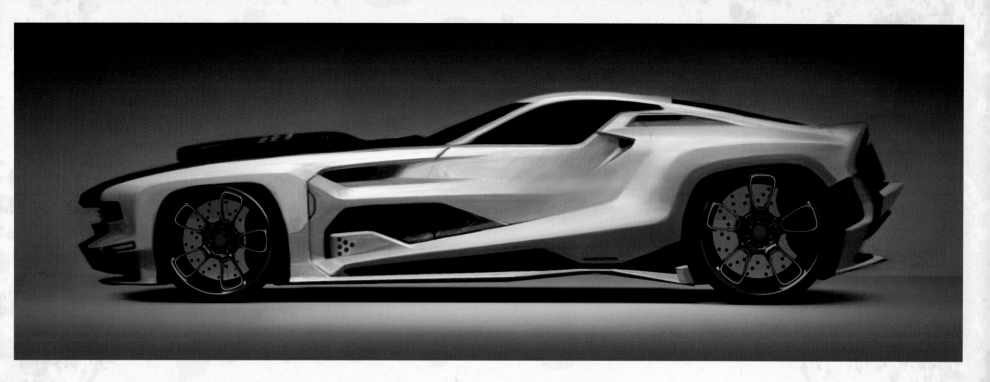

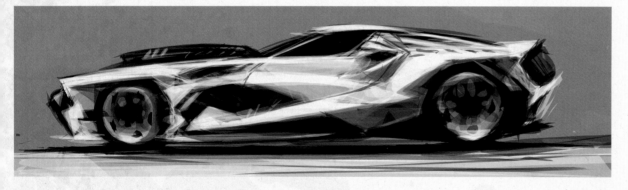

PRO SPORT: Alchemy

The sketch directly to the left is just as it came out of Alchemy. Then, after a first pass of refinement and the addition of wheels out of modo, I had the sketch above. Sure, the study above still has far too much going on, but it's not a bad way to work to help break me out of styling ruts that develop over time. During a 20-year career as a designer, it is easy to develop muscle memory when drawing the same curves over and over again, and this makes it difficult to invent fresh and innovative shapes that no one has ever seen before. This seems to be especially true when designing cars, as the differences in today's marketplace can be quite subtle to the casual viewer. This strong desire of mine to invent new forms has led me deeper into the investigation of new tools and techniques to add to my visualization process, which seems more and more to involve a large dose of abstraction in the mix. Whether it is by using Alchemy, photography, custom brushes or collage in Photoshop or the use of new 3D programs like modo, I find the constant reinvention of my own visualization process to be as enjoyable, if not more so, than the final object that is created with the use of these tools and techniques.

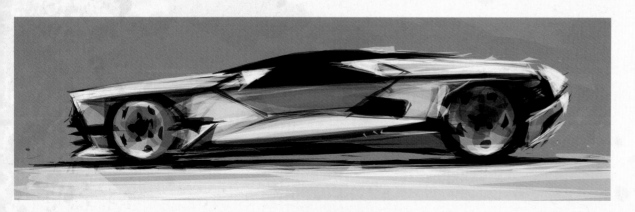

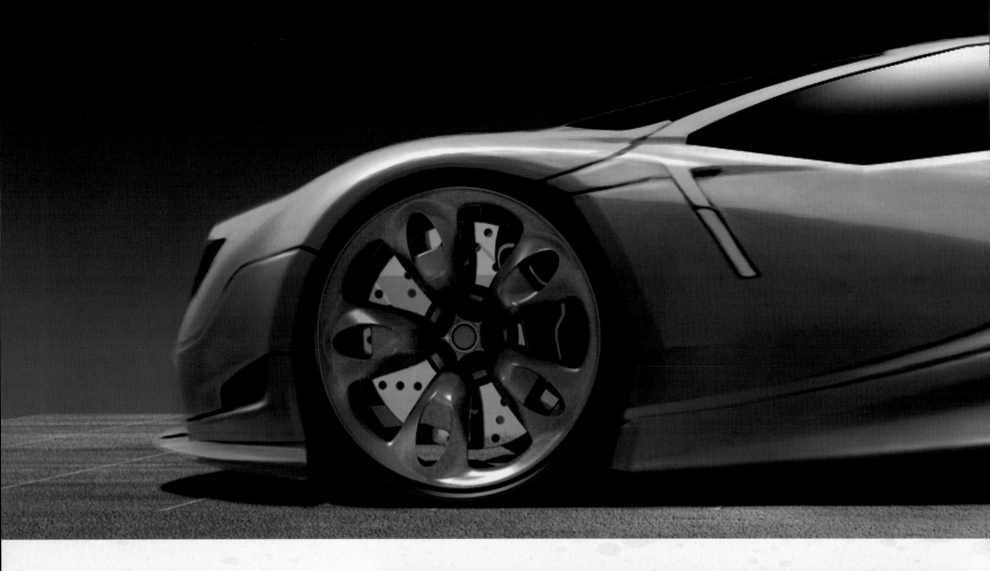

PRO SPORT: process cars

The big sketch above and the sketch to the right represent two concepts created with the aid of new techniques to my visualization process. They both started with an underlay image created in modo of four wheels and a ground plane. Then I moved into Photoshop where I used a series of specifically created custom brushes to collage several layers of shapes and values together over the base chassis. I freely warped the painted forms and values on each layer over the wheels, creating the intended vehicle type I had in mind. The last step was to edit and simplify the information by painting over the top of all the layers.

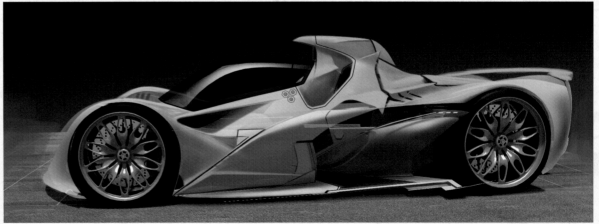

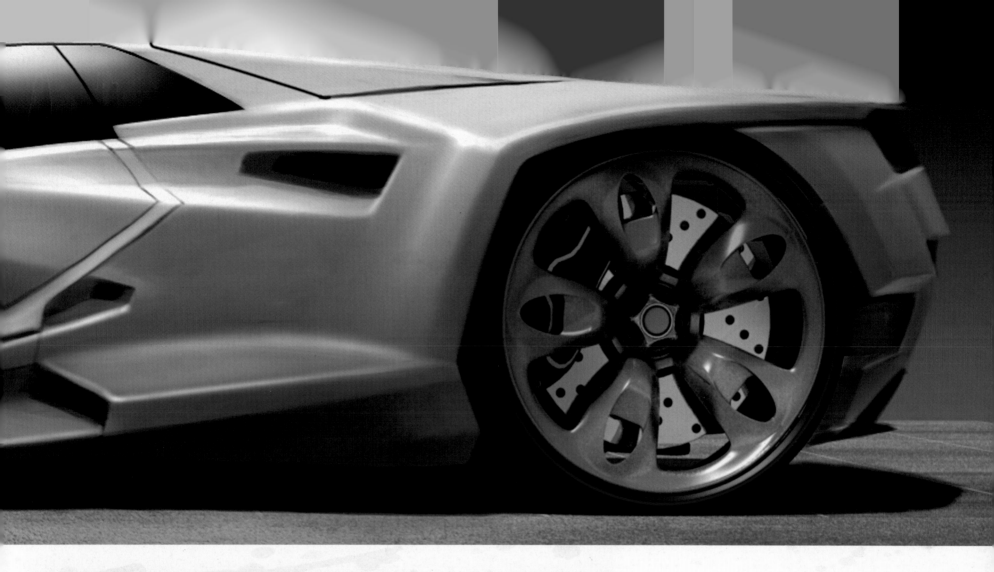

PRO SPORT: modo machine

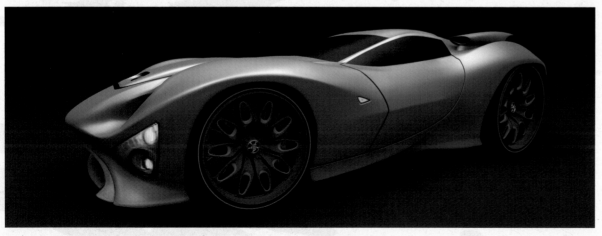

I included the car to the left purely as a historical piece, as it was my first real attempt to 3D model a sports car in modo. I should also add that the model is not as tight as it appears here, as I spent a bit of time cleaning it up in Photoshop.

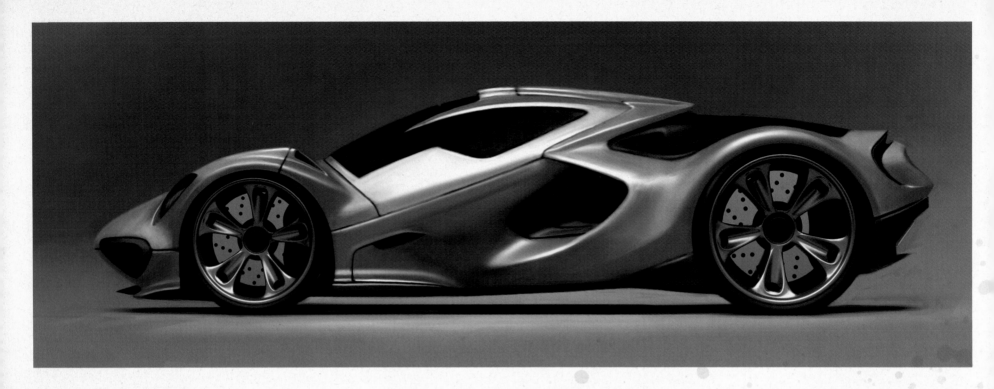

PRO SPORT: **SR-62**

This a cleaned-up version of the design sketch from the middle of page 103. I had some modeling help on this one, as the following pages will show. When communicating the forms for a modeler to build a design in 3D, I will do a sketch like the one to the right. It starts with a traditional pen sketch that is then rendered by hand in Photoshop to help delineate the transitional forms through value changes across the surface. In addition to rendering the forms in gray scale, I will go back and add section lines over the surfaces to make the image as clear as possible. A good modeler can work from matching side, front three-quarter and rear three-quarter views to get pretty close to the finished model.

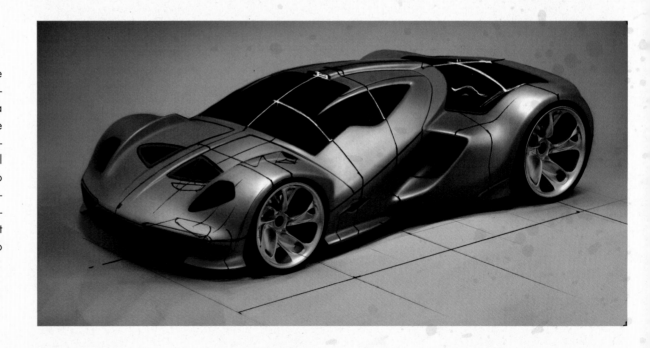

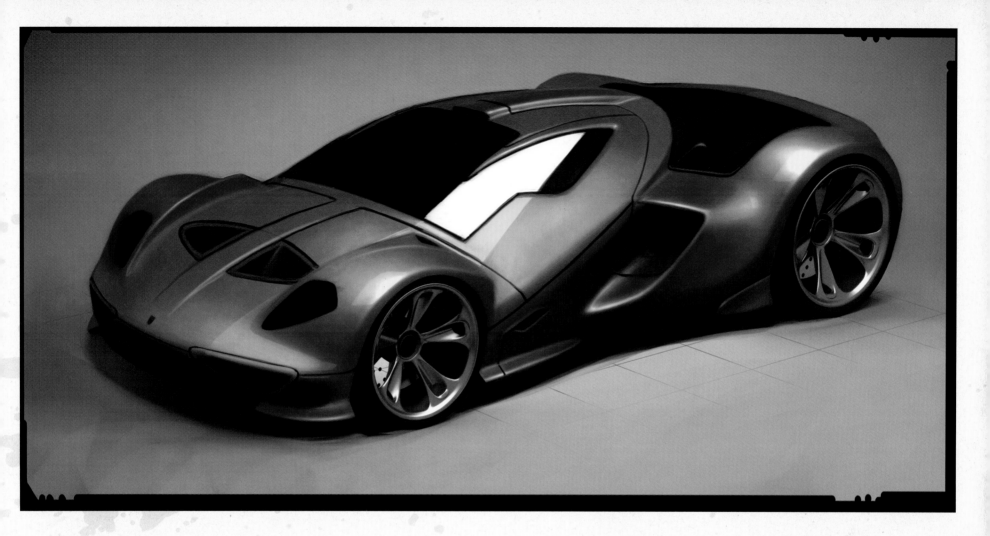

PRO SPORT: SR-62

I colorized the paint to show where the material changes would happen. The addition of a quick reflection of an overhead light box helps bring the illusion of the reflective surfaces to life.

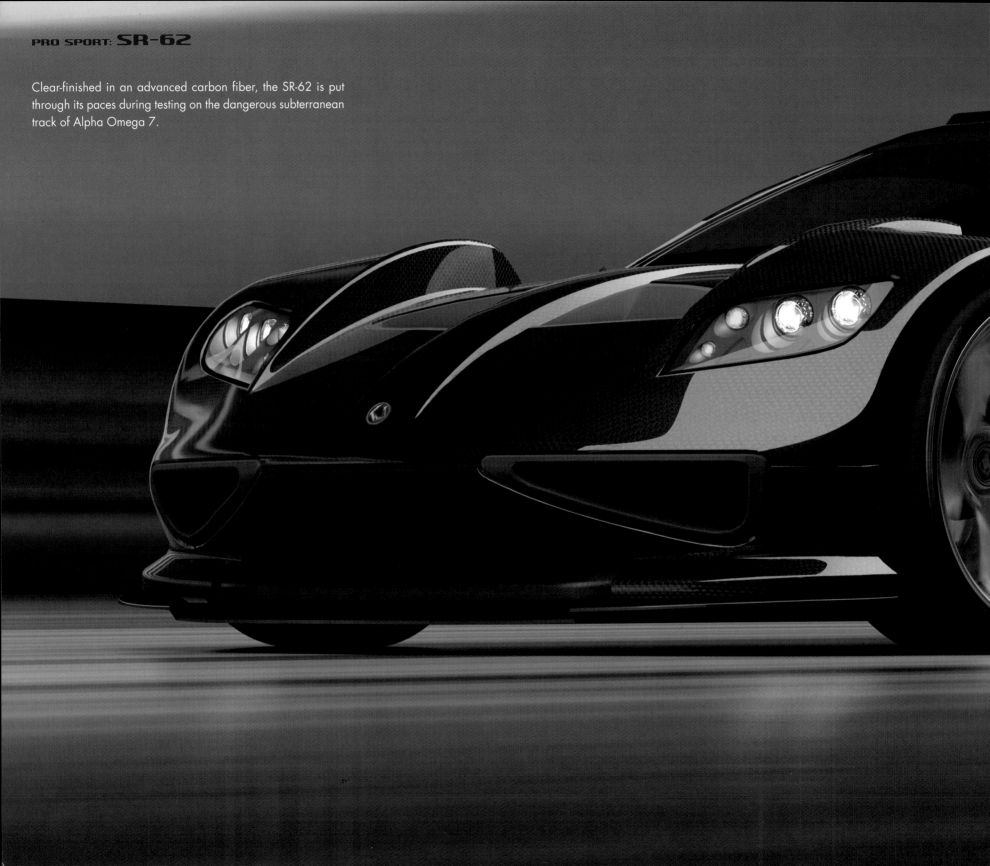

PRO SPORT: SR-62

Clear-finished in an advanced carbon fiber, the SR-62 is put through its paces during testing on the dangerous subterranean track of Alpha Omega 7.

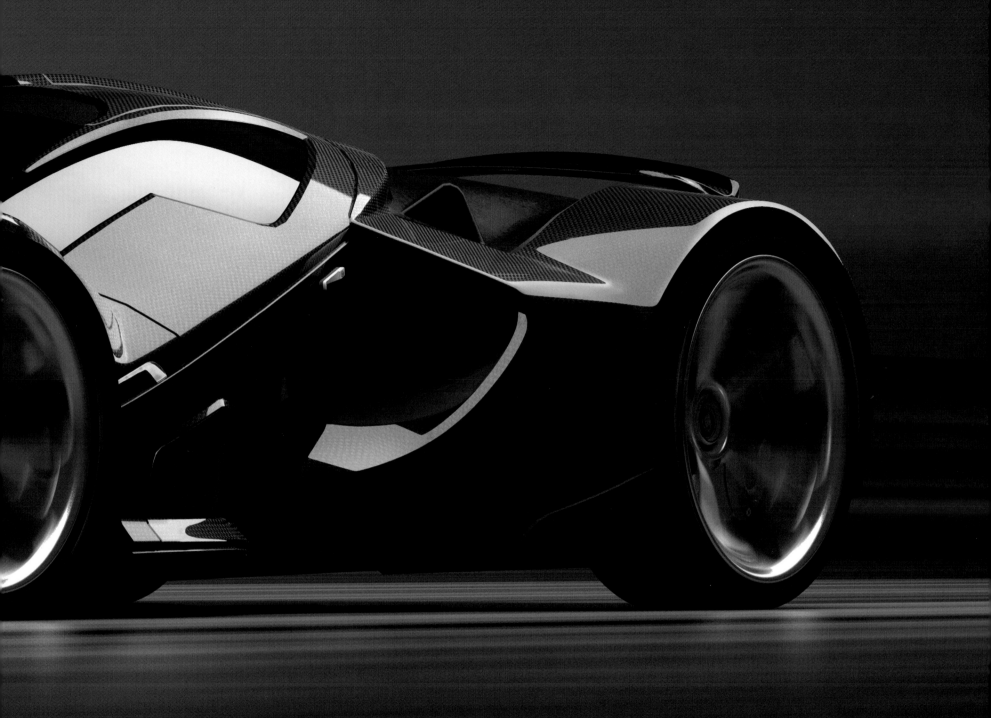

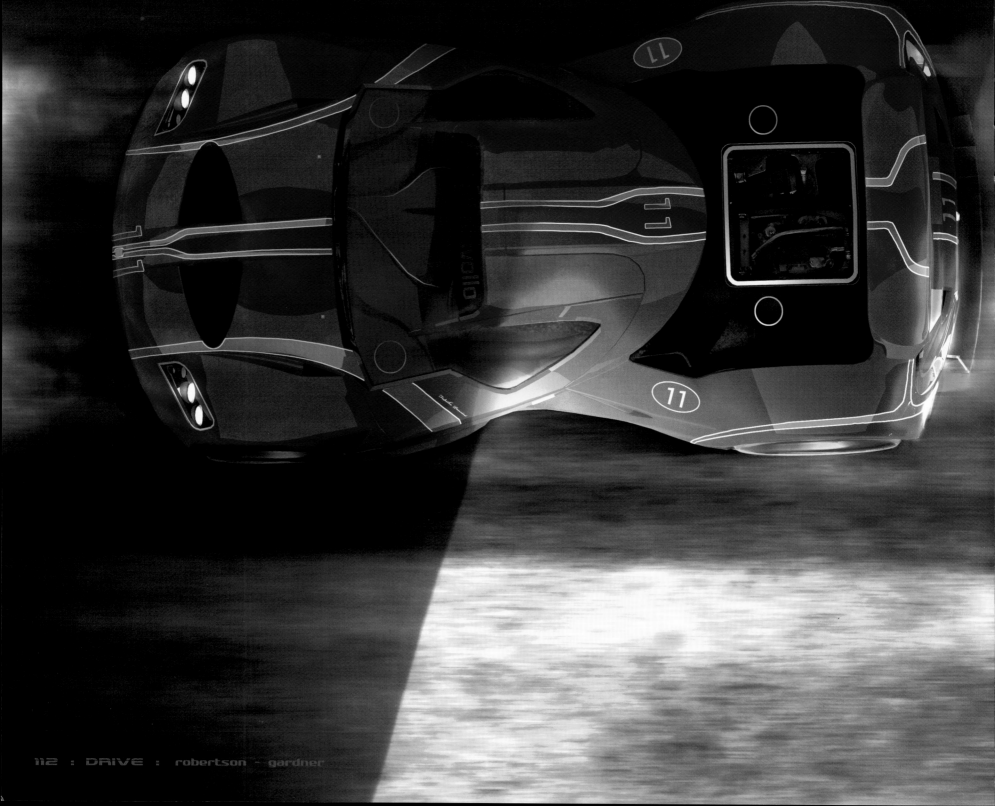

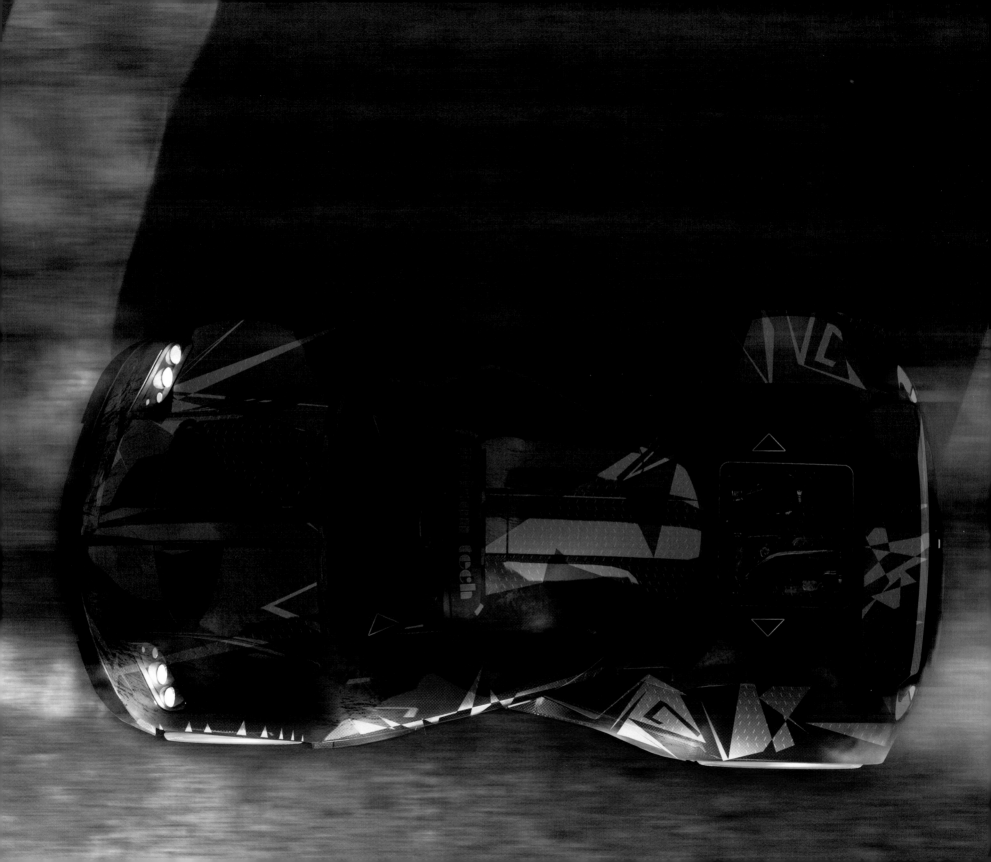

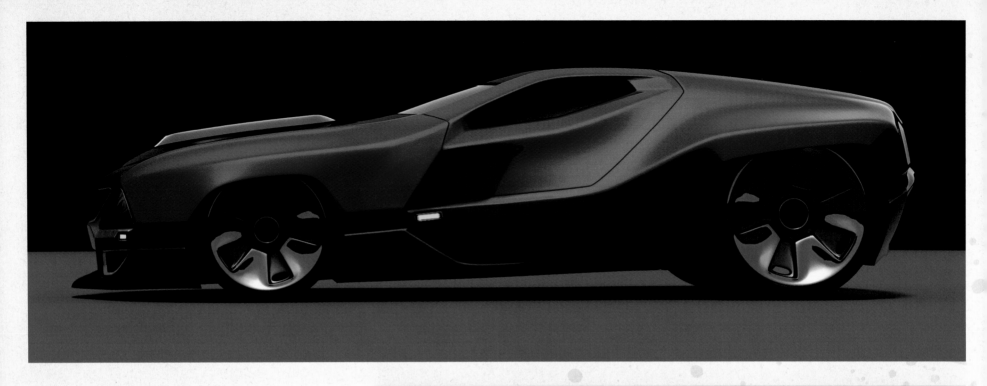

PRO SPORT: Power Slide

I wanted to do a kind of modern muscle car and I chose to develop the sketch at the bottom right into the car above. The first marker and pen sketch is all about a big front engine with a monster hood scoop and aggressive angular forms reminiscent of the late '60s and early '70s-era muscle cars. After moving the sketch into Photoshop, I dropped the wheel arches over the tops of the tires, which I felt gave it an old muscle-car feel. So then to modernize it, I quickly refined the forms and graphics. The 3D model and Photoshop rendering at the top of the page was the first version of the "Power Slide."

The rendering on page 116 shows a slightly softer version of the car than the one above, but I feel it still accomplishes my goal of a muscle-car feel with a modern twist, with some artistic liberties taken, of course, in the areas of functional doors, ground clearance, headlight heights and leaving enough room for wheel travel! Hey, if I can't have fun designing a cool make-believe car for a book, life is going to be pretty dull.

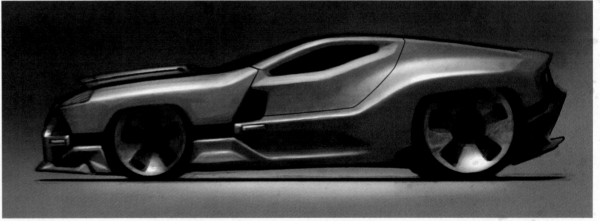

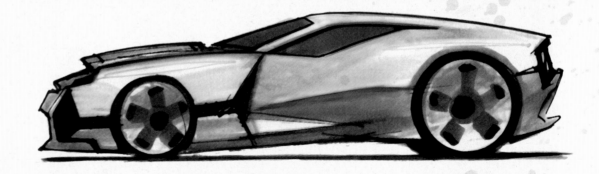

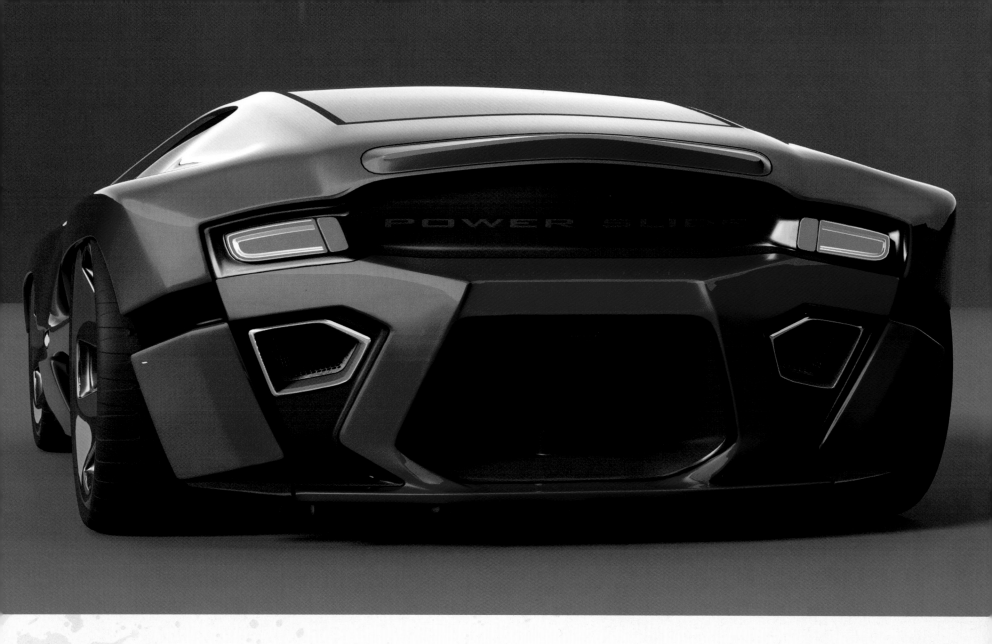

PRO SPORT: **Power Slide**

The rear view takes on a more modern feel than the side view, in my opinion. A hint of some underbody aero-sculpting, big exhaust ports and visually floating red body panels all help to get this car moving toward the future.

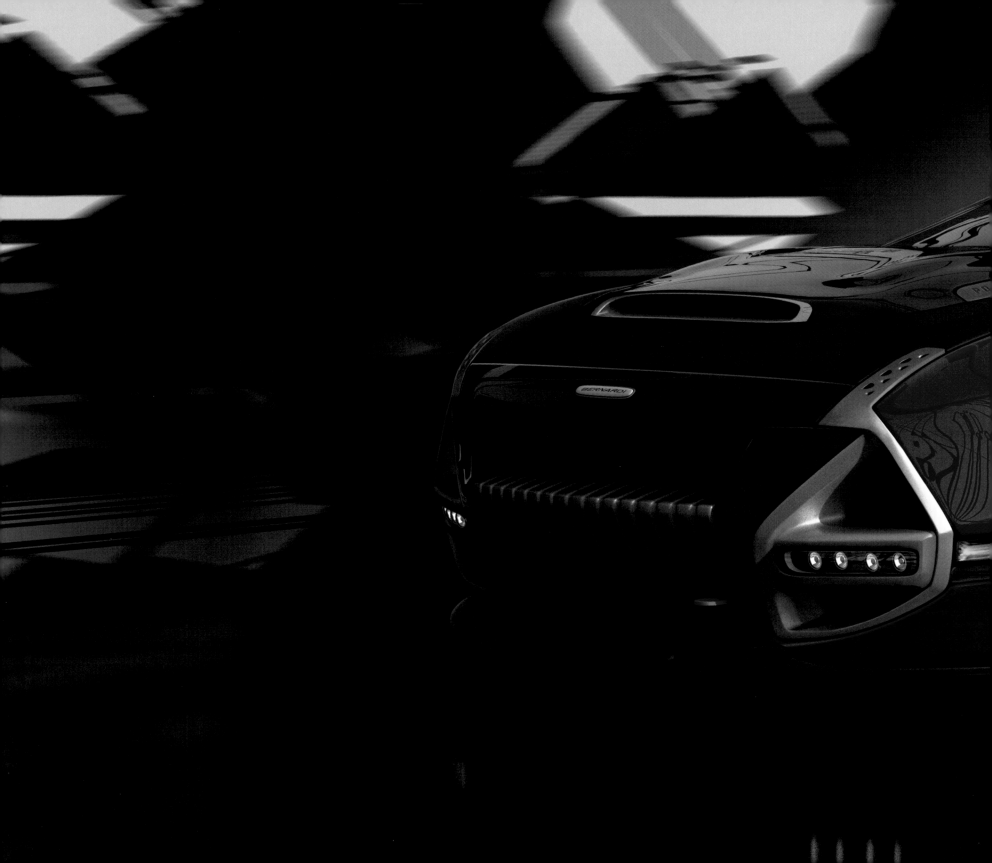

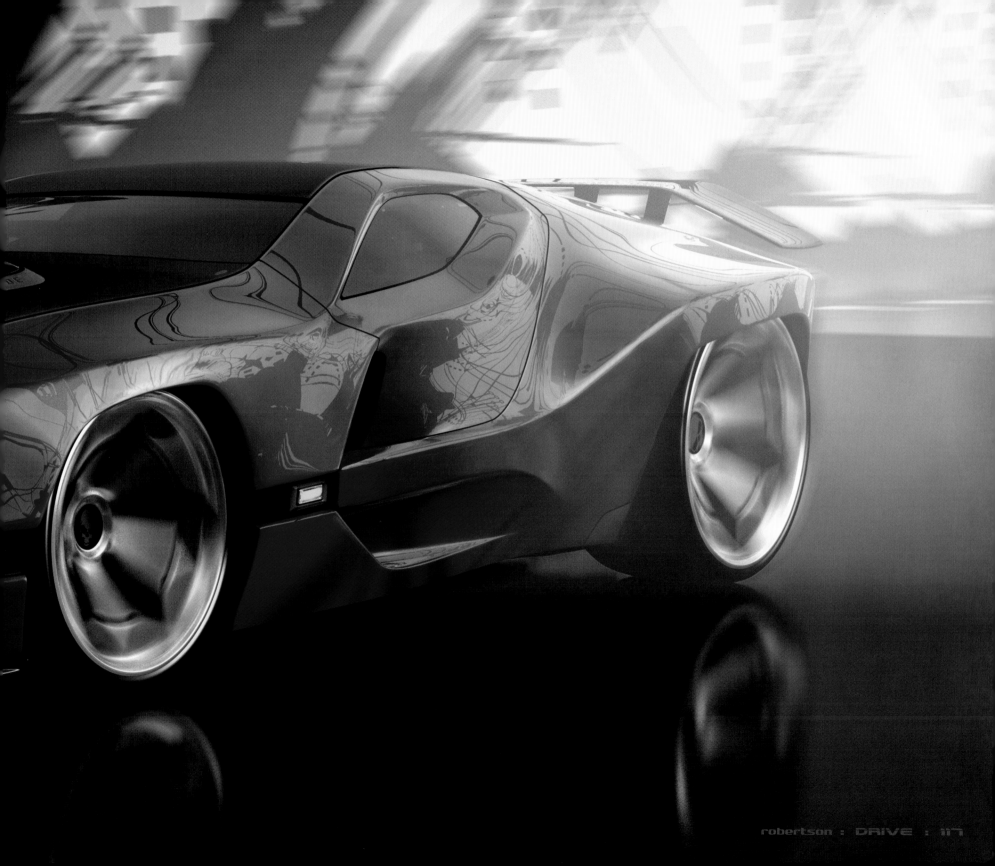

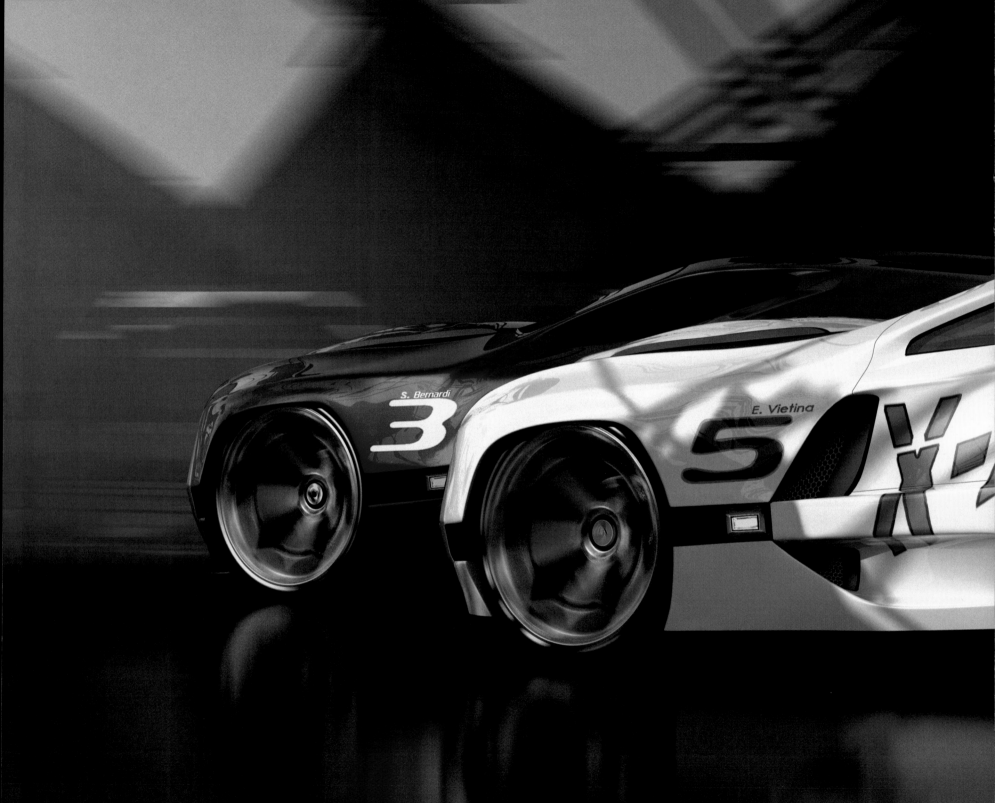

Having made a usable 3D model of the "Power Slide" in modo, why not duplicate it and go racing!

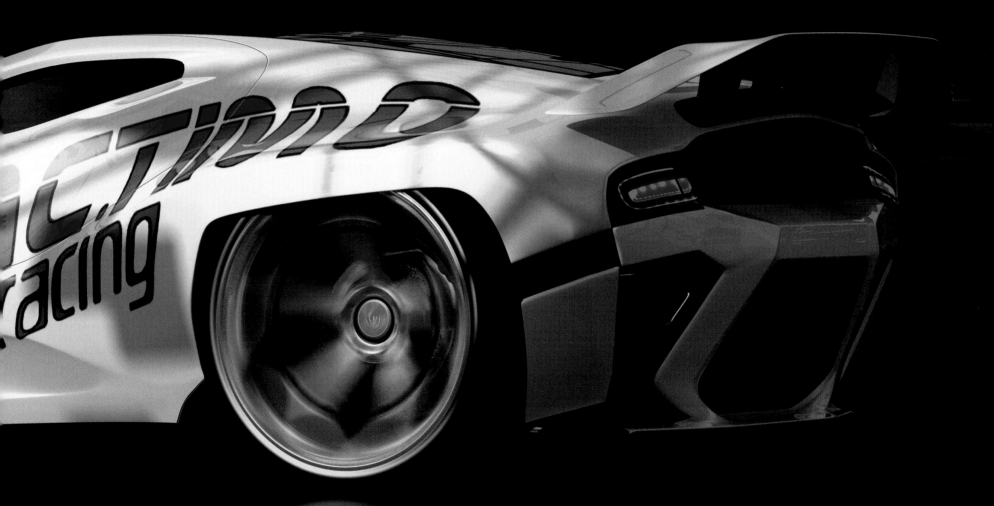

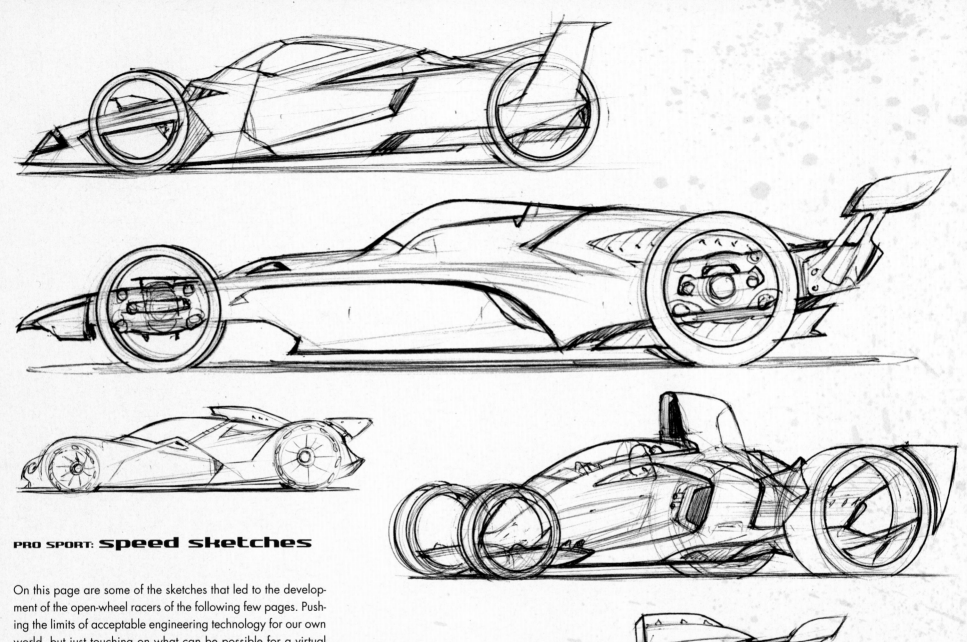

PRO SPORT: speed sketches

On this page are some of the sketches that led to the development of the open-wheel racers of the following few pages. Pushing the limits of acceptable engineering technology for our own world, but just touching on what can be possible for a virtual game world, I think the sketches here strike a nice balance of futurism coupled with the visually familiar.

The car on the following pages pushes a bit further stylistically into a sci-fi racing realm with a 3D study I did in modo. The resulting modo renderings have been heavily stylized inside Photoshop through the application of quite a few artistic filters.

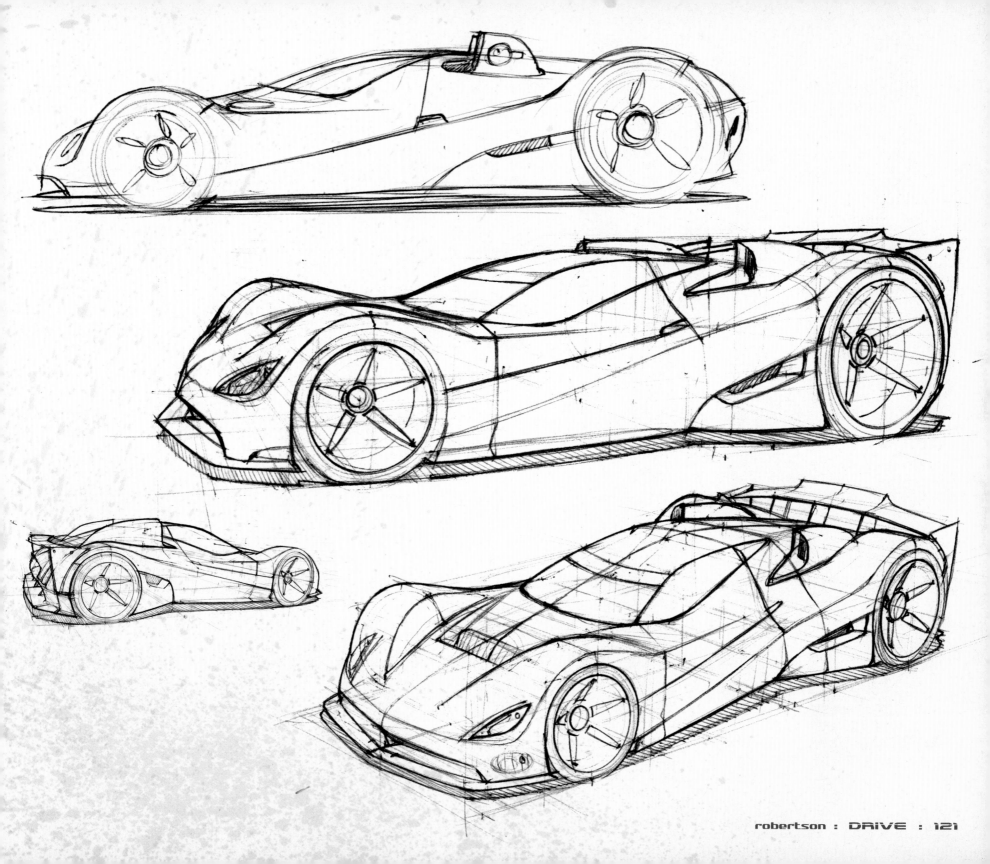

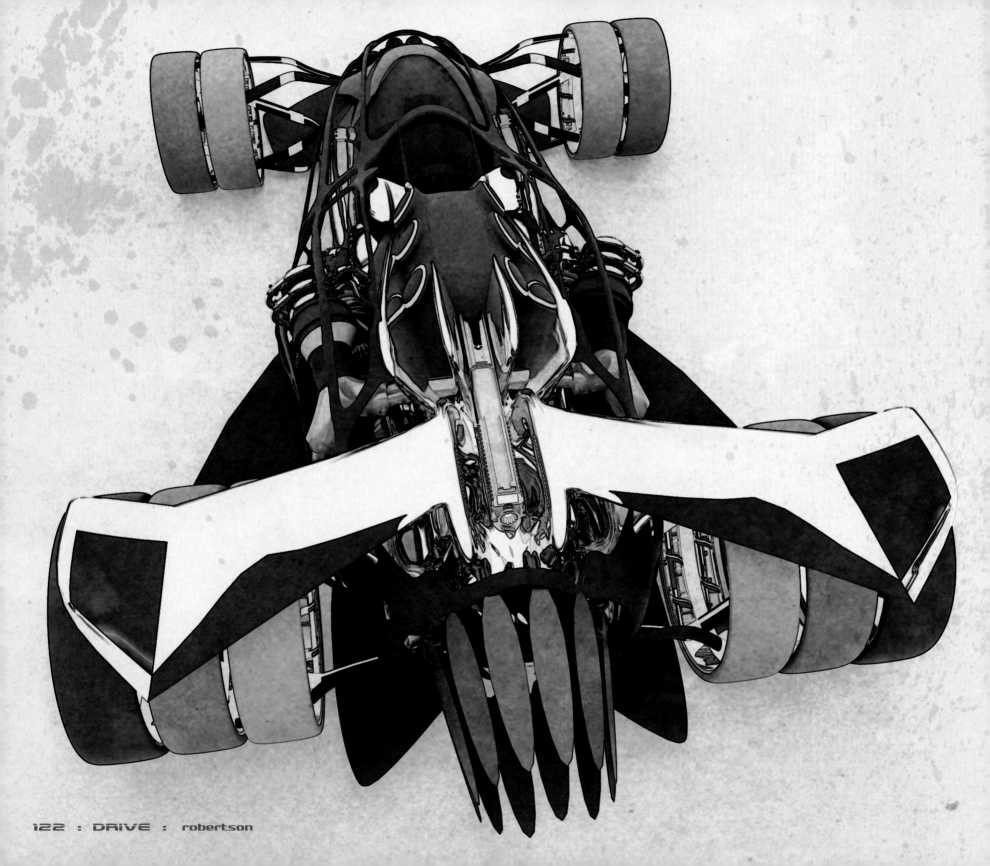

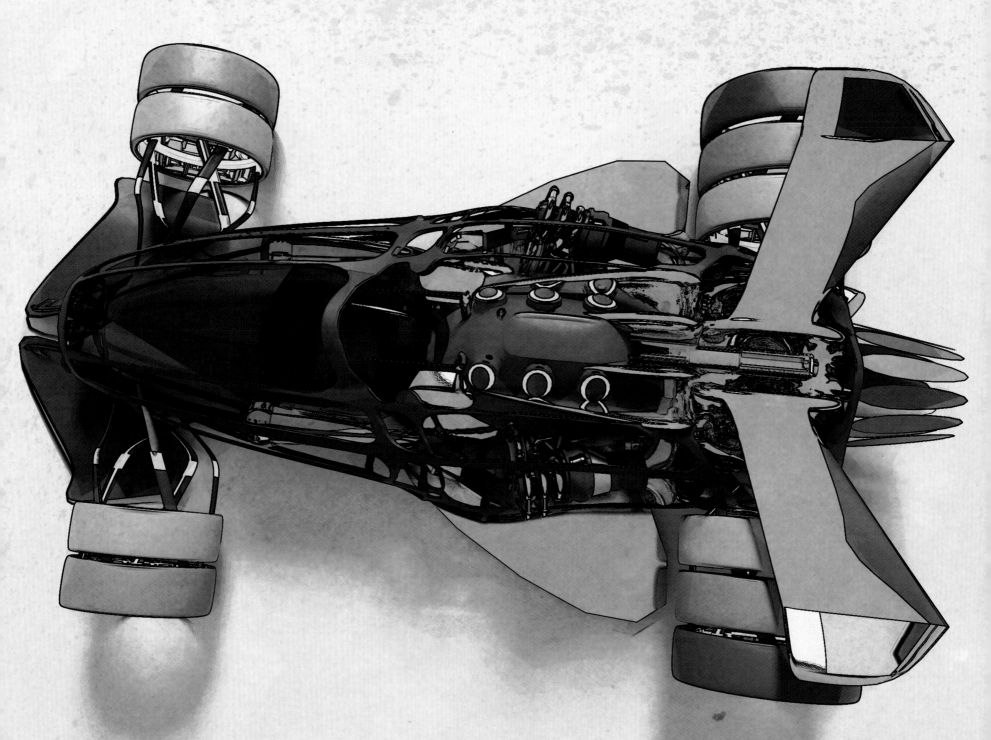

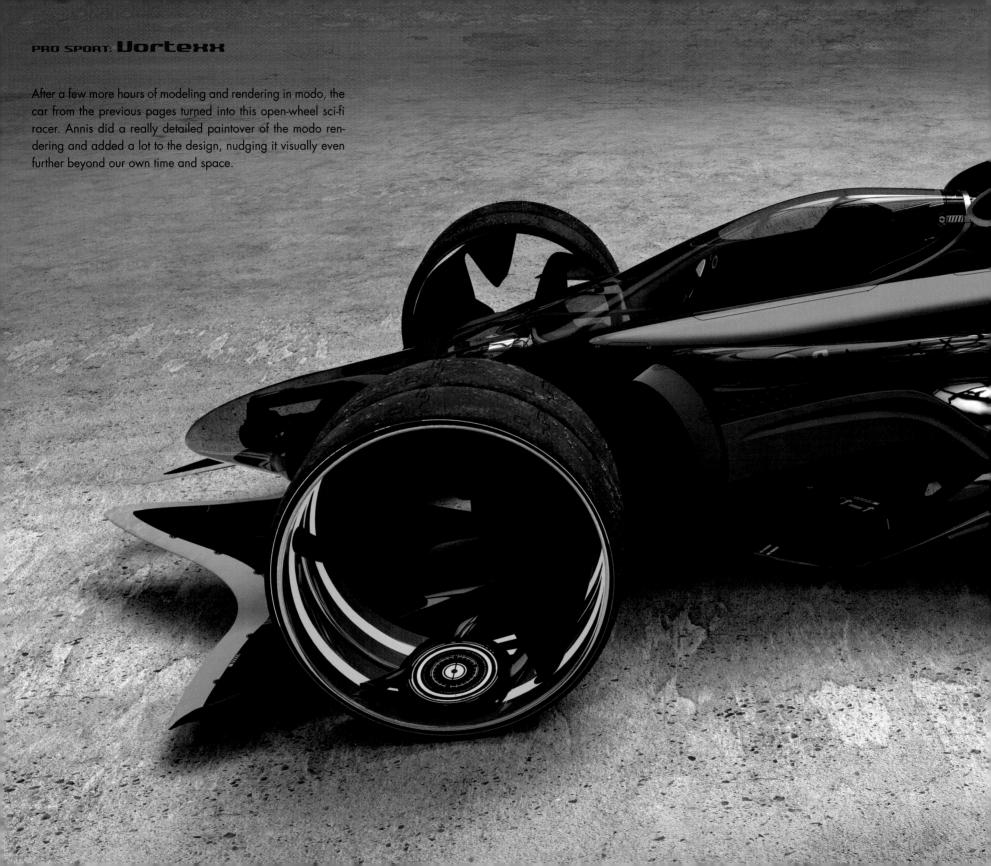

After a few more hours of modeling and rendering in modo, the car from the previous pages turned into this open-wheel sci-fi racer. Annis did a really detailed paintover of the modo rendering and added a lot to the design, nudging it visually even further beyond our own time and space.

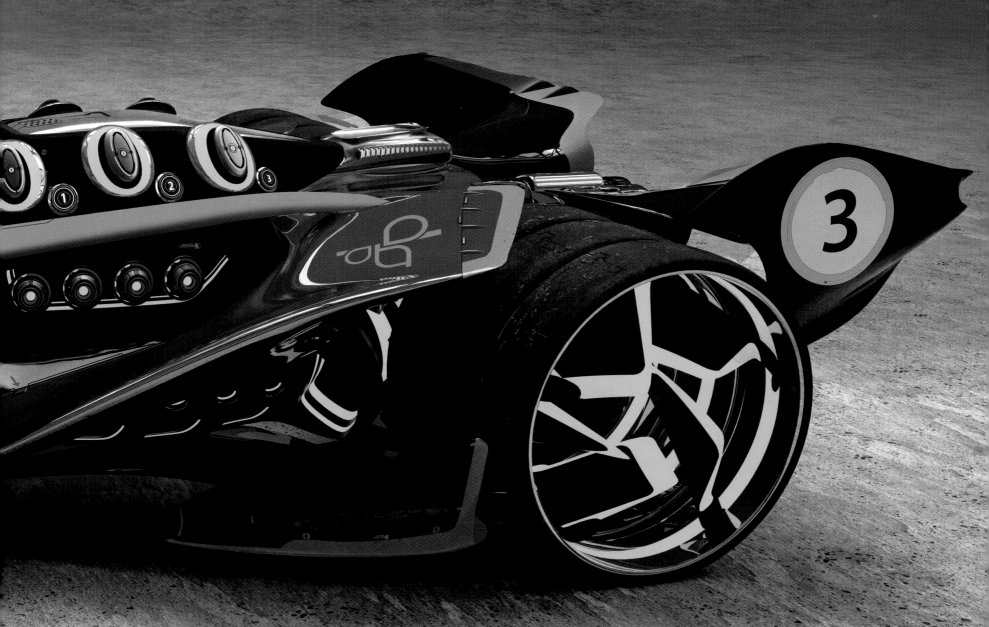

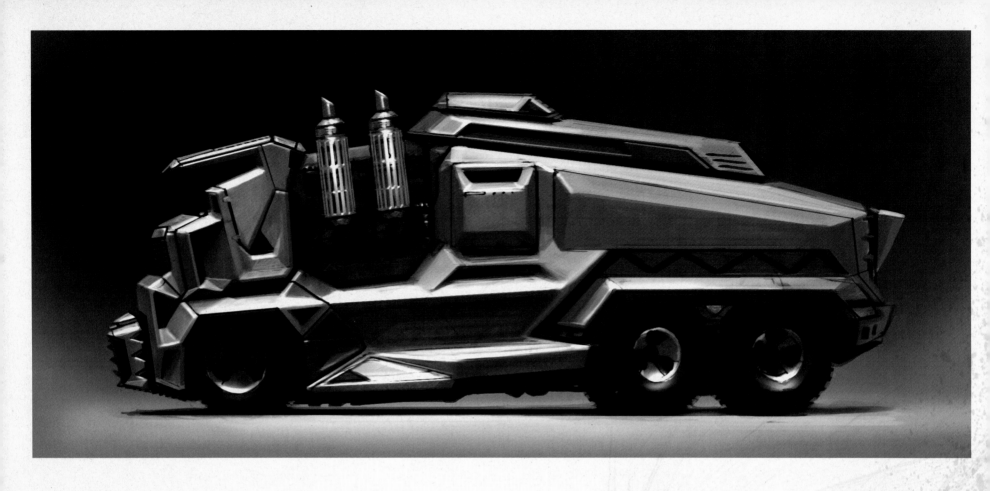

PRO SPORT: truck sketches

Along the bottom are a few more quick marker and pen warm-up sketches for more traditional utility trucks that could offer some brute force to any racing team. The top sketches were paintovers done in Photoshop of the marker sketches below.

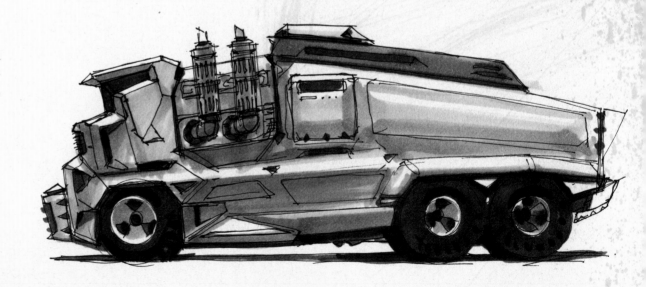

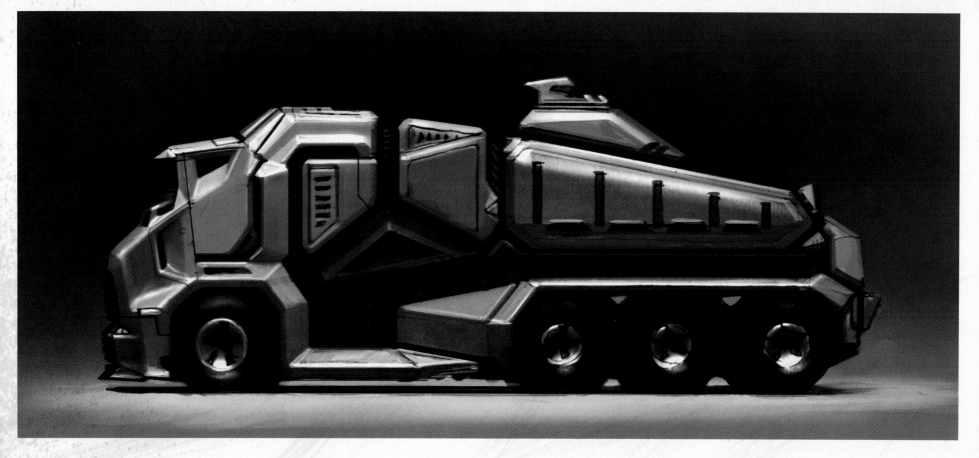

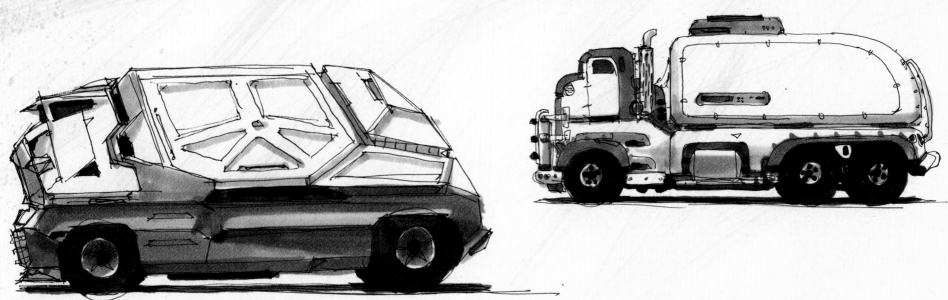

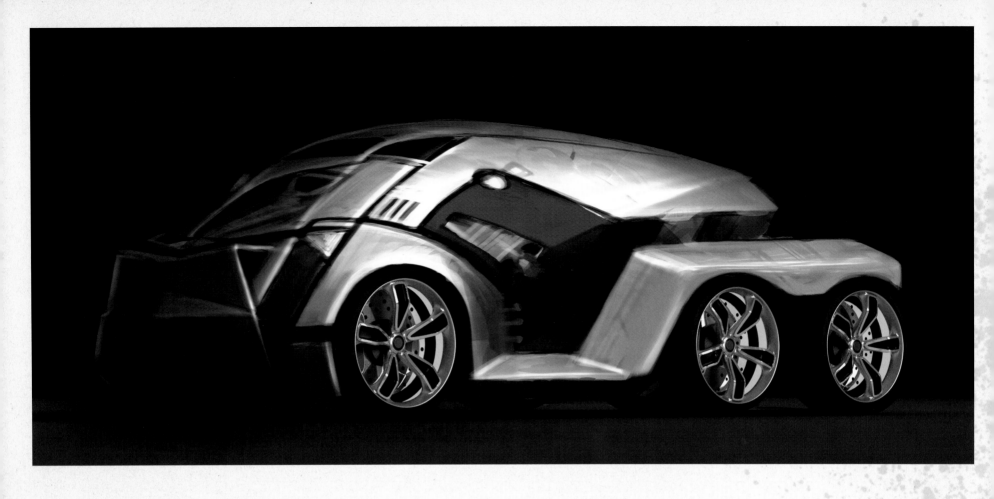

PRO SPORT: truck sketches

More, brute force trucks with big bumpers and even bigger attitudes. All of our tools and techniques are represented on these pages: pen and marker sketching, 3D wheels from modo, digital photo collage and painting in Photoshop.

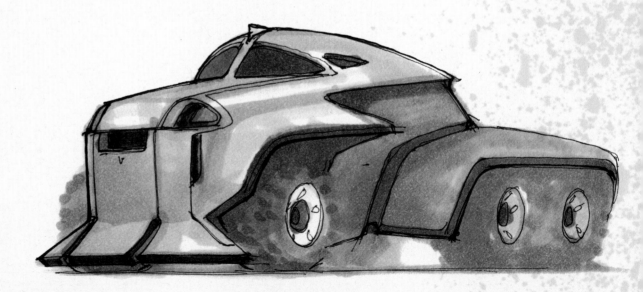

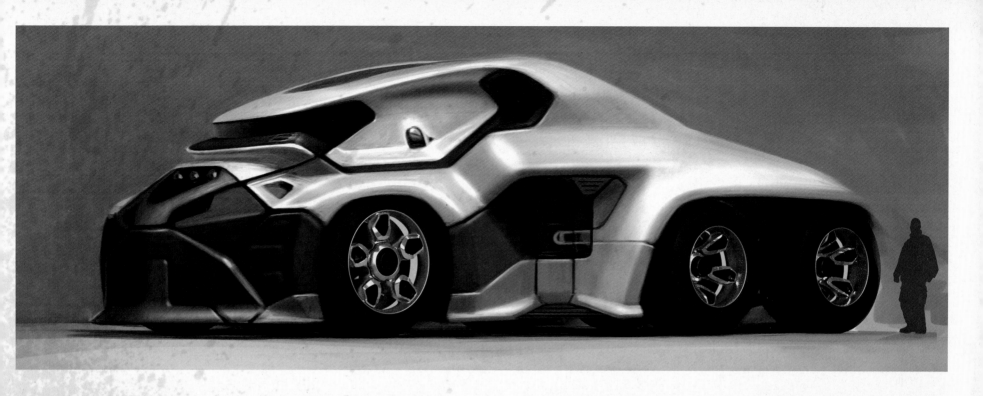

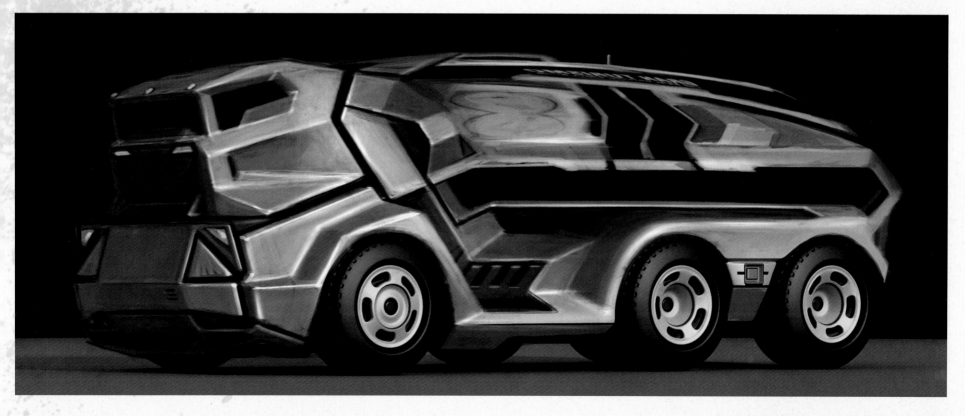

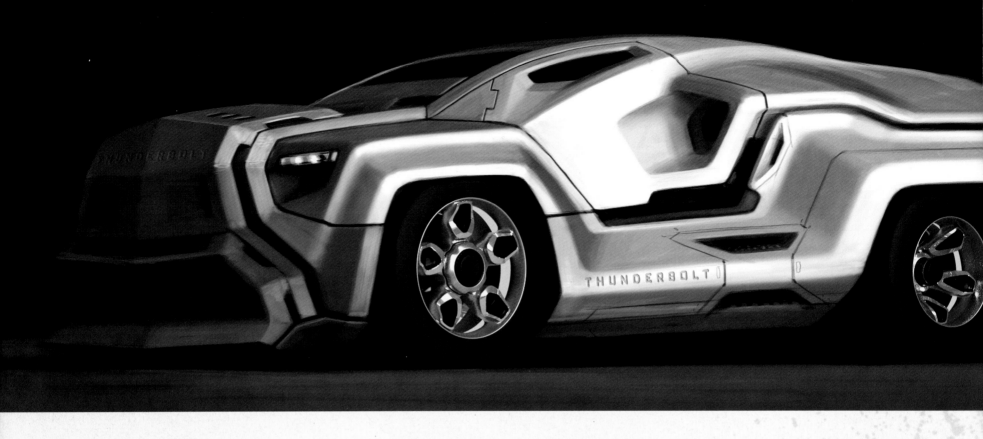

PRO SPORT: **truck sketches**

The "Thunderbolt" (above) borrows a bit of the form language from the "Power Slide." The idea was to design a lower style of brute force vehicle to compete against the taller trucks, but to do it on a similar-sized chassis. The other concepts on these pages take a more sci-fi direction and have a few more free-flowing lines. During the production of this book I made a visual research visit to the Oakland Air Museum and took a few hundred photographs, mostly of old military aircraft. A lot of the bits and pieces of those planes were used as part of the base photo collage we painted over in the creation of some of our vehicle concepts. On the bottom of the far page, the modified canopy elements and air intake on the side give this road machine a strong visual connection to military aircraft of the past. It's really fun to go out and do visual research at museums and junkyards and later to recombine the elements of your photographs into new and strange vehicles that still retain a hint of visual familiarity.

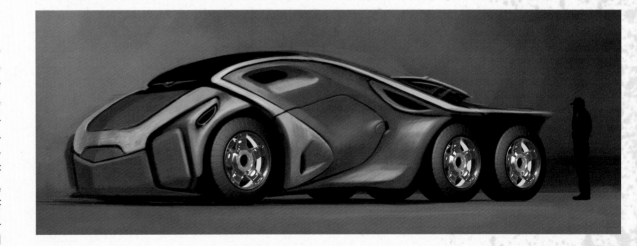

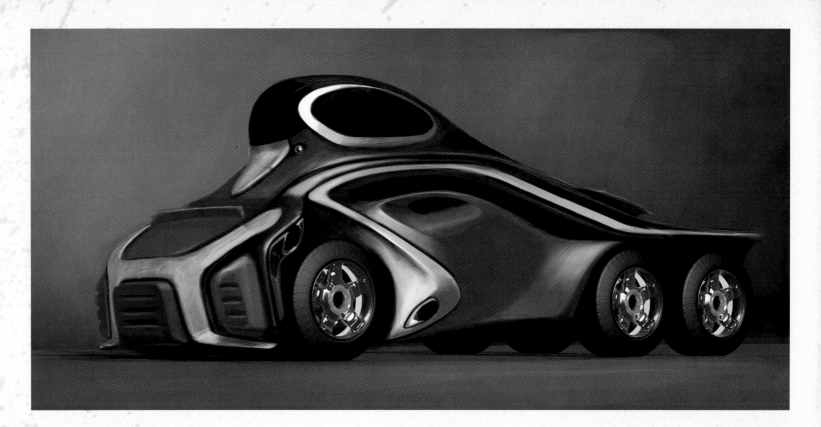

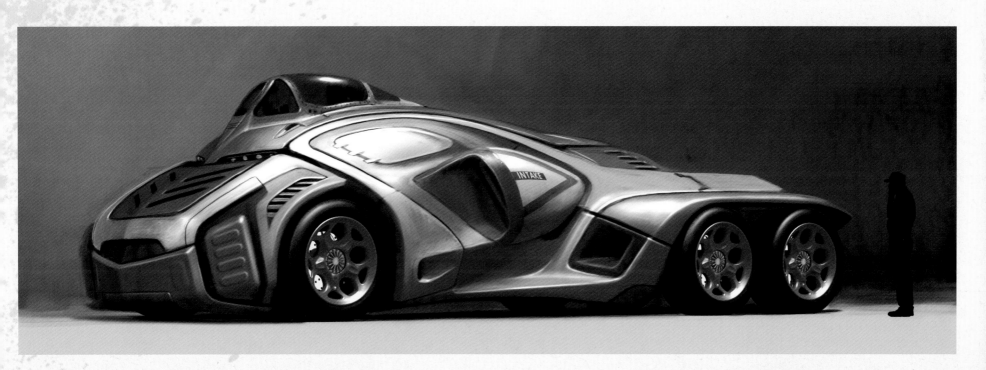

This concept was intended as some form of fast rescue or emergency vehicle. Flowing lines and organic forms take this utility vehicle into a different world than our own. Judging by the windshield shape it appears to have been manufactured by the same company as the SR-62 on page 108.

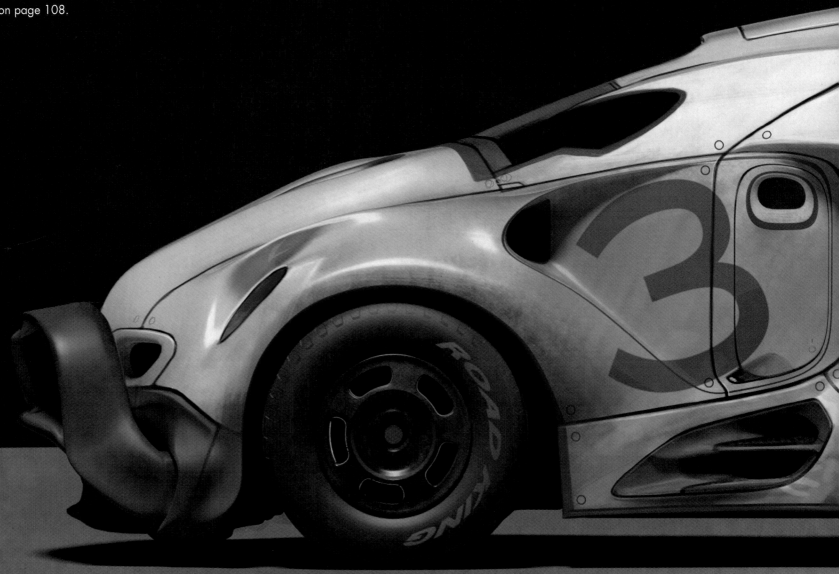

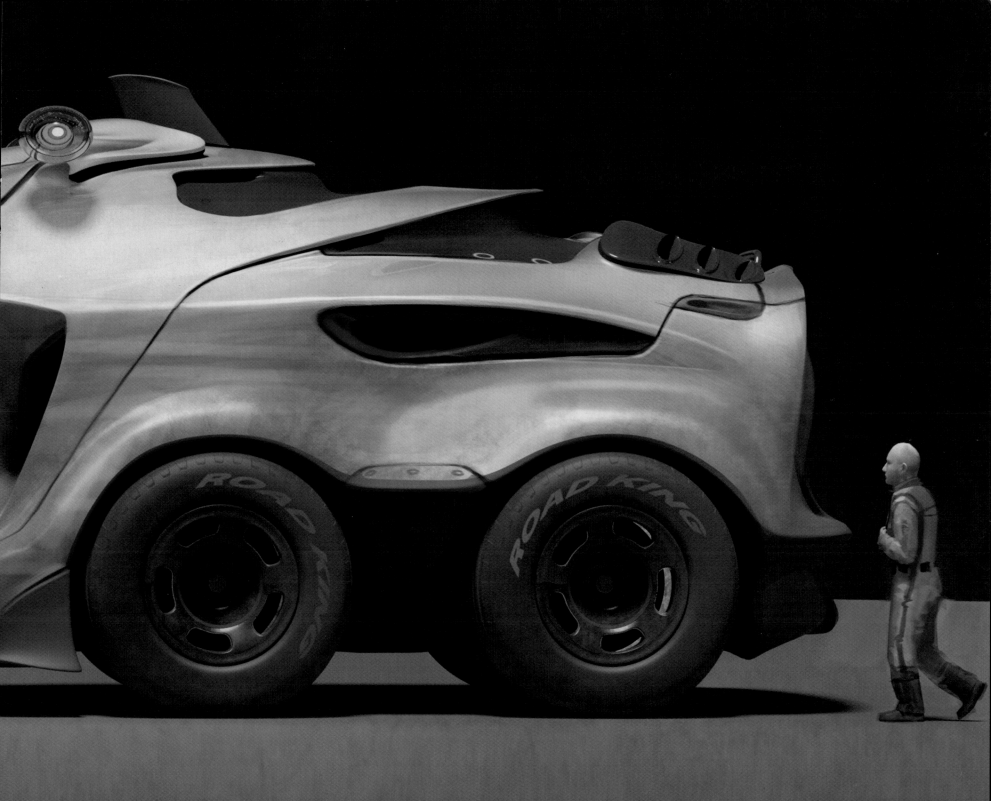

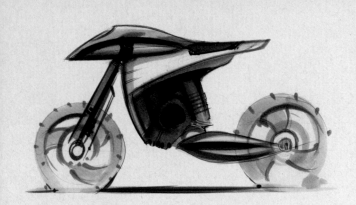

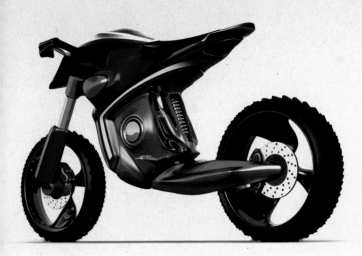

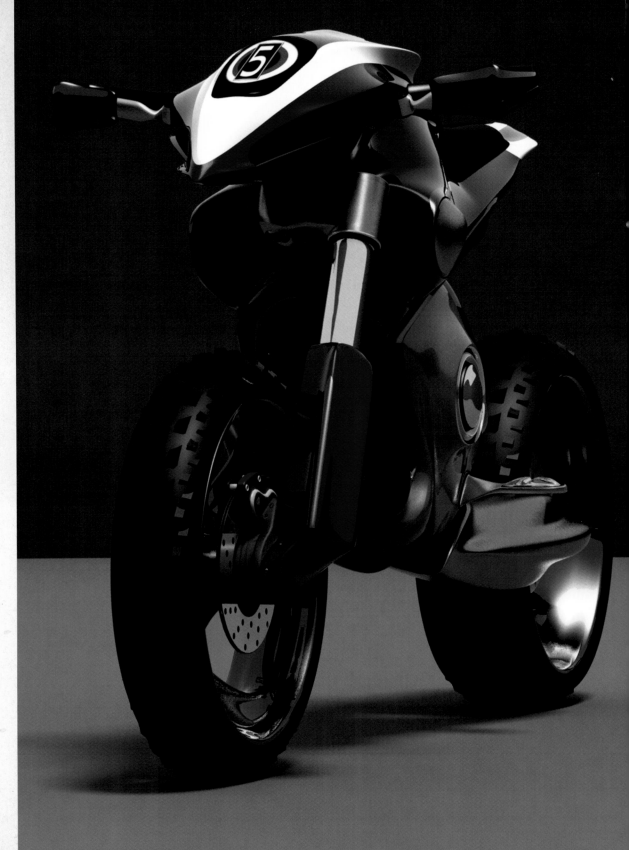

PRO SPORT: **Sport 450**

This is the first motorcycle in the book and there are a couple more in the next chapter. We actually did a lot of bike sketches but never really got around to finishing enough of them to make a chapter, and we only had space for as few as a rising page count kept me from including a lot of the rough sketches. They might be a good thing to post on my blog, now that I think about it. Above, Annis did a marker sketch I liked, so I modeled it up in modo and rendered up these images. The rendering directly above is of the raw model and the two to the right have both had a little work done in Photoshop.

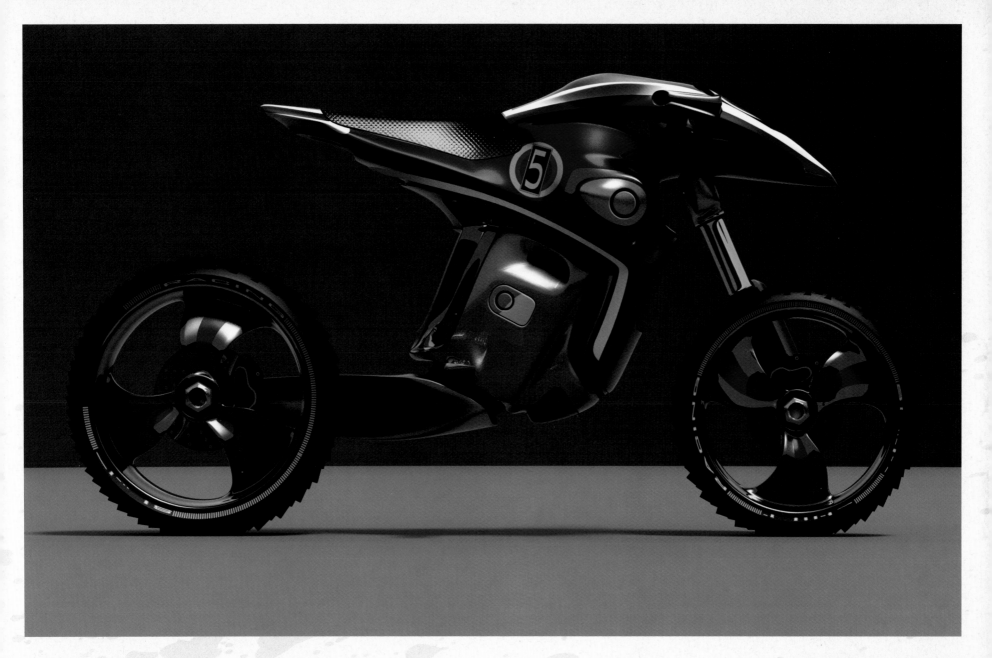

PRO SPORT: Sport 450

This concept is intended to be some sort of off-road bike with decent ground clearance and bit more style at the expense of function than you see in the dirt bikes of our reality.

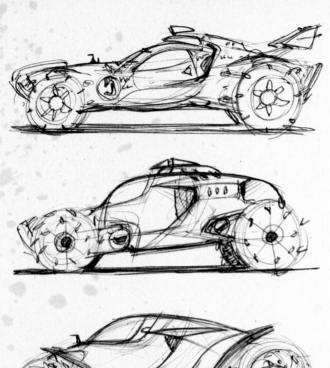

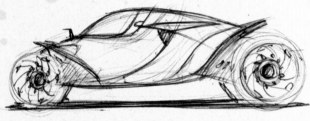

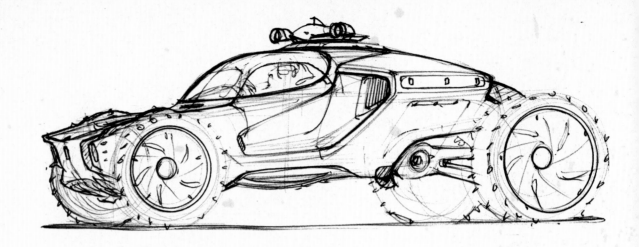

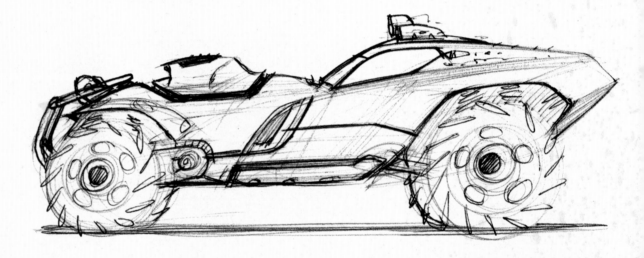

PRO SPORT: off-roaders

These pages feature some quick pen and marker sketches for various off-road racing concepts. As mentioned before, I really enjoy doing wide open concept sketching like this when I can move the big elements of a vehicle around from sketch to sketch, in search of a design direction to develop further. Some have the cabin forward, some back, some have the engine at the front, some at the rear.

The combinations are many and the ideas flow.

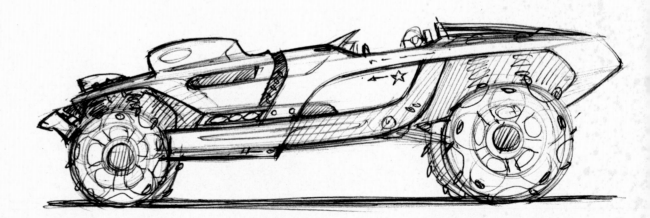

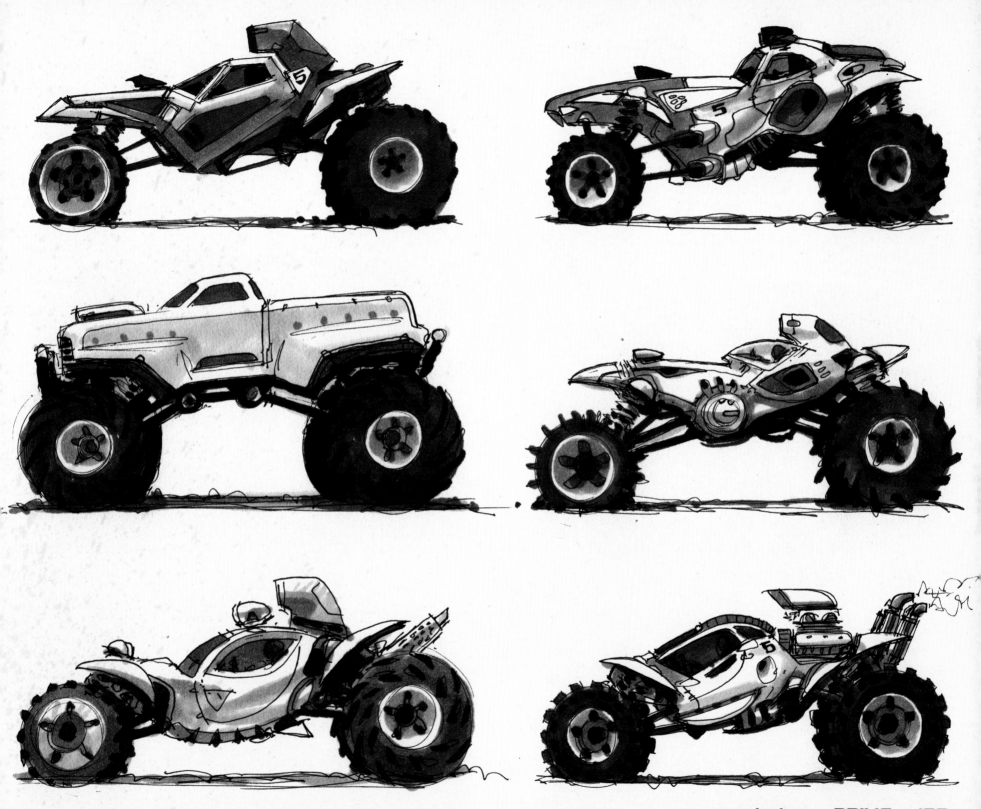

PRO SPORT: Superlight 700

The observant reader will recognize that this vehicle concept is a new proportional study of the first off-road vehicle in chapter one, with some surfacing modifications as well. The proportion, silhouette and stance of a vehicle design so strongly contribute to its initial appeal, that having the ability with 3D programs to fairly easily deform one model into another new concept is really great. Of course sharing wheels from one vehicle to another is also fun. In the last chapter of this book we get much more into this concept of digital "kit-bashing."

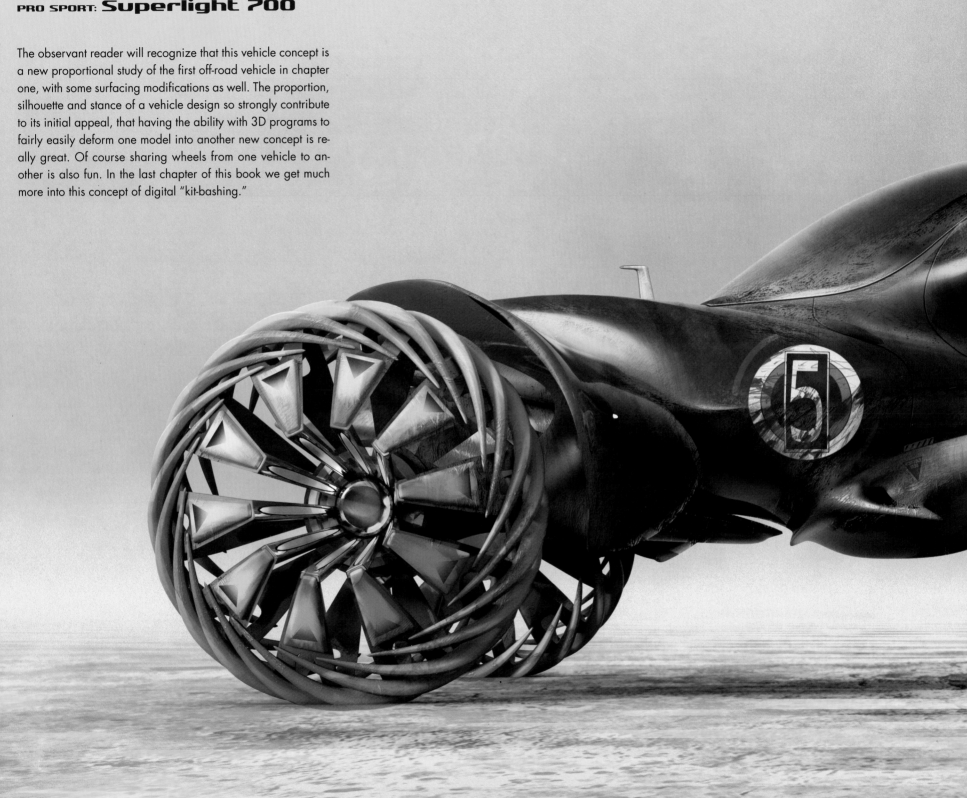

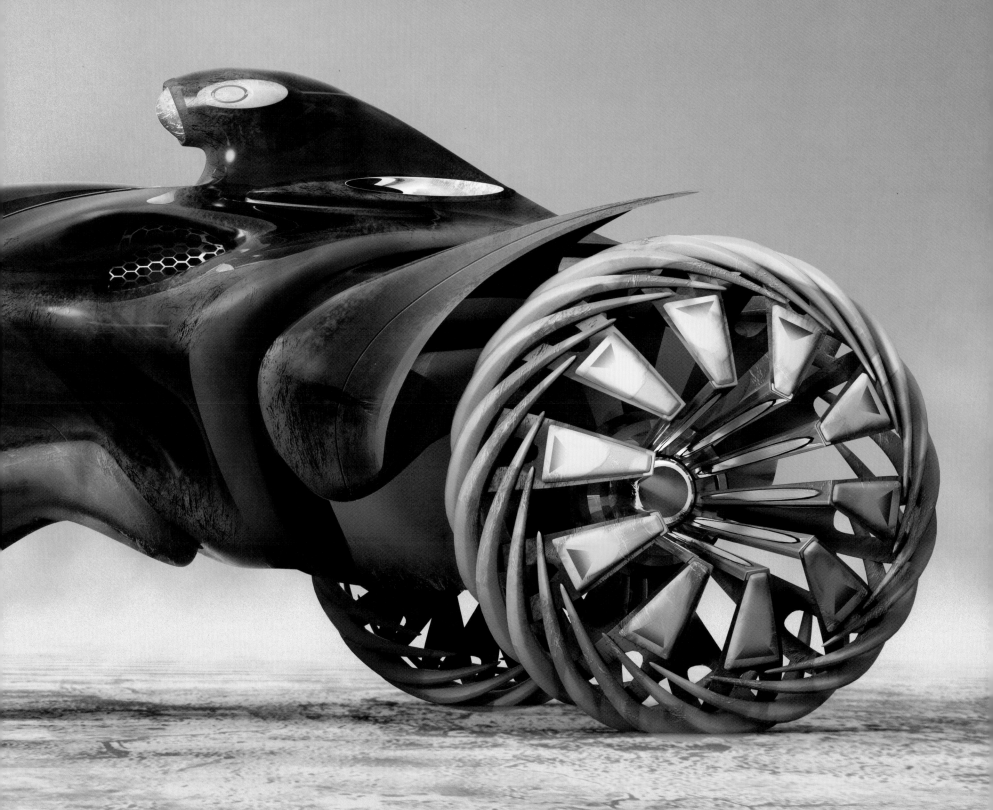

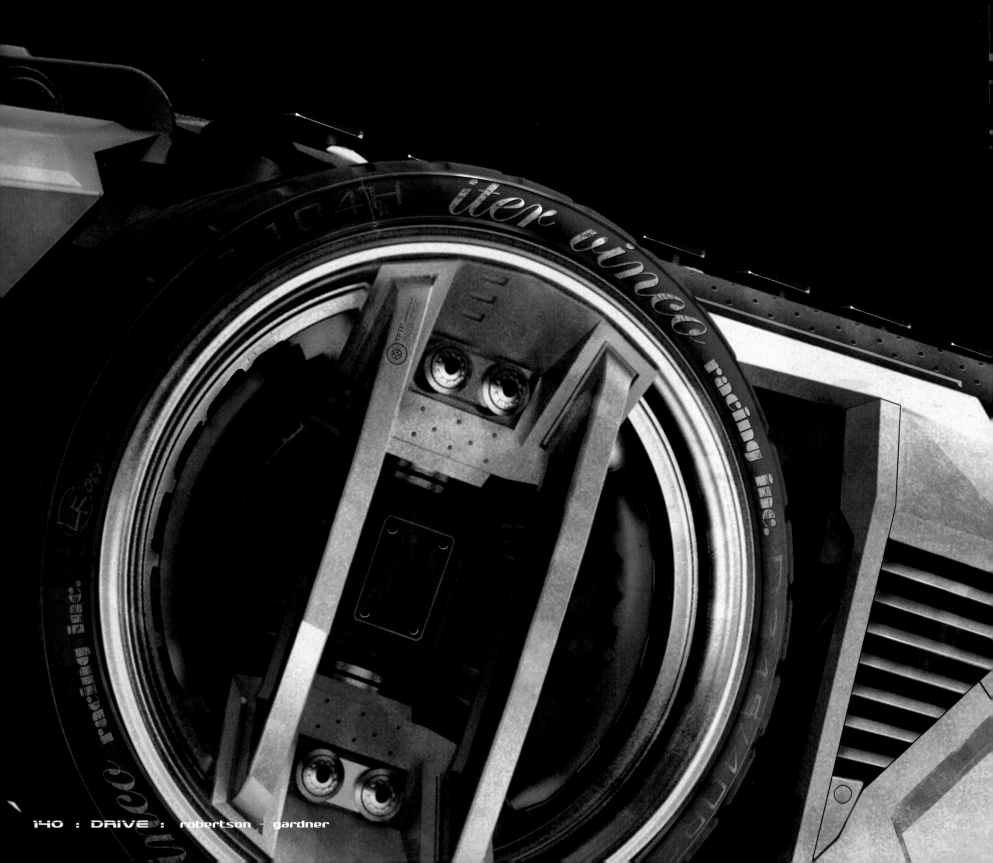

The ease of use of today's modeling and rendering programs, along with the proliferation of digital 3D models available on the Internet for purchase for professionals like myself and for free for hobby modelers, is starting to transform the way in which concept designs for any subject can be generated. My foundation drawing and rendering skills have always been what most would call the "old school" way of doing visual development or concept art. This is not to say that my methodologies stay rooted in the past. On the contrary, I've always sought to reinvent the methods I use to create fresh concept designs. This brings me to the presentation of the work in this chapter specifically. As I have been observing the trends of people sharing more and more digital content online, I feel we are at a point where using modern tools and techniques, coupled with strong foundation drawing, rendering and design knowledge, is ushering in a new way of stimulating the invention of concept designs and art. We chose the Salvage aesthetic as a way to test these new tools and techniques, and I must say the idea of creating vehicles from basically found objects or scrap was the perfect topic to explore the possibilities of a reworked pipeline for myself and my interns.

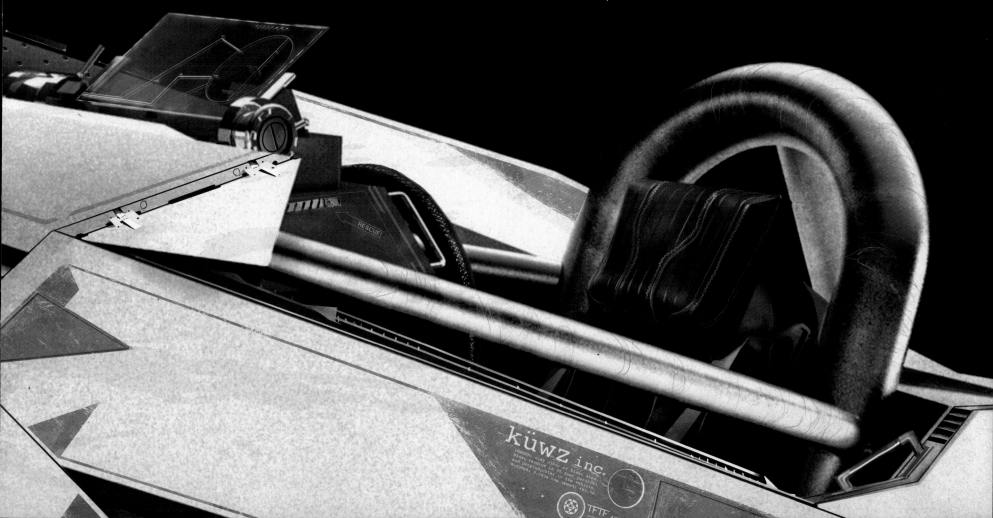

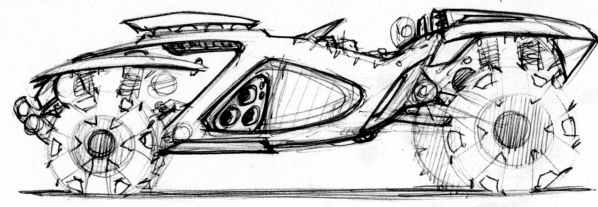

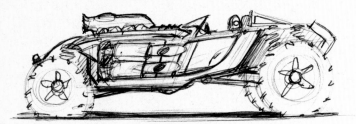

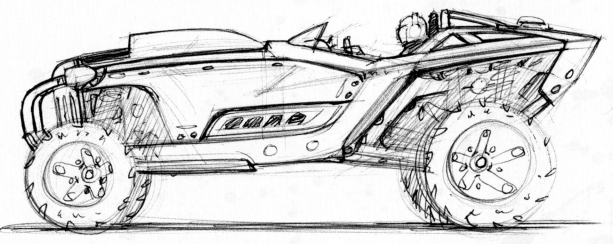

SALVAGE: off-roaders

We learned through our integration of the 3D tools that a lot of time can be wasted in the creation of a new vehicle if you do not enter the 3D program with a clear intent. So this is where the traditional drawing skills are still necessary and allow for us to know where we are trying to go before jumping into the use of the digital tools.

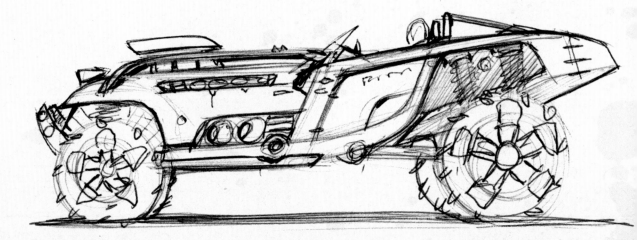

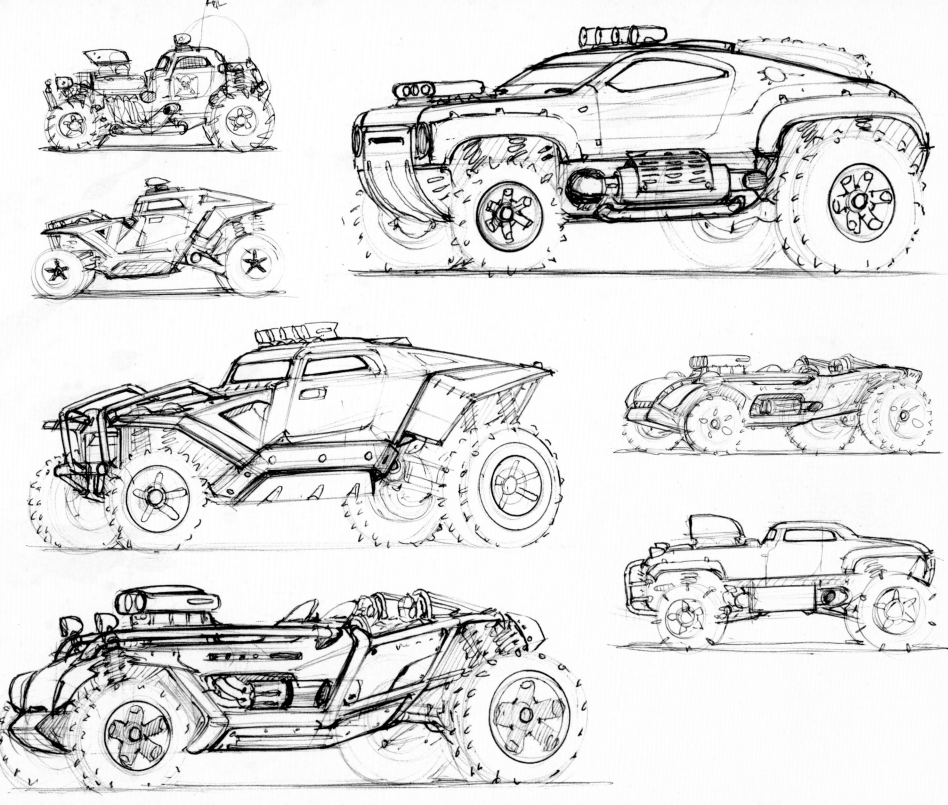

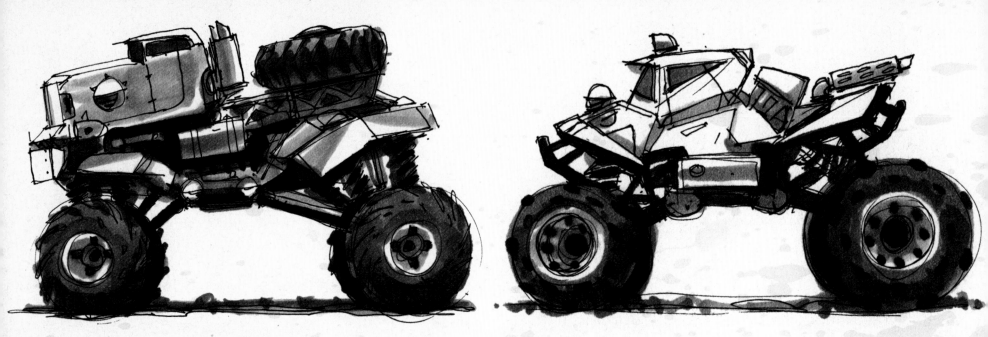

SALVAGE: off-roaders

More marker and pen sketches to establish some quick proportional directions for a few salvaged together off-roaders.

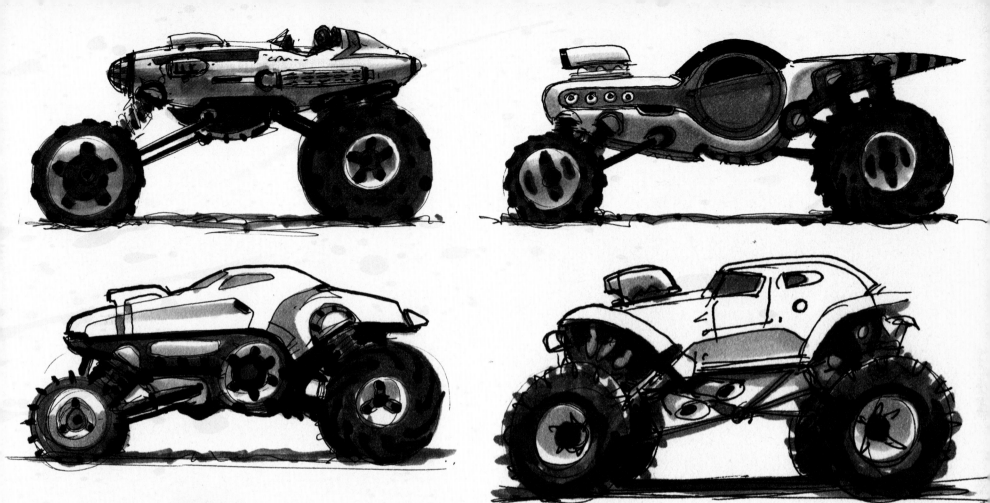

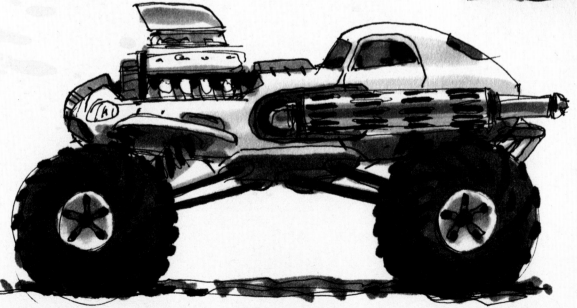

SALVAGE: **off-roaders**

The sketch to the left shows a nice example of mixing a '50s sports car with big V-8 engine, monster-truck-sized wheels/tires and a ridiculously large side exhaust pipe. After doing a sketch like this to audition our new digital pipeline, I might jump onto an online 3D model resource website and buy a V-8 engine model and some wheels and tires. The reason this really works for a salvage style is that the vehicle is supposed to be made from "real stuff," familiar scrap and salvaged parts. Being a big believer in honoring the copyrights of other creators like myself, I chose to invest in purchasing the 3D content for some of our vehicle details and components.

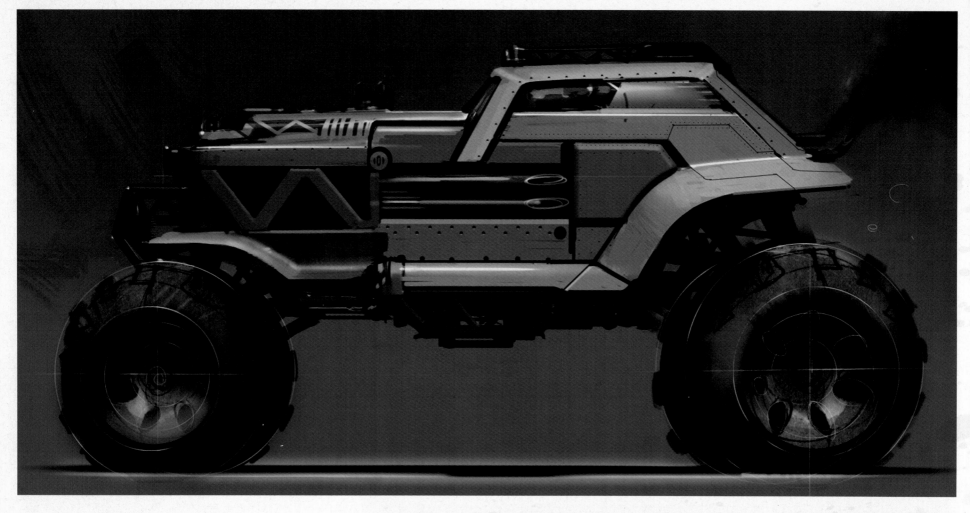

SALVAGE: **off-roaders**

However, should you want the parts to be truly orignal, you need to do the modeling work yourself, no way around it. So quite a bit of our time was spent on modeling as we created the 3D concepts in this book. These sketches Annis did are totally original designs, but they still retain some familiar bits and pieces so they do not become so new we can no longer visually relate to them. This is where the balancing act of using "real stuff" in a concept design comes into the process.

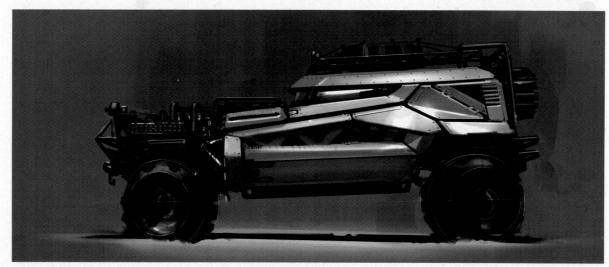

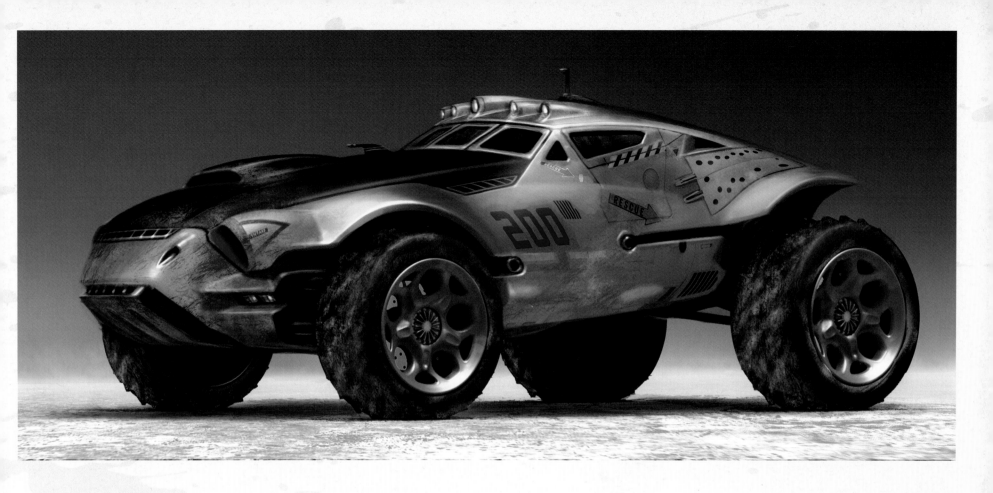

SALVAGE: **Desert Runner**

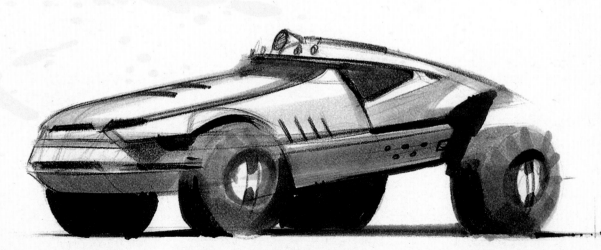

To show something fresh and new, the last thing you'd want to do is use unmodified 3D content you bought online, because if you can do it, so can anyone else and where is the originality in that? So this is where I think that despite the proliferation of all the 3D models online, it is *how creatively you use the content within your own work* that sets the work apart from all the others. In our designs, the main goal was to add realism and believability to the concept of a vehicle that was salvaged and assembled from various bits and pieces found at one super bad-ass junkyard! The rendering above started as the sketch Annis did to the left, and by making my own wheels in modo, painting over the sketch and then using my photos of old aircraft that I warped across the surface, we created the Desert Runner. Danny then weathered it up to add even more realism.

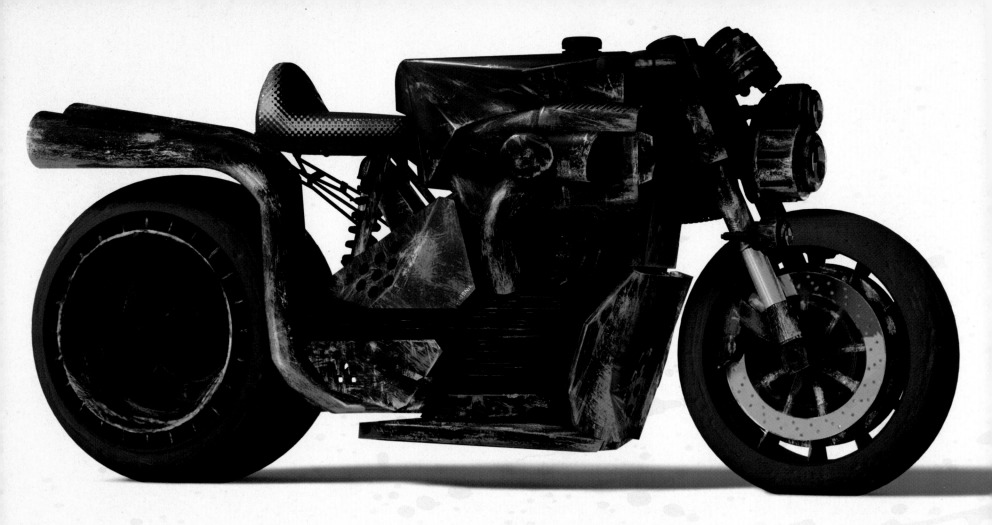

SALUAGE: **bikes**

Whether we worked in modo kit-bashing digital models together, or in Photoshop doing digital painting, or using pen and markers on a white piece of paper, the focus remained the same: create something exciting and in keeping with the stylistic parameters we had created for ourselves. As is often said, "It is not the tools that create the designs and art but the way in which the person skillfully and creatively uses them." The bike on the next page is one that I imagined might have been built from old military aircraft parts. At the top of that page shows how the concept started as a series of simple pen sketches, and then I went into modo to make the wheels, tires and suspension arms before painting the body in Photoshop.

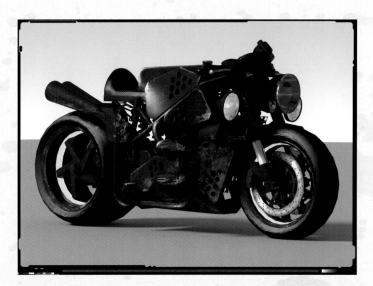

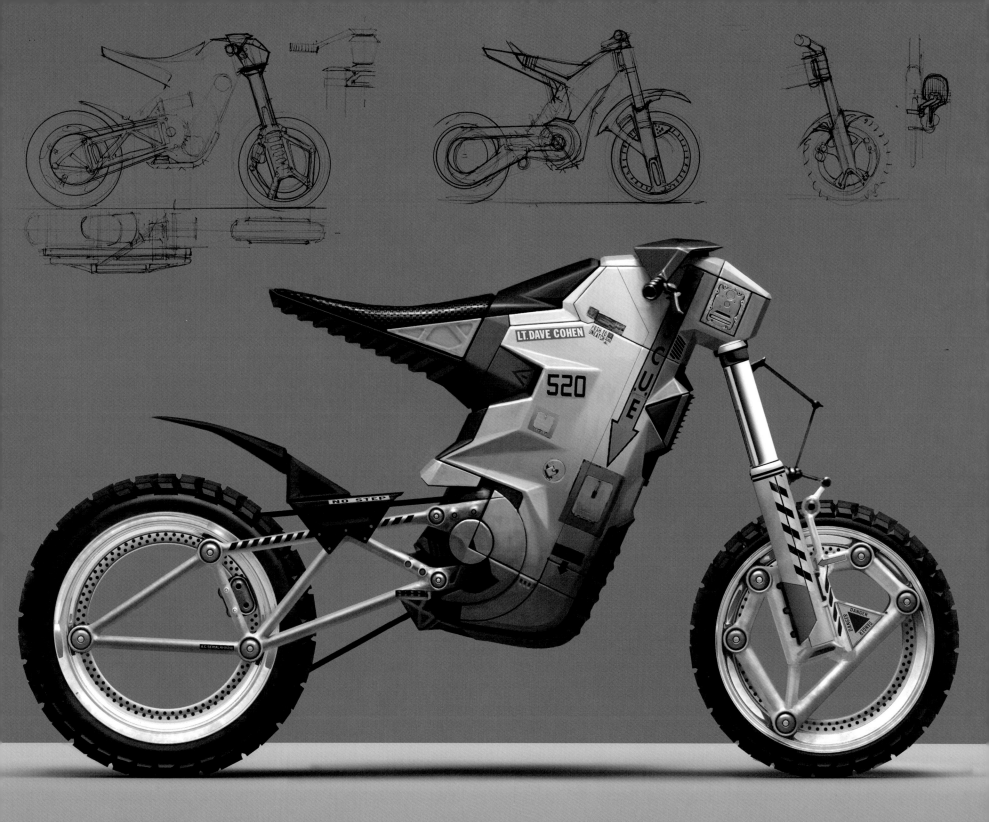

LT.DAVE COHEN

520

NO STEP

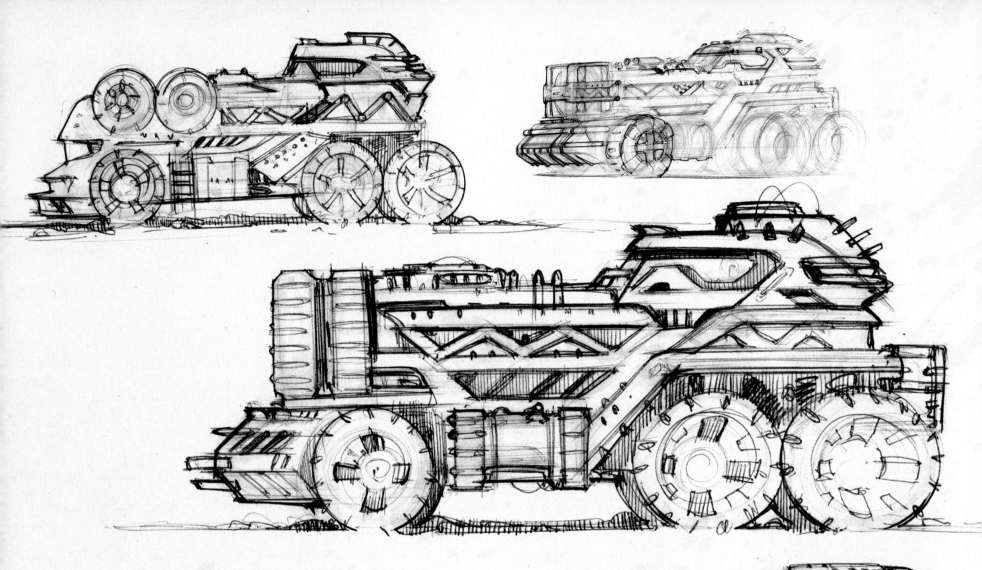

SALVAGE: truck sketches

On these pages Annis searches for a direction of what might become the next Salvage brute to blast through the landscapes of our imaginary worlds.

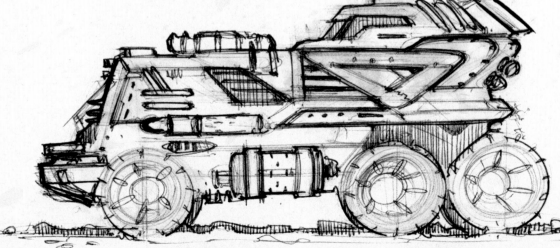

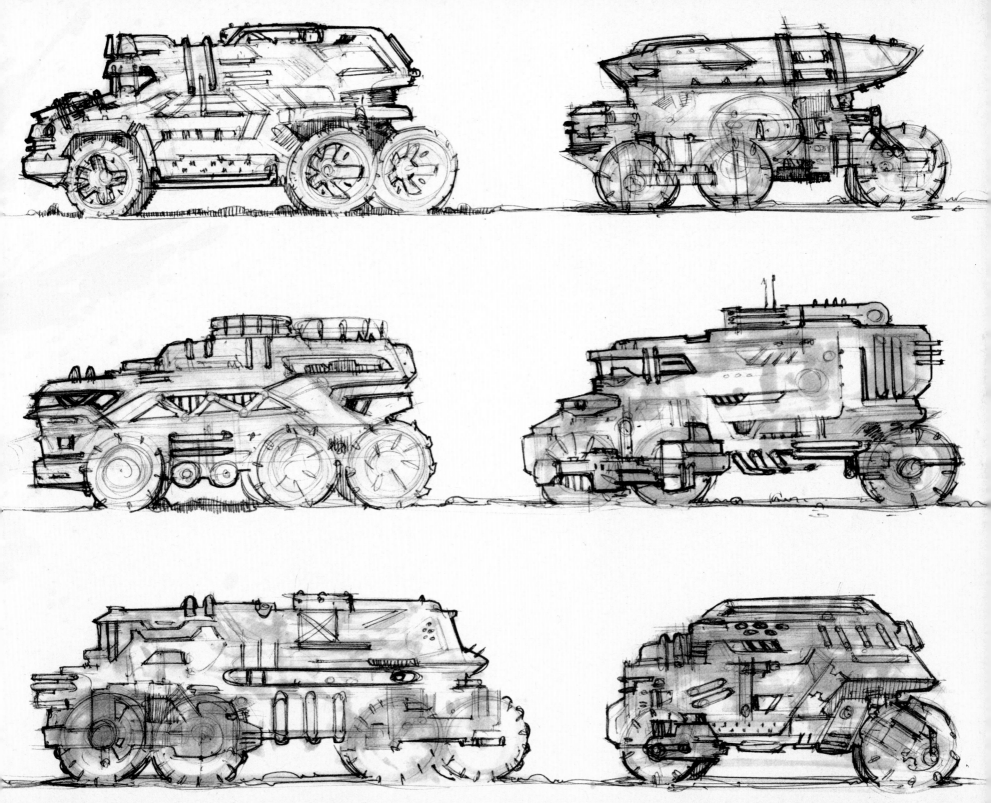

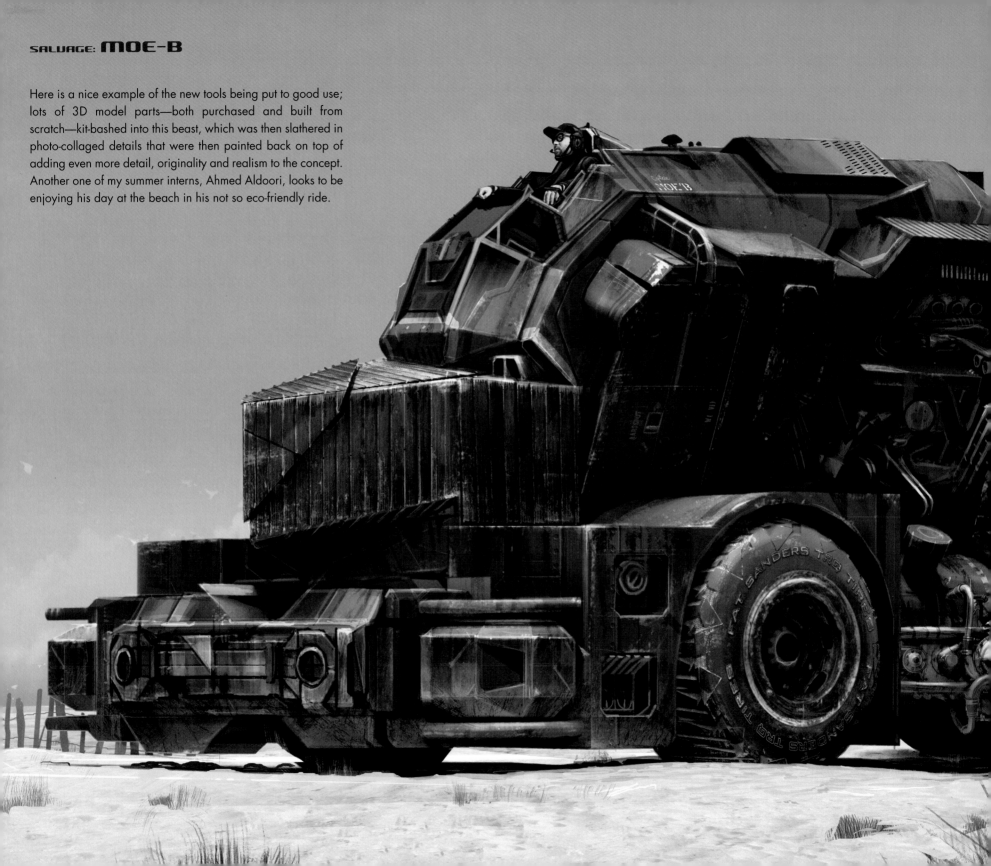

SALVAGE: MOE-B

Here is a nice example of the new tools being put to good use; lots of 3D model parts—both purchased and built from scratch—kit-bashed into this beast, which was then slathered in photo-collaged details that were then painted back on top of adding even more detail, originality and realism to the concept. Another one of my summer interns, Ahmed Aldoori, looks to be enjoying his day at the beach in his not so eco-friendly ride.

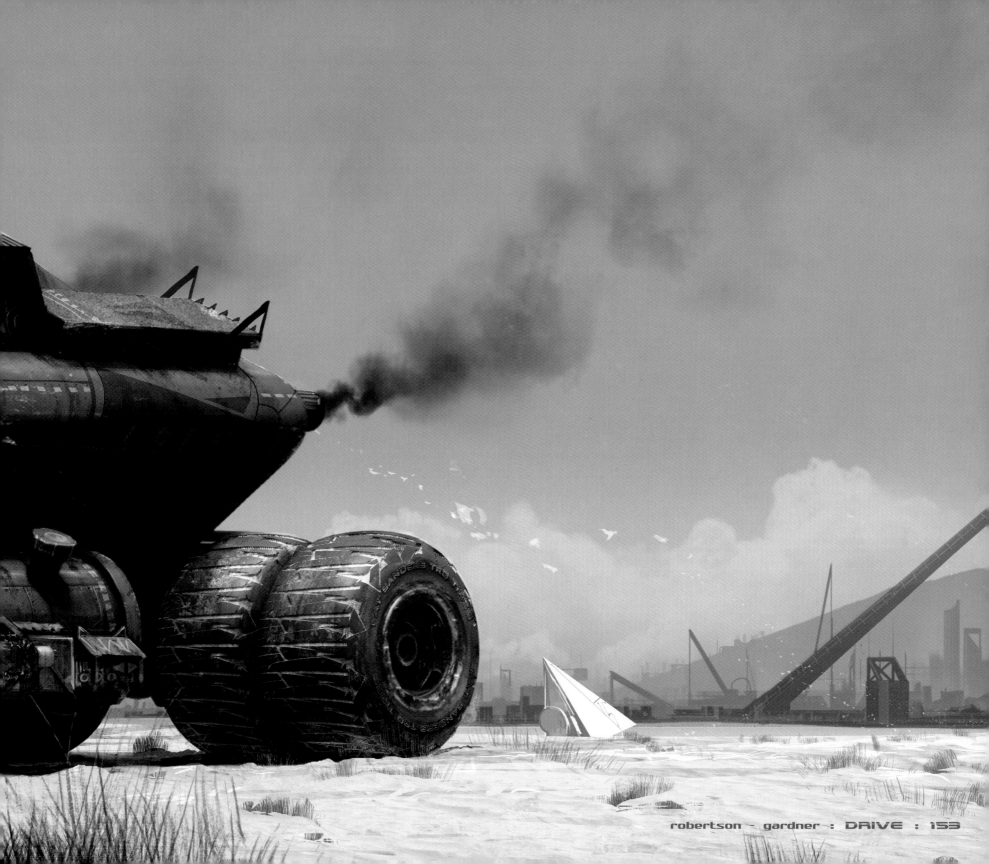

robertson - gardner : DRIVE : 153

A distant cousin of the MOE-B from the previous page, the RHINO gets some added traction from another set of duelies.

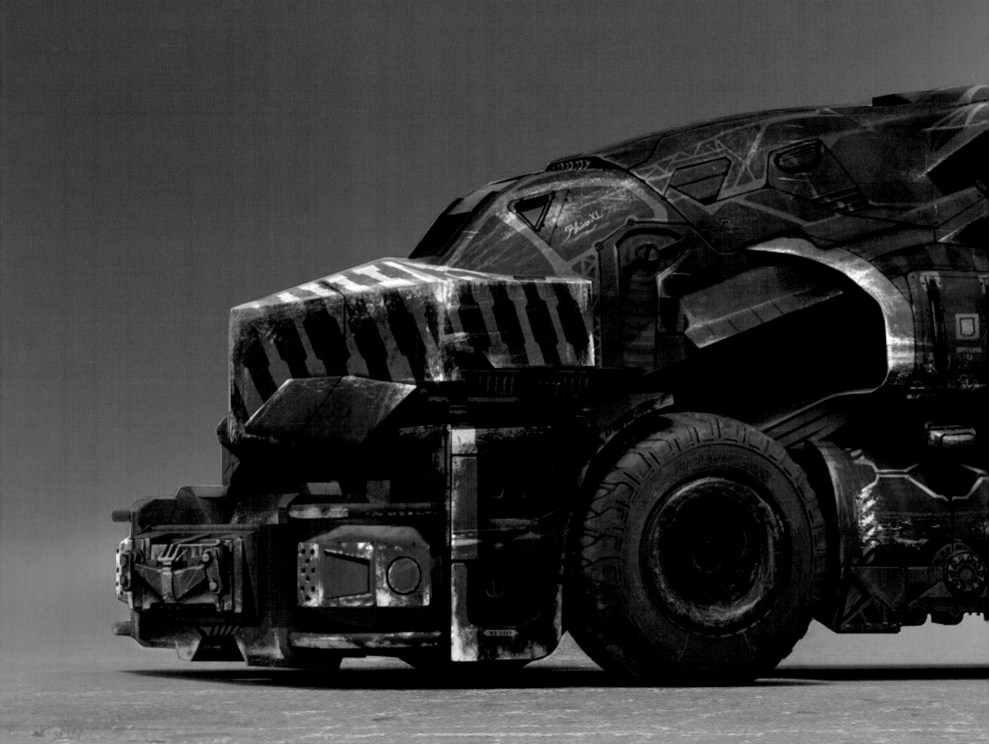

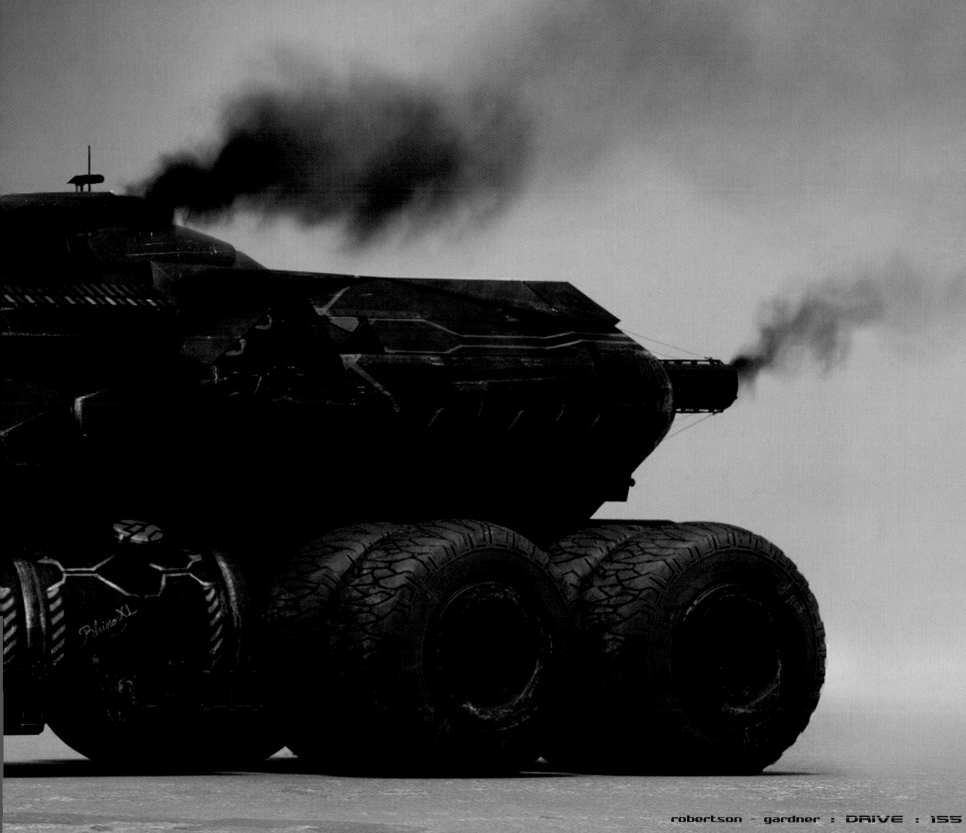

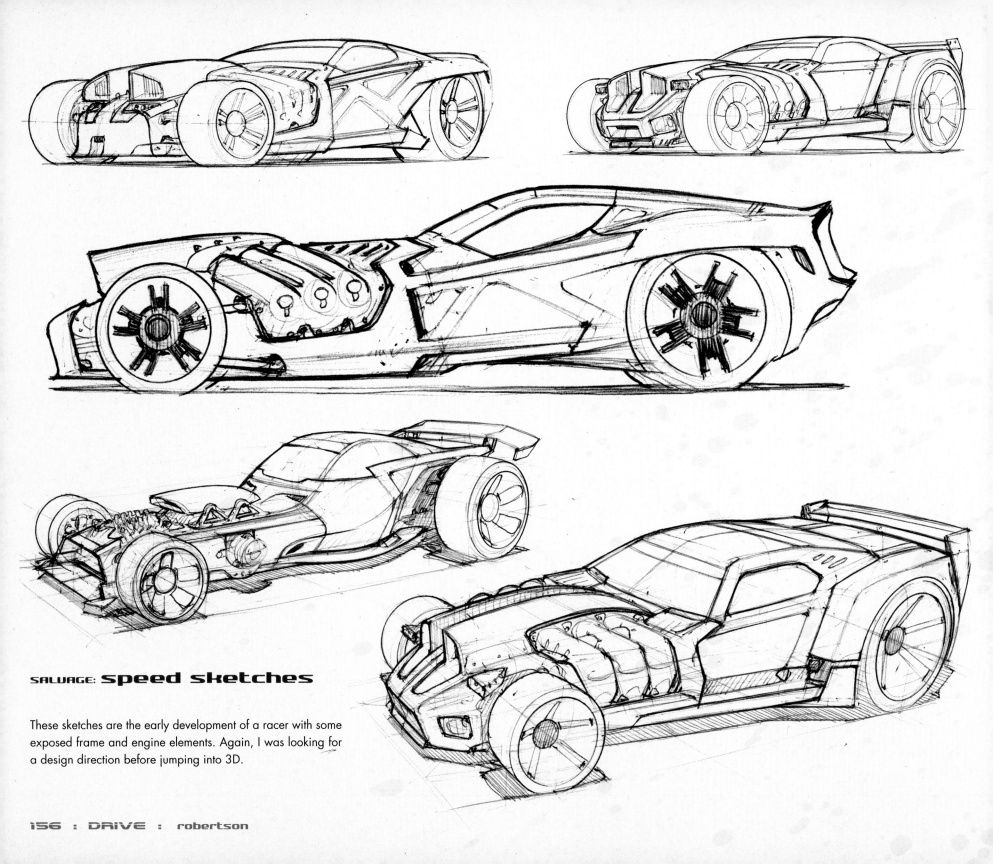

SALVAGE: speed sketches

These sketches are the early development of a racer with some exposed frame and engine elements. Again, I was looking for a design direction before jumping into 3D.

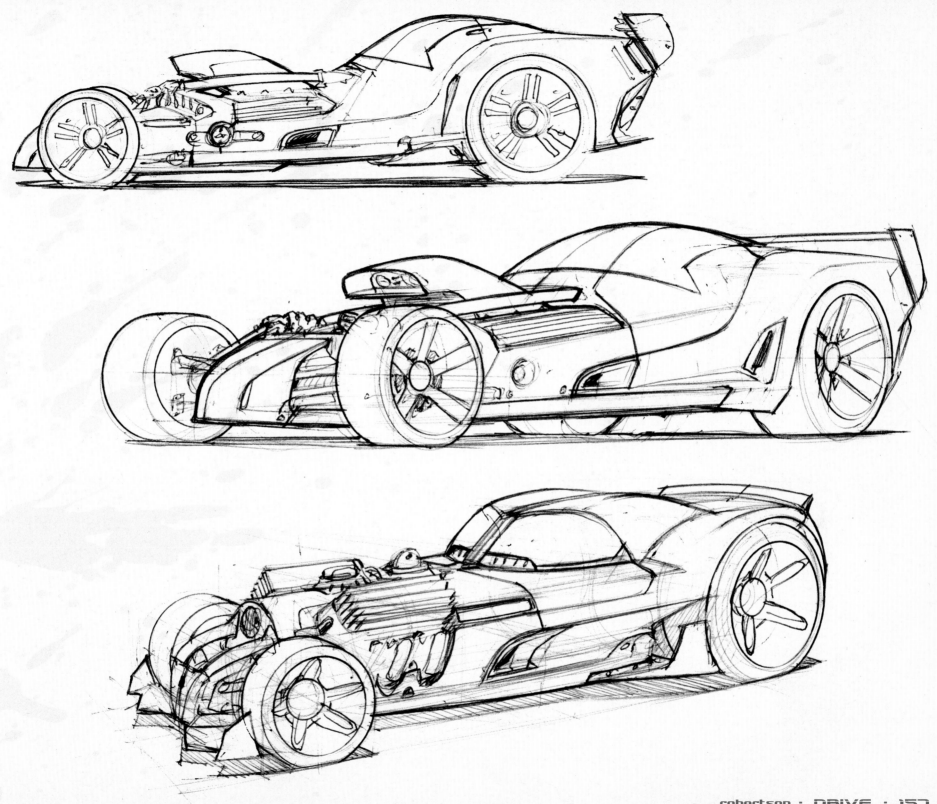

robertson : DRIVE : 157

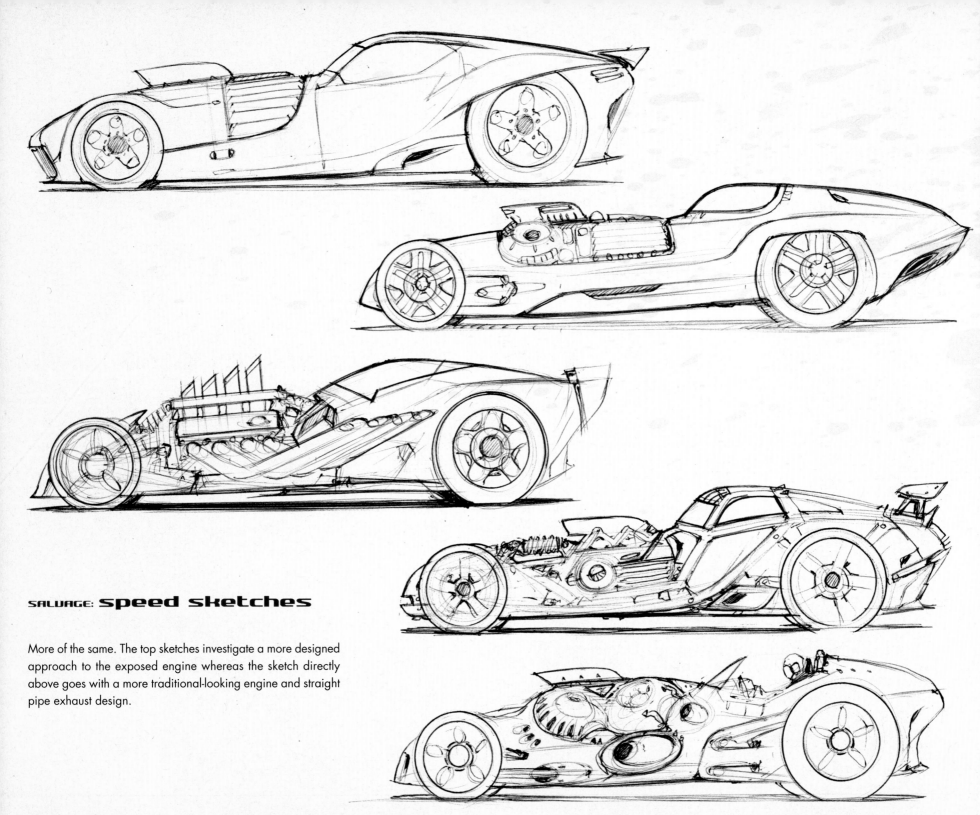

SALVAGE: speed sketches

More of the same. The top sketches investigate a more designed approach to the exposed engine whereas the sketch directly above goes with a more traditional-looking engine and straight pipe exhaust design.

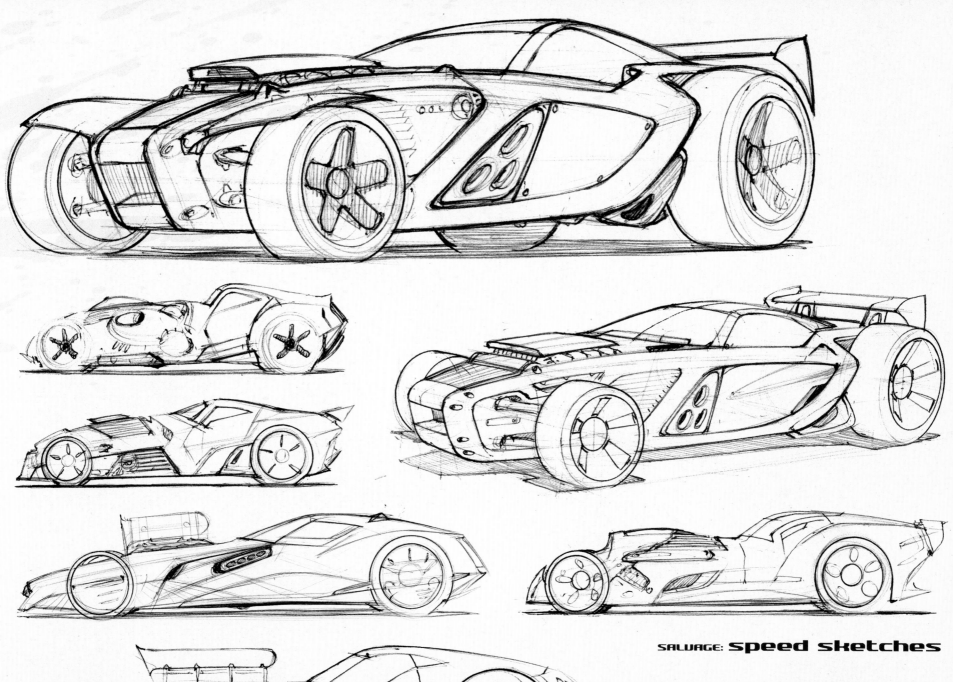

SALVAGE: speed sketches

The top sketches here further explore a hybrid of exposed engine parts with more purposefully designed and formed frame elements. Ultimately the look of this racer would be more defined in 3D than through these sketches, proving to me that for certain projects, a lot of early concept work can be achieved quickly in today's 3D programs such as modo and SketchUp.

This is the final version of the vehicle concept that came out of the sketches on the previous pages. I had modeled something more similar to the sketches at first, but it didn't resonate with me. So this somewhat ridiculous beast was born through the introduction of a huge turbine engine running almost the length of the car, meaning the driver was forced off to one side to make room for the overly large engine. Now this works for me!

On this page we find the driver and crew pushing car 3 back to the pits due to a rain delay. On the opposite page, car 7 is having some data downloaded after initial test runs on a dry lake bed. Turns out, on this day the engineers learn it does better in wet conditions than in the dusty desert!

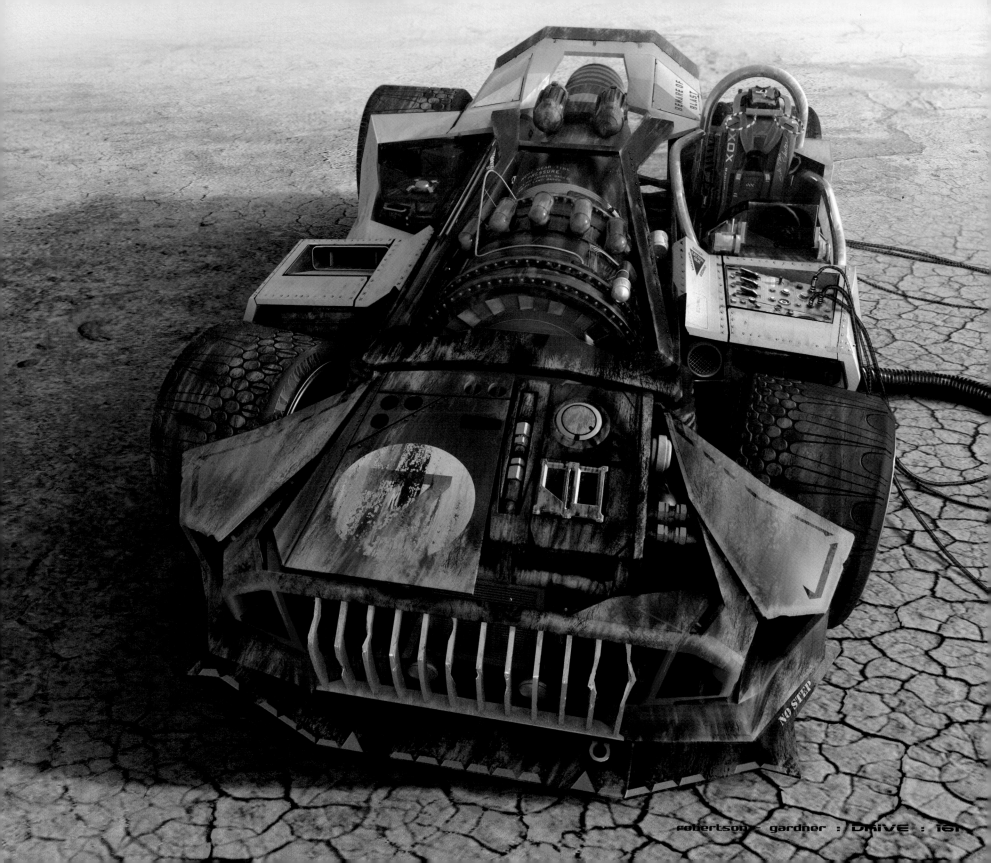

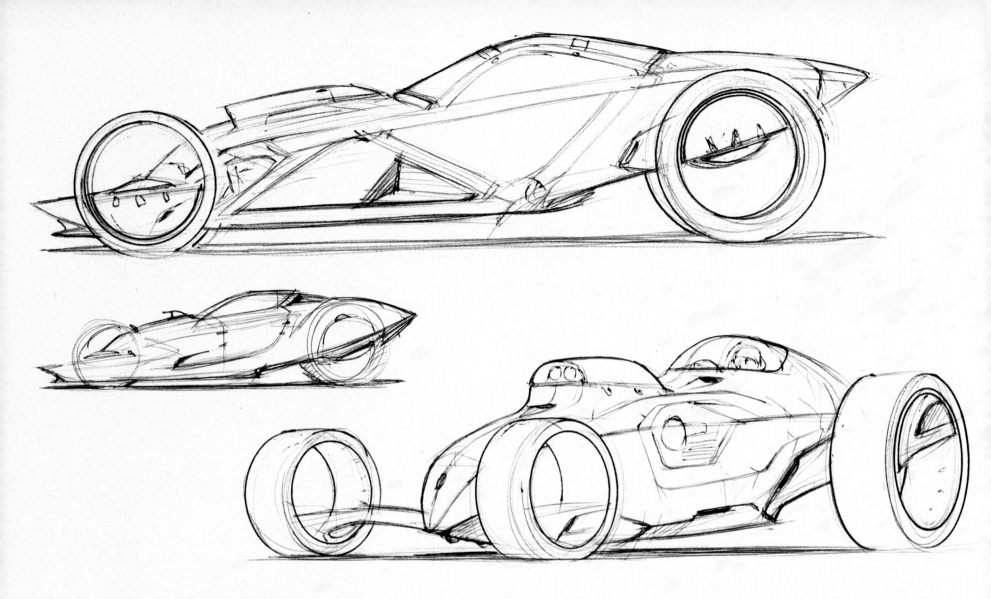

SALVAGE: open wheeler

Classic hot-rod proportions of a long nose, small aft-placed cabin and a raked stance were running through my head while doing these sketches. Combine this with a little sci-fi tech hubless wheel design and you have retro-futurism styling all day long!

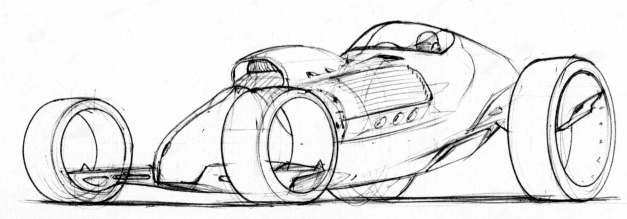

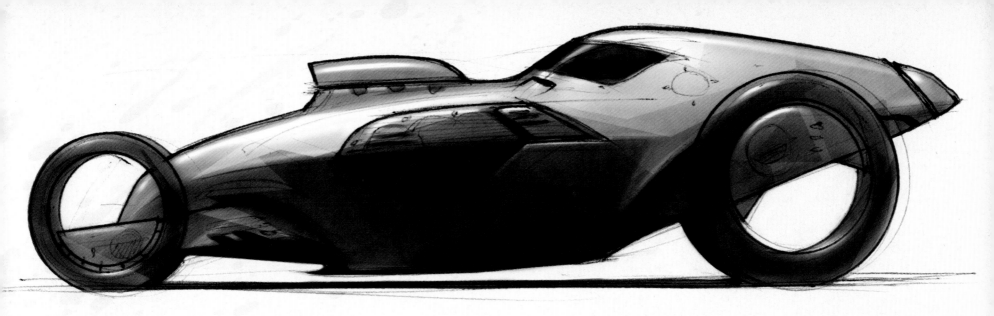

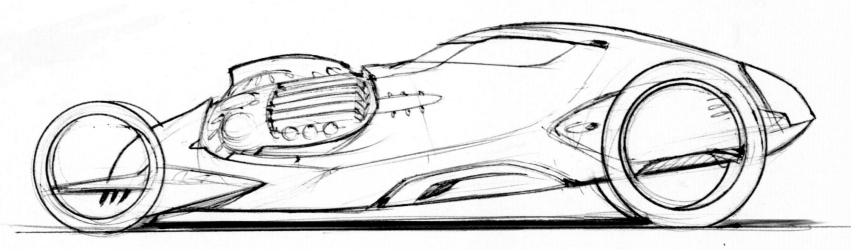

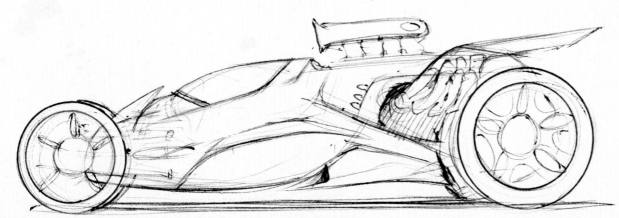

SALVAGE: **open wheeler**

On the sketch to the left I tried a more cabin-forward approach with a mid-engine layout, but it was back to the drawing board after that one.

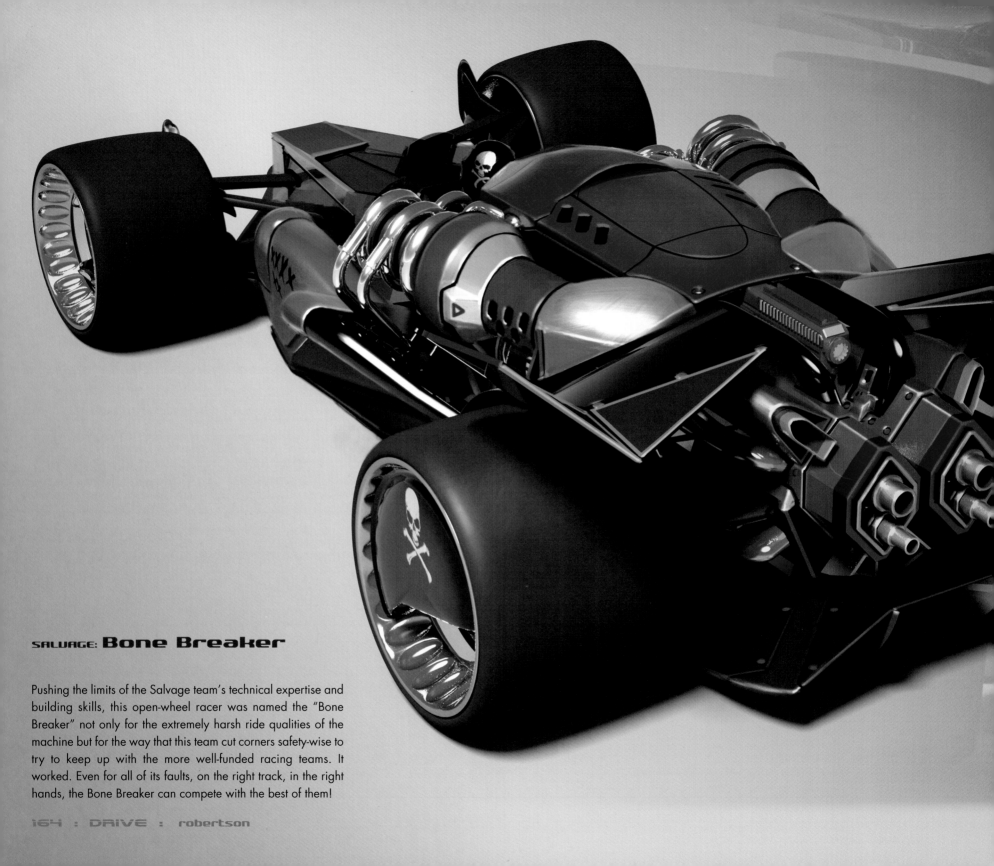

SALVAGE: **Bone Breaker**

Pushing the limits of the Salvage team's technical expertise and building skills, this open-wheel racer was named the "Bone Breaker" not only for the extremely harsh ride qualities of the machine but for the way that this team cut corners safety-wise to try to keep up with the more well-funded racing teams. It worked. Even for all of its faults, on the right track, in the right hands, the Bone Breaker can compete with the best of them!

SALVAGE: **Bone Breaker**

Ready to try and cheat death one more time going for win number seven! Will it be his lucky day?

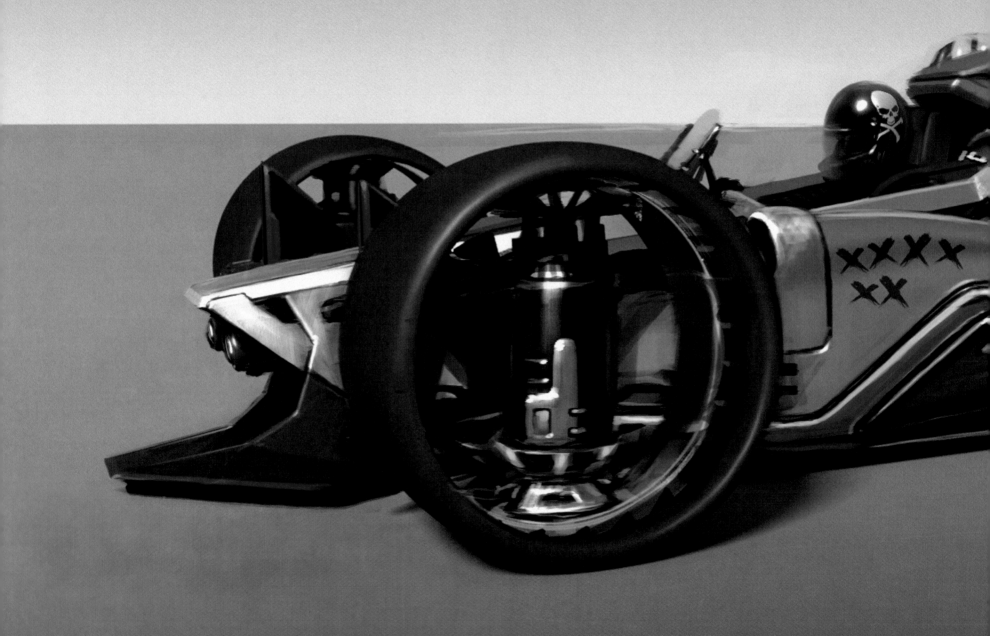

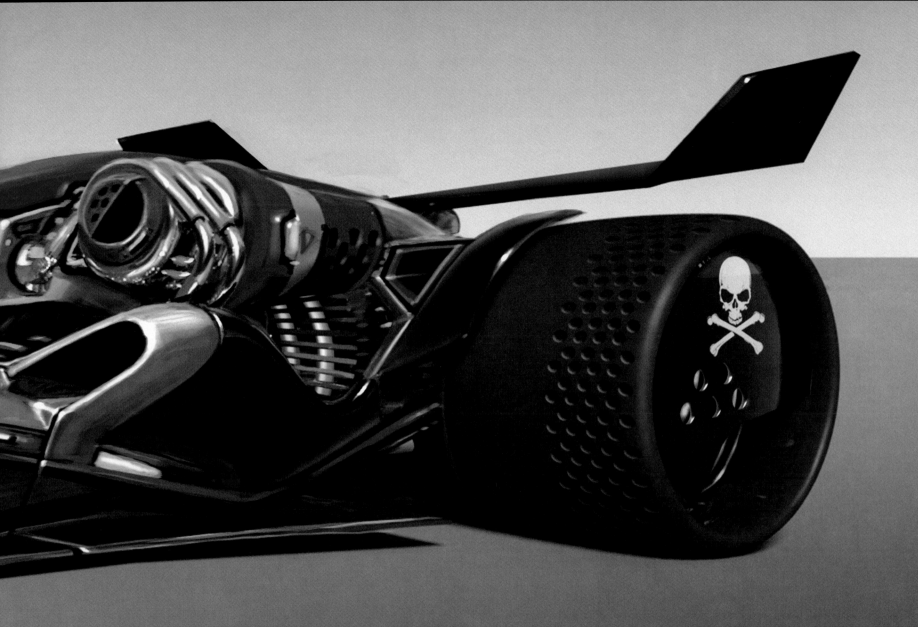

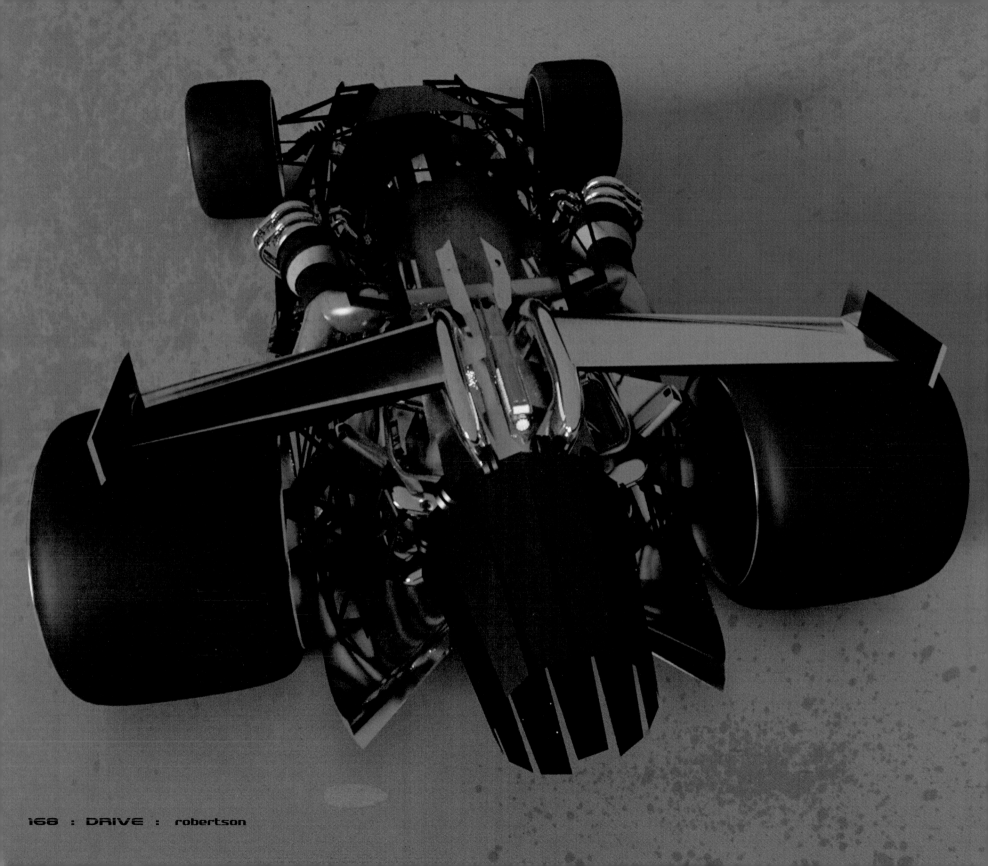

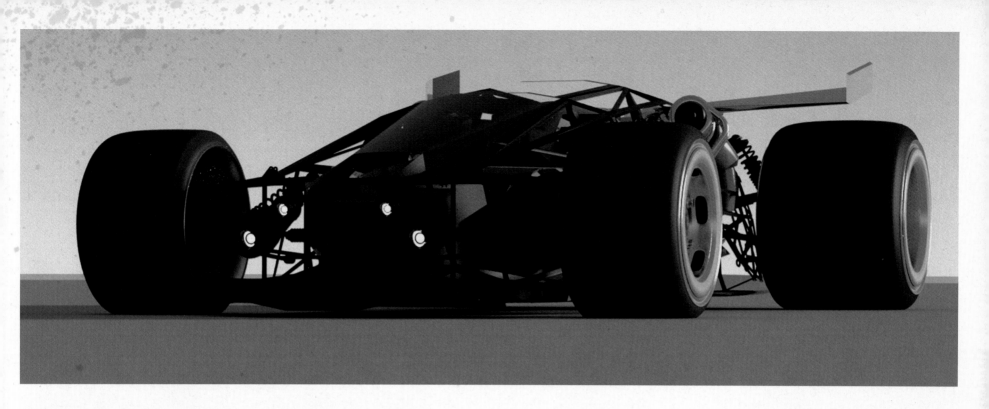

SALVAGE: **Black Widow**

These images show the raw 3D model renderings out of modo that were part of the early development of the Bone Breaker, but were used almost "as is" for the basis of the cousin to the Bone Breaker, the Black Widow. After purchasing a few 3D models of rocket parts, springs, bits and pieces, and making a bunch of our own, this concept model for the Black Widow came together much faster than I could have done it with only my 2D skills. This model more than any other has made modo a permanent tool of choice in my concept design process. It's not that I don't enjoy sketching and 2D rendering, or that I don't have strong skills in these areas. It's just that when tight deadlines loom, new tools will come along that greatly influence the way in which projects can best be completed in the shortest amount of time with the highest quality results. One strong word of advice for concept design students around the world reading this book: The digital tools do nothing to create aesthetically pleasing designs for you. Only a rigorous training in the fundamental principles of design, and how we humans perceive the world around us, will help you to reach this goal.

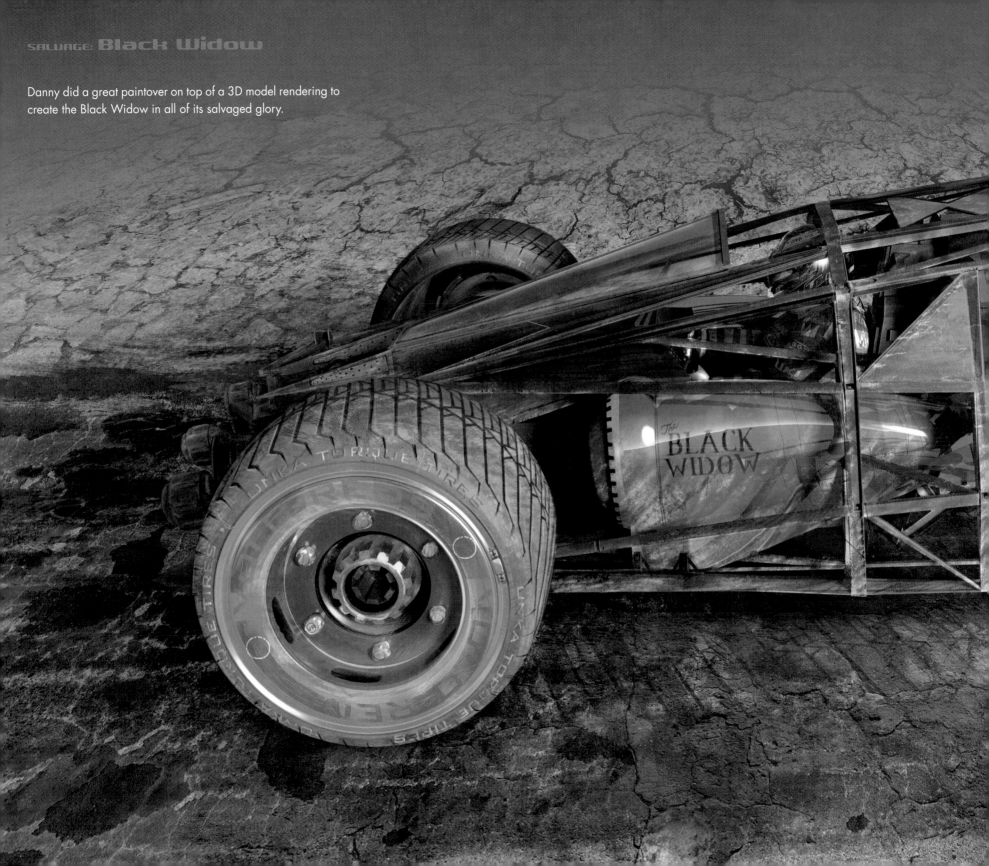

SALVAGE: **Black Widow**

Danny did a great paintover on top of a 3D model rendering to create the Black Widow in all of its salvaged glory.

The BLACK WIDOW

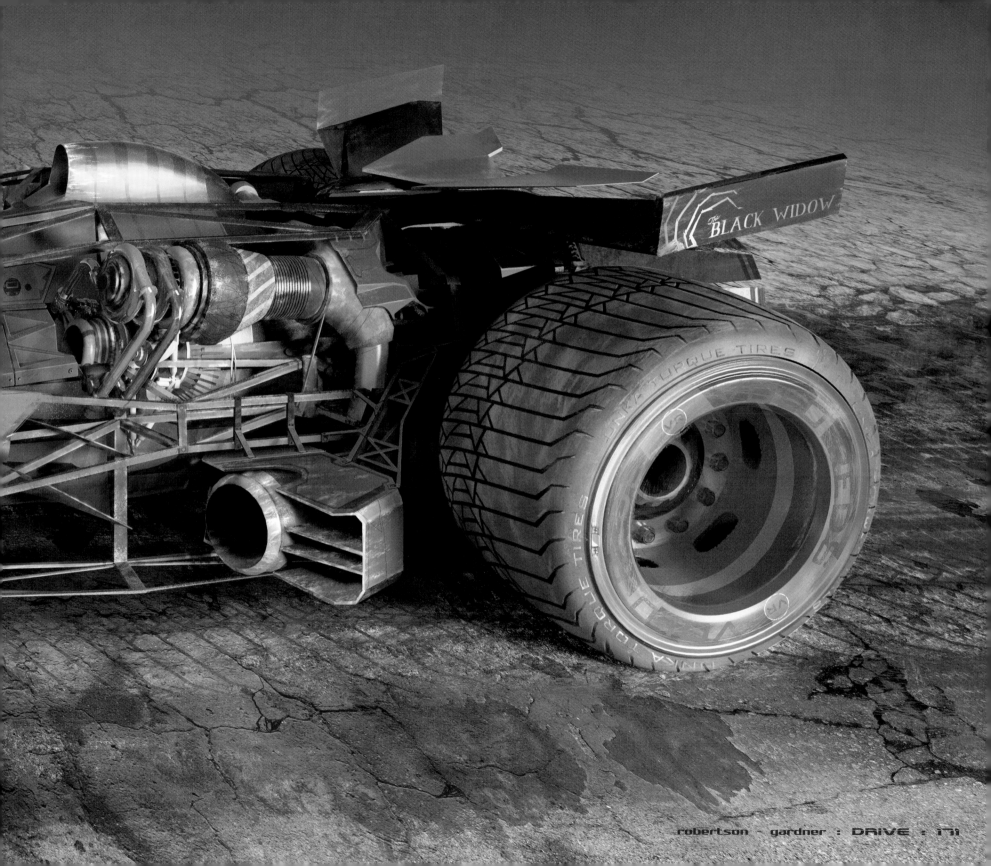

BLACK WIDOW

UNKA TORQUE TIRES

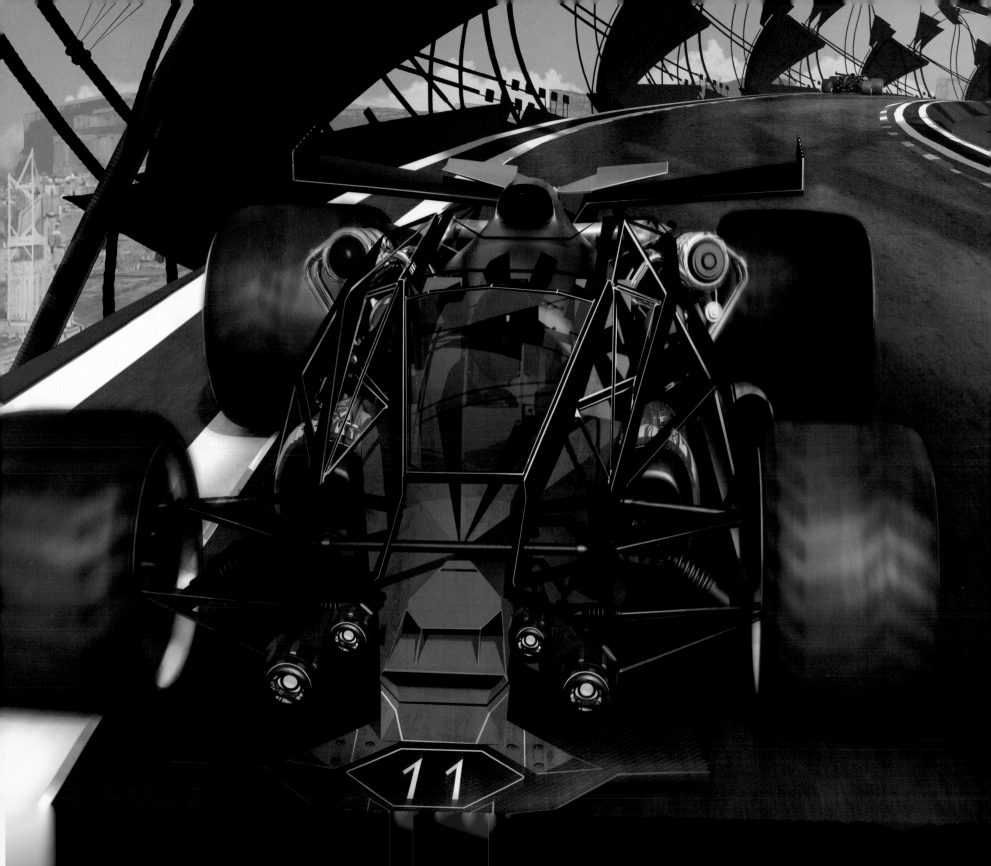

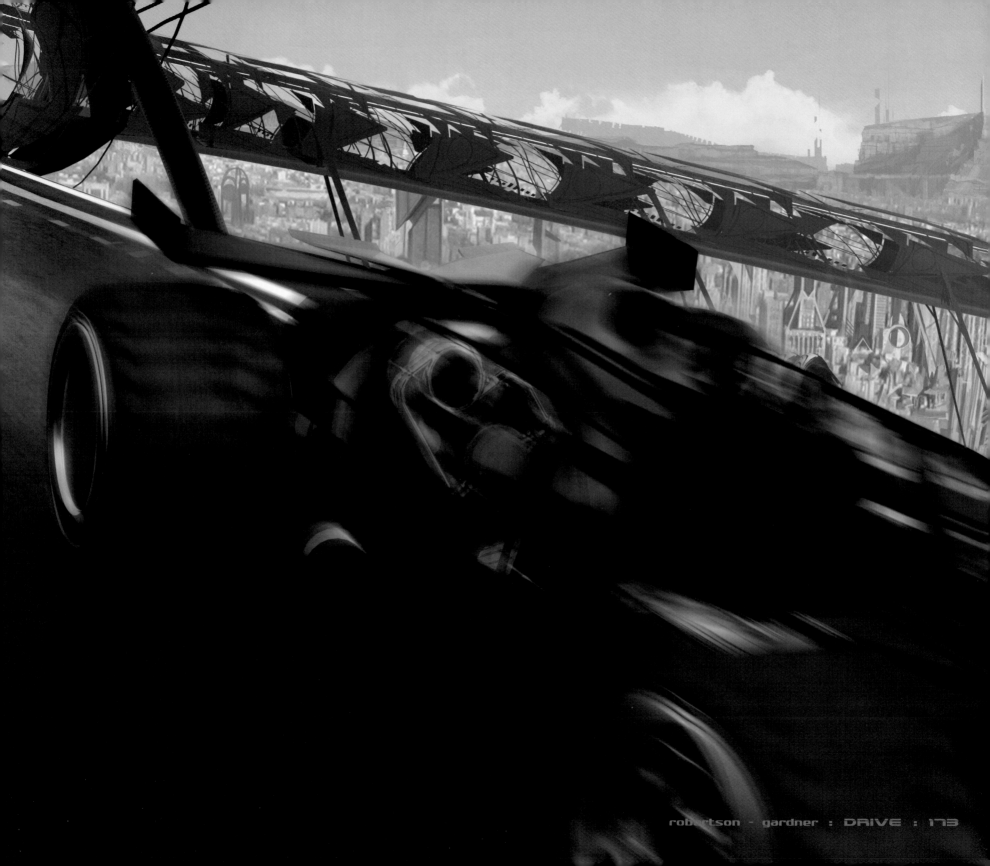

bios

Annis Naeem

Daniel Gardner

Annis Naeem was born in 1987 in Pakistan. He moved to New Jersey when he was 10 and thought he was destined to be a doctor or a lawyer, based on his family's expectations. At 18, he realized that his love for drawing and painting was greater than just the sketches in his chemistry class notebook, and he prepared for a move to California in hopes of receiving an education in concept design at Art Center College of Design. After over a year at Art Center at Night and Pasadena City College, spent preparing the portfolio needed for the transportation design degree program at Art Center, he applied and was accepted. In his first term he met Scott Robertson who convinced him that the new entertainment design program had the balance of design and illustration Naeem was looking for. He soon switched majors and landed an internship with Robertson the next summer through which *Drive* resulted. He is currently a student at Art Center with two more years to go before graduation.

www.annisnaeem.com
annisnaeem@gmail.com

From the beginning, Daniel Gardner had a passion for art. Born in 1989, he grew up in a family of creative people and designers. He took figure drawing, painting and animation classes in high school along with product and transportation design classes through Art Center College of Design's Saturday High program. Gardner had always dreamed of attending Art Center to major in transportation. Although, after a year at Pasadena City College, ready to apply to Art Center, he became aware of entertainment design and how it was going to become a new major at the school. Having immediately fallen in love with concept design, he changed his focus, but still has an immense love for automobiles. Gardner is now halfway through his time at Art Center and is excited to join the entertainment industry.

www.dannydraws.com
dannydraws@gmail.com

Scott Robertson

President: Design Studio Press

Scott Robertson was born in Oregon and grew up in the country. As a child his artist father, Richard, taught him how to draw and design the toys in his imagination. Fascinated by speed, he and his father designed and built soapbox derby cars. At the age of 14, Robertson finished sixth in the world at the annual race in Akron, Ohio.

After two and a half years at Oregon State, Robertson transferred to Art Center College of Design, where his father had attended as an illustration student before him. Robertson graduated with honors with a B.S. degree in Transportation Design in April 1990. He immediately opened a consulting firm in San Francisco, where he designed a variety of consumer products, the majority being durable medical goods and sporting goods. He began teaching at Art Center College of Design in 1995, first with a year-and-a-half stint at Art Center Europe in Vevey, Switzerland (now closed), and then in Pasadena, California. Robertson created the entertainment design major at Art Center, and served as chair of the department for 3 years.

He has worked on a very wide variety of projects ranging from vehicle and alien designs for the *Hot Wheels* animated series, *Battle Force 5,* to theme park attractions such as the *Men in Black* ride in Orlando, Florida for Universal Studios. He art directed 240 illustrations for Mattel's *Hot Wheels AcceleRacers* collectible card game, and authored the book *How to Draw Cars the Hot Wheels Way.* Some of his clients have included the BMW subsidiary Designworks/USA, Bell Sports, Raleigh Bicycles, Mattel Toys, Spin Master Toys, Nike, Patagonia, *Minority Report* feature film, Rock Shox, OVO, Black Diamond, Angel Studios, Rockstar Games, Sony Online Entertainment, Buena Vista Games and Fiat, to name just a few.

Dedicated to art and design education, he founded the publishing company Design Studio Press in 2002. The company's first book, *Concept Design,* printed in 2003 and featured in *Car Styling* magazine edition #155, is a collection of original artwork by seven of the top concept artists working in Hollywood. Its follow-up book, *Concept Design 2,* is currently in its second printing.

As a way to further design, drawing and rendering education, Design Studio Press teamed with The Gnomon Workshop to create a library of "how to" DVDs. Robertson himself instructed on nine DVDs, focusing on drawing and rendering techniques for industrial and entertainment designers. He co-produced an additional 41 DVDs with various top artists, designers, and instructors, including Syd Mead. To view all of the titles currently available, visit: www.thegnomonworkshop.com

To date, Robertson's company, Design Studio Press, has published 31 titles on art and design, with 9 of these having been translated into Japanese by the publisher Born Digital. Over the coming year Design Studio Press will release several new books, some of which feature new intellectual properties, which Robertson is working to option to various entertainment partners to be developed into games, movies and toys.

He currently works as a design consultant to the entertainment industry, and is married to film editor Melissa Kent.

To see more of Scott Robertson's personal and professional work, please visit: www.drawthrough.com

Other books published by his company can be found on their website: www.designstudiopress.com

afterword...

I hope you have enjoyed our design and styling explorations into the realm of hypothetical video-game vehicles. It is with great pride that I have been able to include the artistic efforts of both Danny Gardner and Annis Naeem, and I hope that our collection of sketches and renderings help to inspire a future wave of concept designers to build upon our ideas and techniques, reaching far beyond what we have shared with you here. For our part we will keep striving to reinvent and reinvigorate our own design processes and techniques and continue to share them with the world through Design Studio Press.

more cool stuff...

Be sure to pick up copies of my earlier books *Start Your Engines* and *Lift Off*, featuring many more sketches and renderings from earlier in my professional and educational career.

www.designstudiopress.com

Don't forget to visit my website and join the mailing list to be kept in the loop on new books and events. My blog is also a great place to see work-in-progress for future books.

www.drawthrough.com
www.drawthrough.blogspot.com

If you would like to learn more about the foundation drawing and rendering skills used by Annis, Danny and myself, please check out my educational DVDs at:

www.thegnomonworkshop.com

LIFT OFF »
air vehicle sketches & renderings from the drawthrough collection

scott robertson

Lift Off:
air vehicle sketches & renderings from
the drawthrough collection

ISBN-10: 1-9334-9215-5 paperback
ISBN-13: 978-1-933492-15-5

START YOUR ENGINES »
surface vehicle sketches & renderings from the drawthrough collection

scott robertson

Start Your Engines:
surface vehicle sketches & renderings from
the drawthrough collection

ISBN-10: 1-9334-9213-9 paperback
ISBN-13: 978-1-933492-13-1

For volume purchases and resale
inquiries please e-mail:

info@designstudiopress.com

Or you can contact:

Design Studio Press
8577 Higuera Street
Culver City, CA 90232
tel 310.836.3116
fax 310.836.1136